'Beatlemania' Grips Britain, Continent

Beatles /

★ From First P

dissent amid the joyous wel-|Ringo, Starr, 23,
coming uproar that kept 100|that "he's great —

Stop Show 10 Minutes

By DON ROBERTSON
It is not enough to call last

BEATLES press conference |for those few seconds th
story by Jan Mellow, con- |whooping girls almost bro
—

Beatlemania Lures 2 Runaways to London

Girls, 16, Take Off For London To See Beatles

Cleveland Heights (AP)—Po-| Cleveland Heights Police Chief |arriving Thursday. H

GIRLS LOST ON 'BEATLE HUNT'

SCOTLAND YARD were asked yesterday to trace two American girls, believed to have come to England to meet the

2 Missing Girls May be in London Chasing Beatles

LONDON, (UPI)--Eight thou sand teen-agers screamed a wel come home to the Beatles

PEOPLE IN THE NEWS

2 Ohio Girls Sought In Land Of Beatles

By JIM McLAUGHLIN
Several thousand teen-agers
screamed a welcome home to

and then warned her not to
return to school.
School officials had made

Search Beatles' Lair for 2 Cleveland Girls

The U. S. State Department moved today to locate and return two Cleveland Heights girls who flew to England Thursday, ostensibly to visit the Beatles home

Ohio Girls Elude Scotland Yard

CLEVELAND (AP)—Police in London still are on the look-out for two Cleveland Heights girls police believe went to the British capital because of their love for the Beatles. Word from Scotland Yard today was that no trace of the

Runaway Beatle Fans Are Lost by English Police

Trail has been lost of the two Cleveland Heights girls who flew to England in

Deejay Enlists in Search for Missing Beatle Fans

Harry Martin, morning KYW deejay, is working hard to locate the two Cleveland

Martha Schendel, to call him collect because "I want to hold your hands even if it ha

Torn Letters a Clue in Missing Girl Hunt

Cleveland Heights detectives have pieced tog-letters found in the wastebasket of one of the two
at may

Girls' Beatle Trip Was Planned Early

Two missing Cleveland Heights girls apparently planned their Beatle-visiting trip to England in early July,

Edward F. Gaffney said yes-terday.
Chief Gaffney pasted to-gether two torn-up letters

News | PAGE 13

Beatles join hunt for two American runaways

By JAMES LEWTHWAITE

THE Beatles joined a Transatlantic search last night for two American teenage girls who have run away from home to see

Believe Missing Girls Adrift In Beatle Land

LONDON (AP) — Two young girls missing from Cleveland, Ohio, and believed to be in Brit-

believe it was probably thrown away after I replied to it.
Police called on me today for

Beatle Fans Still Missing

LONDON (AP) — British po-ill had no word Satur ight on the whereabout

Missing U.S. Beatle fans seen in London

TWO pretty 16 years old American girls who flew into Britain on September 17 to pursue their

Two Cleveland Heights Beatle Fans Are Still in England After 18 Days

days have elapsed since those two 16-year-old Cleveland Heights girls, who

Janice's aunt, Miss Margie McBride, and her great-aunt, Mrs. Margaret Klein, with

pieced together by Heights police, yesterday provided the address of another Lon-

pilgrimage this way: "I can't understand what these chil-dren see in them." She was

'Yard' Finds 2 Missing Beatle Fans

LONDON ⏵ — Scotland Yard found two missing Cleveland girls Wednesday, but the young-

Missing Beatle Fans Found in London

LONDON, Thursday ⏵—Two 16-year-old Beatle fans who vanished from Cleveland Sept. 17 have been found

RUNAWAY GIRLS FROM U.S. ARE FOUND

TWO 16-year-old American girls whose Beatlemania

Two missing Cleveland girls found in London

LONDON (AP) — Two 16-year-old girls who vanished from Cleveland Sept. 17 have

OHIO GIRLS IN LONDON

Cleveland Runaways Missing Since September 17

London (AP) — Two 16-year-old girls who vanished from

Two Girls Fine; Yeah, Yeah, Yeah

Missing American pop fans found

London Police Nab 2 U.S. Beatleniks

LONDON, Oct. 7 (UPI) — Beatle fans Martha and Janice Hawkins

BEATLES, FAREWELL!

Scotland Yard Ends 2 U.S. Girls' Junket

LONDON ⏵ — Two 16-year-old American girls left for home Thursday, their week stay

said the girls were tired, had enjoyed their nearly three-

Bobbies Halt Tour Of 2 Beatle Fans

Beatles-Chasing Girls Leaving England Today

LONDON (UPI)—Two teen- or two nights, and then took agers from Cleveland, Ohio, Janice

Bewildered Teen-Agers Heading Home

LONDON (AP) — Two slightly bewildered American teen-agers left for home today, their dreams of an exciting world

FLY-AWAYS SENT HOME

In a flat at Holland Park, London.
Their parents thought the girls had flown to

an apartment in the fashionable low down Holland Park area

Beatle-Chasing Girls Get Cop Escort Home

CLEVELAND (UPI)—Two Martha and Janice had enage girls who journeyed nothing to say to newsmen,

Runaway Girls Back In Cleveland

CLEVELAND, Ohio (AP)—

2 Beatle Fans' Wings Clipped

Cleveland Girls Home In Custody

DREAM TRIP IS OVER

2 Return With Thud From Beatleland

Runaway Girls Released from Detention Home

CLEVELAND (AP) — Two

2 Beatle Runaways Back as 'Delinquents'

CLEVELAND, Ohio (UPI)—Two

Cleveland Girl Beatle Fans Charged

CLEVELAND, Oct. 10—⏵—

Girls Denied Right To See Rolling Stones

CLEVELAND (AP)— Martha Schondel and Janice Hawkins

Two Beatles Buffs Biffed By Blunt Juvenile Judge

CLEVELAND ⏵—Besides group. Promoters for the being judged delinquent group had given the girls

"The parents of Cleve should hang their head

Public Hall to Ban All Beatlemania

Mayor Locher announced today that the Beatles and similar groups will no longer be permitted to use the Public Hall or other city facilities for their perform-

MY TICKET
TO RIDE

MY TICKET TO RIDE

How I Ran Away to England to Meet the Beatles
and Got Rock and Roll Banned in Cleveland
(A True Story from 1964)

Janice Mitchell

Janice Mitchell

GRAY & COMPANY, PUBLISHERS
CLEVELAND

Gray & Company, Publishers
www.grayco.com

Library of Congress Cataloging-in-Publication Data
Names: Mitchell, Janice, author.
Title: My ticket to ride : how I ran away to England to meet the Beatles
 and got rock and roll banned in Cleveland (a true story from 1964) /
 Janice Mitchell.
Description: Cleveland : Gray & Company, Publishers, 2021.
Identifiers: LCCN 2021016625 (print) | LCCN 2021016626 (ebook) |
 ISBN 9781598511161 (paperback) | ISBN 9781598511178 (ebook)
Subjects: LCSH: Mitchell, Janice—Travel—England. | Popular music
 fans—United States—Biography. | Popular music fans—United
 States—Travel—England. | Beatles.
Classification: LCC ML429.M56 A3 2021 (print) | LCC ML429.M56
 (ebook) | DDC 782.42166092 [B]—dc23
LC record available at https://lccn.loc.gov/2021016625

Printed in the United States of America
1

*In memory of my great-aunt
Margaret "Toots" Klein
and my great-uncle
Ernest "Mac" Klein*

The best way out is always through.
—Robert Frost

Contents

PART ONE

*I Want to Hold
Your Hand*

Chapter 1

IT WAS CHRISTMAS BREAK, 1963, and I sat in the kitchen trying to stay awake while writing a homework essay. Homework during break just wasn't fair, but it had to be done. I turned on the large portable orange and white radio that was my lifeline to the outer world, pointed the telescoping chrome antenna toward the window, and turned the dial to 1420 WHK.

Some of the popular songs on Cleveland radio that week were "Since I Fell for You" by Lenny Welch, "Deep Purple" by Nino Tempo and April Stevens, and "I'm Leaving It Up to You" by Dale and Grace. Pretty tame. The liveliest song going was "Louie Louie" by the Kingsmen, a song that kids weren't supposed to listen to because some adults thought it was suggestive. I didn't even know what *suggestive* meant. The radio stations played it, and we danced away.

Instead of working on my essay, I tapped the sharpened tip of my yellow No. 2 pencil to the beat of "There I've Said it Again" by Bobby Vinton. I had nothing against Bobby Vinton, but the tune was kind of boring. Then "Popsicles and Icicles" by The Murmaids: I'd heard it about a million times. I glanced down at the few sentences I'd written and stared out the kitchen window at the dark-gray, winter Cleveland sky. The wind whistled through the trees, and, as usual, it was cold and snowing.

"Dominique" by the Singing Nun came on. She sang it in French, so I didn't know what she was saying, but she had a sweet

voice and accompanied herself on an acoustic guitar, which was cool for a nun. Even though teens couldn't dance to it, the song was in the number-one spot on the *Billboard* Top 10. As an Irish Catholic girl who went to a Catholic girls' high school with nuns as teachers, I had to love this song or risk going straight to hell upon death—or maybe even sooner. All the nuns went wild, so to speak, over this accomplishment by one of their own. I heard a nun or two humming the tune as they passed by in the school hallway, amid the normal nuns-wearing-habits sounds, the jingling of keys, rosaries, and crucifixes.

I turned the dial from WHK to KYW. A new disc jockey, Jerry G, had just arrived at KYW from Chicago. Chicago—the big city I knew of only because that's where my mother went with her boyfriend after abandoning her three children and husband. I didn't hold that against Chicago, though. Maybe, I hoped, this new disc jockey brought some records with him that we hadn't yet heard in Cleveland.

Jerry G was on, announcing a new group with a one-word name. Beagles? I didn't hear the name clearly. Then, a sound I'd never heard before. The guitar chords and harmony electrified me. I jumped up from my kitchen chair, grabbed the radio with both hands, and held it close, straining to hear every note, every word.

The song was "I Want to Hold Your Hand."

After the song finished, Jerry G announced the group's name again: "And that was the Beatles . . ." He described them as a new singing sensation from England.

I almost knocked my chair over as I lunged for the yellow telephone on the kitchen wall. I grabbed the receiver and called the station. Busy. I redialed. Busy again. I must have dialed the number a dozen times hoping to speak to Jerry G and ask him to play the Beatles song again, but I couldn't get through. Every kid in Cleveland must have been calling.

The Beatles! I wanted to hold their hands too, and right then. The words presented such a simple, yet powerful, request. I needed

someone to hold my hand. I'd never experienced that feeling before. I couldn't think of anyone who had held my hand with love, ever. Holding someone's hand meant they thought you were worthwhile, that they cared about you. It meant that they were telling you everything was going to be okay, that you were not alone in the world.

My heart wanted that.

I had to see what the Beatles looked like. I wanted to learn everything about them—as soon as possible. Now, aside from seeing Jesus in heaven, I had something to live for.

Chapter 2

I'M THE FIRST of three children. My parents discovered early on that raising children didn't fit their lifestyle of booze, cigarettes, and partying until all hours. My father was handsome and charming and regularly changed jobs. He smoked Pall Mall cigarettes and drank bottles of Ballantine beer. The day I was born he was fired from his job as a salesman at Sears, Roebuck after being caught stealing. Right afterward, he was seen going to the movies with some woman.

My mother was tall and slender, with dark hair and a ready smile for strangers. But at home, her red fingernails dug into my arm as she dragged me across the living room while smacking me because my presence bothered her. She drank fancy drinks garnished with tiny white onions or green olives with pimentos. Our living room couch, where my mother frequently passed out, was peppered with cigarette burn holes.

One night as my parents were on their way out for a night of partying, my mother took a moment and looked down at me with a sneer to impart some motherly advice. Through the cigarette-smoke haze she said, "Janice, be sure that your cologne is always cool when you spray it on; otherwise it's useless." She finished her martini, checked her hair, fixed her red lipstick, and, with high heels clicking on the bare floor and my father in tow, walked out into the dark night, laughing. The door slammed behind them. I was left alone with my little sister and baby brother. I was five.

Until I was six years old, my parents and my siblings and I lived in a four-family apartment building on East 90th Street in Cleveland, across the street from St. Thomas Aquinas Catholic Church and Elementary School. One of the places I used to run to for shelter was the basement of our apartment building. I tiptoed along the dimly lit hallways and storage areas, ducking cobwebs and looking for whatever might be interesting. On one of my basement treasure hunts, I discovered a storage room with a large piano and bench. I discovered that each of the piano keys made a distinct sound, and soon I could pick out the notes for Shirley Temple's "On the Good Ship Lollipop." For a few moments I could forget about my deplorable home life. The fear and stress faded away with each note, and I was carefree for a little while. This was the beginning of my lifelong love of music.

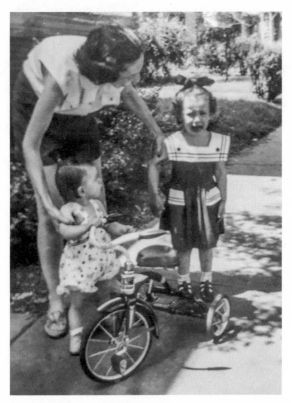

Me (crying) with my mother and sister.

Chapter 3

BY THE TIME I was seven years old, my parents had been frequently dropping off my sister and brother and me to stay with people we had never seen before, for reasons we were never told. Some of these strangers were harmless, and others not so nice. I developed survival rules: keep my mouth shut, ask no questions, and don't bring attention to myself. Upon failure in adhering to these rules, run, hide, and wait it out. My strategy worked, and I survived.

But after a few days or a couple of weeks we always returned to live with our parents in the apartment across the street from St. Thomas Aquinas School and Church. At night, when children were supposed to be tucked into bed dreaming childhood dreams after listening to a lovely story, I lay awake listening to my parents screaming at each other. I lay in my bed with covers pulled over my head trying to drown out the sounds of dishes and glasses crashing, the thump of something heavy hitting the wall, my mother sobbing, and then silence as the two of them passed out in the living room. I prayed to Jesus and decided to become a nun.

Sometimes I stayed with my great-aunt, Margaret Klein, her second husband, Ernest "Mac" Klein, and her adult daughter from a previous marriage, Margie. They lived nearby on East 86th Street. I called my great-aunt "Tootsie Roll" or "Toots" because she was sweet as candy to me. Staying with them was a wonderful break. Everything in their house was clean, and there were three meals a day. I'd skip out the door for school with a brown bag filled

with a sandwich, an apple, and a jar of milk. After school, I would go back to my parents' apartment.

One morning as I was leaving for my second-grade class at St. Thomas Aquinas, Toots announced, "When school is over, you're to come back here." She said I'd be staying with her and Mac from then on.

After school that afternoon, Mac took me back to my parents' apartment to pick up my things. Where were my sister and brother? Weren't we going to bring them with us? But they weren't there. My parents weren't there either. Everyone was gone. "Where are they?" I asked Mac. "Are they waiting at your house?" He said not to worry, they would be fine, and I would see them again but not now.

In fact, I wouldn't see them again for a very long time. We would be raised separately, no longer a part of each other's lives. My parents wouldn't be in my life either. My father signed the three of us over to the State of Ohio. I eventually had two conversations with him not long before he died, in his sixties. My mother, twenty years after abandoning her children and husband, and in her third or fourth marriage in Chicago, died at age forty-eight in a fire she started after passing out drunk with a lit cigarette.

* * * *

When I moved in with Toots and Mac and Margie full-time, I got to know them better and found that Toots wasn't always so sweet.

Toots was old-world Irish Catholic. She didn't believe in wasting time on answering foolish questions asked by children. Children were meant to be seen and not heard. Mac was the calm and steady captain of our small ship. Quietly in charge, he expertly navigated the boat through household squalls and avoided the reefs in the small sea of Toots and Margie, two single-minded Irish women.

Margie was a fashionable career girl who worked in downtown Cleveland. She was two years older than my mother and had never been married as far as I knew. An aspiring socialite, she spent her

evenings and weekends with friends downtown, drinking cocktails at restaurants and attending plays at the Hanna Theatre. She looked the part, too. She was tall and slender, her long legs sported a tan year-round, and her feet were in high heels no matter what. She breezed down the roads driving a yellow convertible with the top down, wearing sunglasses and brandishing a cigarette. She went to the hairdresser every week to have her long, champagne-blond hair touched up, washed, dried, and rolled into a perfect French twist. When she was at home, she painted her nails with red polish, smoked cigarettes, and sipped cups of tea, leaving her trademark red lipstick along the rim of the cups.

When I was eight years old, Toots, Mac, Margie, and I made a big move from the city of Cleveland to the suburbs—Cleveland Heights, where life was beautiful. My new elementary school and church were both named St. Ann. The church was a beautiful cathedral. The school had a large gym, and below it in the basement was a full-size indoor roller-skating rink with a snack bar that served french fries and Coca-Cola. Father Goebel was the cool priest. He'd show up at the snack bar smiling and joking around and be quickly surrounded by grade-school roller skaters. "Father Goebel! Father Goebel!" we'd all yell, and we'd skate over to him hoping to be the first one to get near him. I had my own white lace-up skates with pom-poms and a case to carry them in. I was one of the fastest skaters and won ribbons in speed competitions.

In our new neighborhood, mysterious-looking mansions along Coventry Road were set back in large yards bordered by towering trees, with U-shaped driveways. Even our grade-school teachers, Ursuline nuns, lived in one of those mansions.

We lived on more modest Renrock Road, upstairs in a two-family house. My bedroom was the corner sunroom. It had six windows, its own door from the outside hallway, and French doors that opened to the dining room. The daily routine of the household gave me a chance to feel settled. Having school friends and neighborhood friends come over to our house wasn't encouraged,

but I was content going to their houses. I liked to read, bike, and take walks. The chaos of my early childhood faded.

We barely went anywhere as a family except church, the occasional visit to Toots's son, daughter-in-law, and grandson, and the rare drive to visit Mac's son in Massillon, Ohio. Sometimes we visited the Peoples family, who were longtime friends of Toots. One of their relatives was an Ursuline nun who was the principal at Ursuline Academy of the Sacred Heart, a Catholic girls' high school I would eventually attend.

St. Ann Church and St. Ann Elementary School were just down the street and across busy Cedar Road from our house. The church was open all the time. When I felt worried, I went there, down to the lower-level chapel. In the quiet darkness I'd sit on the floor in the hallway outside the chapel, lean back against the cool, soothing marble walls, and think. I was free to think about anything, and it was okay to talk to God about whatever was on my mind.

My life felt almost perfect.

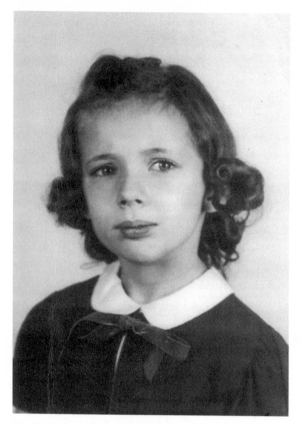

My school photo from second grade, February 1955.

Chapter 4

THE LITTLE BIT of luck I was born with served me well. I had my Uncle Mac now, full-time. A black cigar box bearing the words OLOGY CIGARS sat on a table near his cushiony living room chair. Part of a cigar, chewed up, dark brown, always rested in an ashtray within arm's reach, waiting for him to resume his newspaper-reading and cigar-chewing time. Margie hated it. I cherished it. Every time I saw his cigar, I felt joy, knowing my uncle was in my life.

Mac was kind, patient, and fun. "*Eins, zwei, drei,*" he said while we were driving someplace. "This is how you count to ten in German."

"*Eins, zwei, drei, vier, fünf, sechs, sieben, acht, neun, zehn,*" I happily recited for my uncle. He laughed. His was a happy laugh that made me feel sunshine in my heart. "Now you will always know how to count from one to ten in German. That's a good accomplishment."

Sometimes Mac sang German songs. "Sing with me," he said. "Ach, Du Lieber Augustin." It was a popular German and Austrian children's song with the same tune as the nursery school song "Did You Ever See a Lassie?".

We sang and laughed. All it took was one song to instantly make me feel free and happy and forget anything that was bothering me.

On Sundays, Mac and I read the funnies together. Our favorite comic strip was *The Katzenjammer Kids*. The best part was Mac

reading the words out loud with an exaggerated German accent to make me laugh. We were like Heidi and the grandfather in the Shirley Temple movie *Heidi*. No one could take our happiness away.

I'm not saying there weren't bumps along the way. Obedience was the Irish Catholic child's requirement. The unspoken rule was "Don't ask questions if you know what's good for you." Once, Toots thought I had raised my voice, which was forbidden. Although I wasn't aware of raising my voice, I was ordered to sit on a hard chair in the corner of the dining room and repeat, in a seemingly endless loop, "A young lady never raises her voice; she always speaks very quietly." Growing up under the forced, silent obedience of old-world Irish Catholicism was oppressive. The pressure fanned a small flame of rebellion in me.

It wasn't that I didn't love my great-aunt—I did. But since moving in with her full-time, I always felt like I was on the outside of her love and attention, and there was no way in.

Toots had a wooden buffet table in the dining room. In the top drawer on the right there were clear plastic tubes with silver screw-on tops. The tops had narrow slots in them. Each tube was labeled: "Nickels," "Dimes," "Quarters." I watched her feed the coins into the tubes and listened to each one clink into place as the stack grew.

"Don't get any ideas," Toots said. "Billy is my priority." Billy was her only grandchild, her son's son. "We're saving up for him to go to West Point." Billy's bedroom at his home was decorated with Civil-War-themed wallpaper and lamps and military decorations. I don't think Billy was allowed to imagine any future other than attending West Point.

Toots's announcement, although it stung, gave me some relief in an odd way. It explained something I hadn't understood. As hard as I had tried to get Toots's attention and approval, I had never been able to. Now, I realized I never would. She let me live in her home and help her with laundry, dishes, and dusting, but there

would be nothing more. This was the first formal declaration of my standing in Toots's home, but it wouldn't be the last.

My Uncle Mac saw me in a different light. He made me feel like I was a normal, carefree child, just being silly and having fun. I admired how he quietly persevered and prevailed in our little household.

"Now, now, Margaret," he would say to Toots when she got upset about something, and she would stop right away. Mac always had the final word. His gentle ways and calming influence made life beautiful for me.

Mac taught me to ride a bicycle at our first house, on Rexwood Road. The bike wasn't much to look at. It was from some friends of Toots who occasionally gave me secondhand clothes—a bike their daughter had outgrown and apparently not maintained very well. At least it was a girl's bike, but it was way too big. Still, I was determined to master this blue beast. As Mac steadied the bike, I managed to push myself up onto the seat, but I couldn't reach both peddles at the same time. I rode standing up, wobbling along the sidewalk. My neighbor Ellen, who always had the newest and best clothes, was on her own, brand-new bike. "Look at Janice on that ugly old bike," she called out. "Don't pay any attention to her," Mac said. With his steady hand and encouraging words, I could conquer anything.

Mac never went to church with us. He never went to any church. My heart would sink when Toots, Margie, and I would leave for Mass at St. Ann. "Mac, can't you come with us?" I'd ask. "No, you go on. I'm fine here." I'd look back at him sitting in his chair reading the newspaper and chewing on his cigar. Sometimes I worried that he might not make it to heaven because he wasn't Catholic. I was well aware that non-Catholics were supposed to go to hell when they died. But surely Mac had a special dispensation. Why would God send him to hell? He was the best person I ever knew in my life. God wouldn't do that to him.

Mac had been an expert tool and die maker. A retirement

plaque with a tool he had used, mounted on a wooden base with an inscription on it, stood on his bedroom dresser—right in the center. After we moved to Renrock Road, he worked as a school crossing guard at St. Ann's.

I loved going to school at St. Ann's. I wore a uniform: white blouse and blue jumper with the school emblem stitched on the bib. The emblem was SAS with the A larger than the other two letters. Saddle shoes, brown and white or black and white, were mandatory; I wore mine with pride.

To get to school, I walked to the corner of Stillman Road and Cedar Road, just a block from our house on Renrock. This was Mac's corner. I beamed as I watched him hold up the red and white stop sign, made sure the cars stopped, and walked with us kids across the street. "That's my uncle," I would say to the other kids. In the winter, he wore a dark-blue cap with a brim like a policeman's hat, thick earmuffs, a long, heavy navy-blue coat with big round buttons, a scarf tucked into his coat, huge gloves, and boots with buckles. Even on the coldest day, Mac was my sunshine.

Finally, life was good. For the next seven years, I was happy.

* * * *

On Tuesday, March 11, 1963 at six a.m., everything changed.

"Wake up! Wake up!" I heard Toots cry out. It sounded like she was in the bathroom. I jumped from my bed and bounded through the dining room toward her voice. She stood in the bathroom doorway with a wet washcloth in her hand.

Mac was crumpled on the floor. Toots was smacking him with a wet washcloth. "Wake up. Wake up," she cried. He wasn't moving.

"Don't come in here," she ordered. Mac had been getting ready for work as usual when he collapsed. I couldn't understand why he didn't get up.

"Heart attack," the ambulance men said. I stood silent and in shock. They wheeled a large black bag on a gurney through the dining room, past my bedroom, and away. Mac's face was covered

up inside the bag. I needed to see him and lean my head on his shoulder just one more time. *Uncle Mac, please wake up. I need you!* I wanted to cry out, but he could no longer hear me.

I ran into my bedroom and threw myself facedown on my bed and sobbed. This was the sunniest room in the house, but the sun would never shine again for me. My world went black. Indescribable pain stabbed me in my head, heart, and stomach. I didn't want to stop crying. How could I live without him?

Margie came into my room and perched on the end of my bed.

"You loved him, didn't you?" She sounded surprised that I could love anyone.

I was stunned that she had come into my bedroom—she'd never done that before. She spoke to me as if I were a human being. Another shock. I hated that she saw me being so vulnerable. Of course I loved him—he was the kindest person I had ever known. And he was gone. I wanted her out of my room, but I couldn't speak. I just wanted to be left alone. I was fifteen years old, and my life was over.

After Mac died, we moved to the second floor of another two-family house, on Belmar Road, still in Cleveland Heights. It was about a fifteen-minute walk from Renrock Road, but I might as well have moved to Mars. I missed my sunny bedroom, my house, my neighbors, my friends in the neighborhood, and being across the street from St. Ann's. Most of all, I missed Mac.

Toots became ill and depressed and began to experience memory loss. She would often say she was waiting to die. It was so incredibly depressing to me to hear that. I felt helpless.

Margie quickly rose to the level of tyrant. She made it clear that she had never approved of Mac and was thrilled that he was gone. When Mac was alive, Margie hadn't come home often for dinner; instead, she hung out with her friends. But with Mac gone and Toots not well, Margie was home more, trapped by a sense of duty that was cutting into her social life. She clearly resented it. She never lifted a finger to help Toots but instead would yell at her and

complain that the potatoes were too cold, the tea was too hot. She told me that the only reason I was allowed to live with them was to help Toots clean.

The hole Mac left was becoming increasingly filled with illness, anger, and isolation. I started to feel desperate in a way I couldn't understand.

Toots had always baked from scratch. When I was young and started staying overnight at her house, I often found her in the kitchen whipping up something so delicious it didn't even matter what exactly it was. Growing up, I'd sit next to her while she cradled a big bowl in her left arm, pressing it against her plump, soft body as she whipped butter, sugar, and cocoa together to create the best chocolate frosting on earth. Her chocolate cake was heaven. I'd watch, mesmerized, while she scooped frosting from the bowl with a metal spatula and seamlessly swirled and smoothed it on the cake. She'd let me scrape the frosting from the bowl.

"I'm not baking any more cakes," she announced one afternoon after Mac died.

"Toots, no!" I said.

"No one appreciates what I do around here," she said.

"I appreciate what you do," I insisted.

I begged her to make just one more chocolate cake, but she denied my request. This was too cruel. Now I had only the beautiful memories of the most delicious cake ever with slightly melted vanilla ice cream beside it. One more thing gone.

"What about lemon meringue pies?"

"No," she said. It was final. "We'll have frozen Sara Lee cakes from now on."

That was the start of Toots's decline. When she was too tired to cook, I took the rare opportunity to learn some cooking skills. Cooking in her kitchen had been off limits to me, no matter how many times I begged her to teach me. This was my big chance to learn to cook a scrumptious hamburger or delectable pork chop. Her cooking secrets had to be revealed if we were to eat dinner.

I gleefully raced back and forth between the kitchen stove and
Toots, who rested on the couch in the living room, and followed
her instructions.

I had been babysitting for a couple of years, and had learned
that if you did things for other people, they gave you money. Now
I searched for other things to do. The shoe salesman across the
street paid me a penny a card to address postcards to customers
advertising his shoe sales. Two ladies who lived next door, a mother
and daughter, paid me to put their freshly washed hair in rollers.
Eventually, I saved enough money to open a savings account at the
bank. I watched with delight as the growing total was stamped
each time I made a deposit. I kept the book tucked away in a secret
place in my closet.

But sometimes I had to spend my money. I needed eyeglasses,
after the school discovered I couldn't see the blackboard. "There's
no money for that," Toots said. There was never any money for
things I needed. I didn't know of any other kids who had to earn
money and save up for their own eyeglasses or clothes. I either had
to do without or figure out a way to earn more money.

Toots used to pop popcorn and put it in a brown paper bag for
me to take to the movies at the Cedar Lee Theatre on Saturday
afternoons. I joined my friends and shared my popcorn, and after
the movie we would walk to the ice-cream shop on Lee Road.

Mac always gave me the money for my ticket and ice cream.
"Now don't spend it all in one place," he would warn, laughing.

"I won't." I'd laugh too.

Now I clung to memories of Mac like a life preserver.

Chapter 5

URSULINE ACADEMY of the Sacred Heart was an all-girls' four-year Catholic high school on Euclid Avenue in East Cleveland. I was now a sophomore and had still not gotten used to the long commute from our house to school. I would walk to the bus stop, take the bus to the Rapid Transit station, take the Rapid to the last stop, and walk from there to the corner of Euclid and Belmore Road. It took about an hour each way. The school was run completely by Ursuline nuns. The rules were simple. No talking in the hallways or in the classroom unless called upon, no makeup, no loose long hair, no chewing gum ever, no laughing, and skirts had to be below the knee.

I loved wearing my school uniform. As at St. Ann, we wore saddle shoes, black and white or brown and white. I preferred brown and white. When it came to socks there were even more decisions to be made. Ankle socks or knee socks, either were acceptable, and when it came to sock colors the color palette was a dazzling array of white, gray, or navy blue. My preference was blue knee socks. Blazers were dark gray, blouses were white, and skirts were gray plaid. The blazers had two outside pockets. One had to remain sewn shut; the other was for carrying your supply of small white demerit cards. There would be hell to pay if you put anything else in that pocket.

A demerit card equaled twenty minutes in detention after school on Friday. All a nun had to do was look at you with piercing

laser-beam eyes and hold out a hand, palm up. It was like being in a science fiction movie—you felt the power. Avoid eye contact. Don't dawdle. Without hesitation I'd reach into my pocket, pull out a demerit card, place it in the nun's hand, and keep walking. I was in detention several times with no idea what I had done. If I asked why, I might be compelled to hand over another card. This was the Catholic school way.

One time, though, I decided to break the rules. "Let's wear lipstick to school," I said to my good friend Gerry.

"They won't even notice," she agreed.

The next morning I applied my Tangee lipstick (it was the best because it turned a different color on each girl who wore it) and met Gerry in front of the school. We laughed, thinking about how easy it would be to fool the nuns.

Ten minutes into homeroom, our teacher announced, "Janice and Gerry, report to Sister Mary Ellen's office immediately."

Uh-oh. The principal.

Sister Mary Ellen wore the Ursuline nun's habit, which seemed to fill the entire room. She peered through her eyeglasses at us.

"What *is* that on your lips?" she asked.

"Lipstick, Sister," I answered.

"Why are you wearing it?"

"So we don't get chapped lips, Sister," I answered. I guess I was the spokesperson.

"Have you ever heard of *candle wax*?" Sister Mary Ellen asked. A chill ran down my spine. Was she going to have hot candle wax poured over our lips? That would be way beyond a demerit card.

"No, Sister," I said. I couldn't imagine how I'd get candle wax on my lips. Toots wouldn't even let me light a candle at home. "What about ChapStick?"

Her look became even more stern, although she never raised her voice. "Wipe that stuff off your lips and get back to homeroom. Don't let me see you wearing lipstick again. And no talking in the hallway on your way back." She looked away. We were dismissed.

No demerit card. This time.

Although I had friends at school, I rarely had friends over to my house, and then only one at a time and only when someone else was home; otherwise, it might upset Toots. So I spent a lot of time at the Cleveland Heights library on Coventry Road, walking distance from home.

Coventry Library was like a storybook cottage. The chocolate-brown brick exterior with candy-colored stained-glass windows was topped with a peaked slate roof. The building was on a low, gently rising green hill, and walking paths led to tall, carved, caramel-colored wooden entrance doors. Only beautiful things were inside such a place as this. I could step into the story anytime and feel welcome. The library was a safe, sacred space.

The librarians were friendly and willing to help with any request. They didn't judge. I could stay as long as I wanted and ask about anything. I loved to read, especially Nancy Drew stories. Nancy was a girl after my own heart. She was independent, resourceful, brave, and adventurous. But reading about her adventures in *The Quest of the Missing Map*, *The Clue in the Diary*, or *Nancy's Mysterious Letter* could only take me so far.

I began to feel the need for more in my life.

A record player. If I had a record player, I could borrow records from the library. With that in mind, I was on a mission to find as many extra babysitting jobs as I could. After a few months, I saved enough to purchase a portable record player. I brought it home, carefully placed it on the desk in my bedroom, lifted the lid, and gazed with awe and pride upon my very own turntable.

A whole world of music waited for me at the library. At first I checked out mostly classical—Bach and Beethoven—and folk. Then I found an album of rhythm and blues. The music was soulful and emotional, and I felt strangely drawn to words I could relate to that spoke about sadness and lonely times. It was comforting in a way.

Walking home from the library along Coventry Road carrying

record albums, I stopped regularly at the corner soda shop, Irv's Deli. I sat on one of the round red seats nestled under the long counter and ordered a chocolate phosphate or a cherry coke. Sometimes, if I could afford it, I had a bowl of Irv's matzo ball soup. Irv's was the best. It had pretzel rods in round glass containers, bubble gum, and candy. It also carried my favorite teen magazines. I was forbidden to have those at home, but I bought them anyway and snuck them into my bedroom, and no one was ever the wiser.

I was now fifteen years old and more or less free to do what I wanted. Toots was content to stay home. Margie was often not at home in the evenings. She talked about meeting friends after work and having cocktails and dinners at the New York Spaghetti House on East 9th Street or at Pierre's Restaurant in Playhouse Square. Sometimes she'd come home late, drunk, and fall asleep on the living room couch. Toots would hit her on her legs with a wet washcloth the next morning to wake her up so she wouldn't be late for work.

On Friday nights I stayed up late to watch Ghoulardi on television. He was the beatnik host of a horror and science fiction movie show called *Shock Theater* on Channel 8. Starting at 11:20 p.m., the show featured movies like *The Beast with a Million Eyes*, *The Brain from the Planet Arous*, *Invasion of the Saucer Men* and *The Zombies of Mora Tau*. These movies transported me to other dimensions for a couple of hours.

Much as I hated to miss the end of any of these movies, when I saw the headlights of Margie's yellow convertible turn into the driveway, I jumped up, turned off the television, dashed to my bedroom, closed the door, dove into bed, pulled the covers over my head, and hoped she hadn't seen the light from the TV as she was driving up to the house.

One Friday night, trying to stay awake to watch the last moments of *Invaders from Mars*, I fell asleep on the floor in front of the TV. Big mistake. I awoke to the smell of alcohol, perfume, and stale cigarettes. The sickening smell reminded me of my mother, but

it was Margie. She was leaning near me and whispered, "Janice, you're so pretty."

I felt sick.

"I want to make a deal with you," she said. "I'll pay for your college education if you agree to take care of me until I die."

I was in my own science fiction movie. I scrambled to my feet and, without looking at her, dashed to my bedroom and shut the door tight.

Later that week, I was doing history homework in my bedroom. My book was open on the bed; with pencil in hand, I methodically wrote down the answers to homework questions on a pad of paper. I wanted to improve my pathetic grades. My bedroom door was closed. I knew Toots was watching one of her programs, probably *The Lawrence Welk Show*. Margie was in the living room, smoking cigarettes and painting her nails red.

Without warning, my bedroom door burst open. The crystal doorknob slammed into the wall. I was horrified that the doorknob made a dent in the plaster. I didn't want to be blamed for that. It was Margie. She looked like the embodiment of the creature from the sci-fi movie *The Attack of the 50 Foot Woman*.

She roared, "If you don't get out here and start being a part of this family, I will follow you to the ends of the earth for the rest of your life."

I now lived in a monster movie.

I dragged myself into the living room and sat silently on the couch looking at the television. Lawrence Welk introduced the lovely Lennon Sisters. The three sisters all had their hair in French twists and bangs and wore dresses with full skirts and high heels. They cheerfully sang "Dominique," the song made into a hit by the Singing Nun. The Ursuline nuns would be proud.

My homework was still not done. We sat in silence for the duration of *The Lawrence Welk Show* with the bubbles and his constant comments about how everything was so "wunnerful, wunnerful." I began to realize that with Mac gone I no longer belonged here. My

life had no bubbles without Mac. It wasn't "wunnerful." Somehow, I had to get away from Margie. That's all I knew right then and there.

* * * *

Life changed again on November 22, 1963.

I was hall monitor for one period in the afternoon at Ursuline. The hallway was quiet. Classes were in session. In every classroom on every floor hung framed pictures of the three most important people for Catholics: Jesus, Pope Paul VI, and President John Fitzgerald Kennedy. President Kennedy's picture was larger than those of the Pope and Jesus. Our Catholic president was the pride and joy of Catholics—and especially the nuns.

I heard the unmistakable rustling of a nun's long habit. The soft shuffling loomed closer and closer. I took a quick mental inventory of infractions I might have committed but couldn't think of any. I was where I was supposed to be, doing what was expected of a hall monitor. I felt mildly confident that I wouldn't be asked to present a demerit card.

The nun stood right in front of me, looked down, tears in her eyes. "The president has been shot! Go home to your aunt."

This was the first time I'd seen a nun cry.

As the news spread, the sounds of shocked voices and crying filled the halls. I put my head down on my desk and sobbed; what would happen to Jackie, Caroline, and little John-John? A word I'd never heard before, *assassination*, was said over and over again. The days that followed were dark and heavy.

The year 1963 was filled with pain and sadness—Mac's death, Toots's illness, Margie's abuse—and now President Kennedy, our handsome smiling Catholic president, was gone. It didn't seem as though there was anything left to lose. My world had gone dark.

Sacred Heart Academy was an all-girls high school run by Ursuline nuns on Euclid Avenue in East Cleveland. Demerit cards got frequent use. *Courtesy of the Ursuline Sisters of Cleveland Archives*

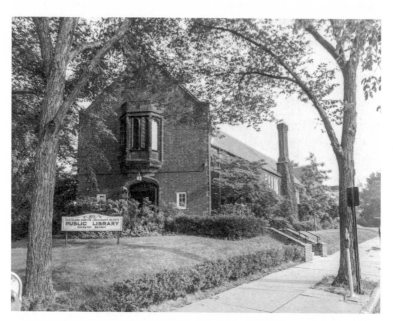

Coventry Library in Cleveland Heights—a safe space. I could stay as long as I wanted and ask about anything. *Heights Libraries*

Chapter 6

MUSIC WAS A big part of my life throughout 1963. I had my record player and my library card. I checked out classical and folk (I really liked the new Sandy Bull record) and rhythm-and-blues records and brought them home. I also had a small transistor radio and listened to the steady, constant heartbeat of pop music and commercials. The radio had an antenna wire with a clip at the end that had to be attached to something metal to improve reception. I'd clip it to the radiator in my bedroom at night, put the earpiece in my ear, and listen to the radio under my covers.

The two radio stations in Cleveland that played pop music were KYW and WHK. They made it easy for listeners to telephone the on-air deejays and make a request. Our phone was on the wall in the kitchen. When Toots was finished for the day after dinner dishes were done, she'd relax in her favorite chair watching TV while she sewed or hooked a rug. The kitchen was all mine to do homework or talk on the phone. I could call the radio stations and make requests. Toots didn't pay much attention to what I was doing anymore. But I still had to keep my radar up. She could be pretty tricky when she was in the mood.

"Janice, what are you doing now?" she sometimes demanded out of nowhere.

"Nothing."

KYW's Harry Martin and Specs Howard were the most popular morning-duo disc jockeys in Cleveland. They were silly, but they

played the latest records. I listened to them every morning before school. I hated leaving my radio behind while I was at Ursuline Academy—I was missing the best parts of their show. So, despite my brush with trouble over the lipstick fiasco, I came up with a plan. Our uniform blazers had those two outside pockets (one for demerit cards, the other kept sewn closed), but there was a third pocket on the inside. It was the perfect size to hold my small transistor radio. (I had never actually heard a rule against it, so . . .) The earphone cord was long enough to run from the radio all the way down my left sleeve. I held the earpiece in my ear while resting my head on my palm. I would look down at my textbook and write something in my notebook. I hoped it looked like I was concentrating. This way, I listened to Martin and Howard during geometry. The eagle-eyed nun who taught the class never noticed. Neither did the girls in my class. It was a total victory, except for my grade. I received a D in the class.

In the fall of 1963, when I was in tenth grade, I met Harry Martin when he emceed a teen mixer. Girls and boys from Catholic high schools attended mixers to introduce the young males and females in a controlled environment with chaperones casually keeping an eye on everyone. The hope was that these meetings would ultimately result in eventual marriages—especially if both teens were Irish Catholics.

I didn't care about meeting boys; I just wanted to be around the music. I watched *American Bandstand* on television after school occasionally. Many of the girls on *Bandstand* wore Catholic school uniforms and seemed to be having a blast dancing. Our school mixer was not *American Bandstand*, but it was better than nothing.

At the mixer, I stood at a distance and watched Harry Martin. I was fascinated. He was like a movie star, but he talked freely and easily with all the kids. He was tall, upbeat, suave, sparkly, and a flashy dresser. I inched my way up to the front to get a closer look. As I got closer, I saw that Harry was older than Dick Clark, the

host of *American Bandstand* on TV, and more handsome than he sounded on the radio. There was something appealing about him that I didn't understand. I got closer than I realized, and suddenly he looked right into my eyes, smiling.

"What's your name?"

My heart pounded.

"Janice."

He made some mundane chitchat about the music and asked if I liked it. I'm sure I said I did. He was smiling at me.

"Janice," he said, "why don't you call me at the station when I'm on in the morning and I'll play a request for you."

Am I dreaming? I wondered.

"Hey," he added, "come on down to the station and I'll give you the tour."

"When?" I asked.

"Anytime you're free. Give me a call at the station."

This was way better than dancing with any high school boy.

A few days later, it was Columbus Day and there was no school. I took the Rapid Transit downtown to the Terminal Tower station and walked across Public Square, downtown's outdoor central plaza, to the KYW radio and television studios at 1403 East 6th Street. I told the young woman at the reception desk that I was there to see Harry Martin. She picked up the phone, and he met me in the lobby.

"Well, hello, Janice," he said.

He remembered my name. He seemed taller and older than at the dance. His booming disc jockey voice and broad smile were louder and larger than I remembered. I was wearing a white and turquoise sweater and a matching turquoise pleated skirt. We were on the elevator, just the two of us, and stood facing one another with our backs against opposite walls. The elevator doors closed.

"That sweater looks nice on you," Harry said.

When I was younger, I dreamed of having a can of paint that made me invisible. Being in the elevator with Harry made me

wish I had that paint. But he was one-half of the most popular morning-radio disc jockey duo in Cleveland, so how could anything be wrong? Finally, the elevator door opened, and I entered the magical world of the KYW radio station.

Harry said I should have a seat and I could listen and watch. He went back to the sound booth where Specs Howard was announcing a record. I could see Specs with the microphone in front of his face. He was talking and spinning a disc. The morning show continued, and Harry dedicated a song to me. I wasn't in love, but I sure felt special.

I had no romantic experience with boys, much less men. The prior year, I'd had a sort-of boyfriend named Paul, who was two years older than me. His father drove us to the movies and to the Home and Garden Show. For Valentine's Day, Paul gave me a red heart-shaped box of candy, a bottle of Emeraude perfume, and a stuffed white poodle wearing a red bow with a heart charm attached. He was a nice boy, but I didn't want a steady boyfriend. I wanted to be free.

Harry Martin was too old to be my boyfriend. I didn't know why he liked me. I sat watching and listening to the morning show. I felt more comfortable when I saw that I was part of a small audience. *He probably invites someone here every morning.* A commercial started playing. Harry stood up in the booth and smiled. I stood up, gave a little wave, and headed to the elevator.

* * * *

Besides music, I had something else to look forward to. Next year, I would be transferring from Ursuline Academy of the Sacred Heart to Cleveland Heights High School, where I would start my junior year in September 1964. I just had to get through one more semester at Ursuline. I liked the school, but it was too far from home. I wasn't looking forward to resuming the bitter-cold trek after Christmas break—crunching along on the snow to the bus stop every day, waiting for the bus that would take me to the Rapid

Transit platform, and standing outside in the bitter arctic air waiting for the train, which was usually late in the winter. Sometimes it was so cold the train doors were frozen shut and we'd have to wait on the outdoor platform for the Cleveland Transit System workers to show up and pry the doors open. I then rode the train to the last stop, Windermere station, and plowed through snow drifts all the way to Ursuline. By contrast, Cleveland Heights High would be just one glorious short bus ride away.

When I had first raised the idea of going to Heights High, back when Mac was still alive, Toots had been against it. How could I give up a good Catholic high school education to go to public school? "She wants to go. Let her go," Mac had said. The matter was settled. Mac's final wish for me would be honored, even though he was gone.

But in the dreary, dark month of December 1963, after Mac's death, after President Kennedy's assassination, it was music that really kept me going. Music on the record player in my bedroom. Music on the small transistor radio hidden inside my school uniform jacket. Music on the larger portable radio in the kitchen as I plodded through that homework essay assigned over Christmas break. And then, suddenly and without warning, on December 26, 1963, it was music—one song, jolting through a single tiny speaker like a shock wave of pure emotion—that reshaped my world completely.

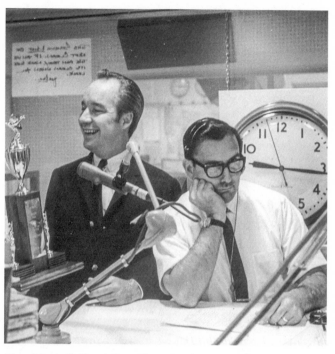

Harry Martin (left) with Specs Howard in the KYW radio station.
Courtesy of Marty Liebman

Chapter 7

"MARTY," I SAID. "The Beatles!" I held the phone's receiver away from my ear as we both started screaming and shouting.

It was early January 1964, and after Christmas break all the girls at Ursuline were now talking about the Beatles. Even the nuns loved the Beatles. Everyone at Heights High, where Marty went, was talking about the Beatles, too.

After school and on the weekends, I'd frequently go to Marty's house to hang out. She was my best friend. We had met when we both lived on Renrock Road and stayed friends after I moved to Belmar. We would listen to the radio, sing, dance, and read the latest teen and Beatle magazines. We made up our own Beatle adventures: "George and I were walking down the street hand in hand singing songs. We stopped so he could play his guitar." "Paul and I were excited to start planning our wedding day . . ."

Music was our bond, and our love for the Beatles made it unshakable. Marty's parents were divorced. I liked Marty's mom and sister and was glad to be invited to stay for dinner sometimes or for lunch on Saturday. We talked and laughed and had fun. They even liked my jokes. It wouldn't have mattered to them if the potatoes were cold or the tea was too hot. Marty's family felt like they were my family too.

On January 20, 1964, an album of Beatles songs was released—*Meet the Beatles!*. There was no time to waste. I took the bus to the brand-new Severance Center shopping mall in Cleveland Heights

and raced to Disc Records, afraid they'd be sold out before I got there. The Beatles were scheduled to appear on *The Ed Sullivan Show* in about three weeks, and I could barely stand the wait. Their new album would have to tide me over until then.

On February 7, the Beatles themselves arrived. Flying from London, the Beatles landed at New York's Kennedy Airport. My friends and I could hardly believe it: The Beatles landed in America. Finally! How I wished I could be there to see them in person at the airport. The TV news showed them getting off the plane and all the kids screaming with excitement. How lucky they were. They were breathing the same air as the Beatles.

Finally, on Sunday, February 9, the most momentous night of my life arrived. At eight o'clock the Beatles would appear on *The Ed Sullivan Show*. For the first time, I would be able to hear *and* see the four lads from Liverpool. A dream come true after hours and days of longing gazes at pictures on album covers and magazines. John, Paul, George, and Ringo would be in my living room performing live from New York. Oh, how I wished I could be in New York. Why did I have to live in Cleveland? The Beatles were too fab to ever come here. I was happy and sad at the same time.

Toots, Margie, and I were in the television room ready to watch Ed Sullivan on our Zenith TV. Usually I watched Ed Sullivan with Toots, and normally we'd have ice cream, but tonight I was much too excited for ice cream. I walked over to the TV, turned the dial to Channel 5, and sat on the floor, barely able to contain my excitement, waiting for the Beatles to appear on the little black-and-white screen.

As soon as they appeared, everything around me disappeared, and the Beatles had my full attention. They performed "All My Loving" first, followed by "She Loves You." Nothing else mattered except how happy I felt watching and listening. The Beatles— finally in my life. They also performed "I Saw Her Standing There" and the song that had changed my life forever, "I Want to Hold Your Hand."

Yes, the Beatles were real.

The next day on my way home after school, I stopped at Marty's house. Together, we sang all the Beatles songs they had performed on TV, then listened to more songs, on their 45 rpm singles—two songs, one on each side—and on their new album, screamed and jumped up and down, and danced around. It was a new day. The Beatles' performance on TV infused us with even more love and devotion.

Not everyone felt the way we did. Toots had made it clear she thought the Beatles were silly. "They can't even sing," she said. "What was Ed Sullivan thinking?"

And the newspapers—they really didn't get it. The Cleveland *Plain Dealer* ran an editorial a day later that said, "After one sickening glance at the British Beatles, one is moved to wonder what these four young men possess that causes teen-agers, especially girls, to swoon, scream, tear their hair and act like complete idiots. Certainly it can't be the sounds the Beatles make, sounds which have been described by one expert as 'hoarsely incoherent . . .'" The paper's TV critic said, "the mass hysteria by Sullivan's teen-aged girl audience was nothing short of revolting." He complained about the Beatles' "clothes too tight and sheep-dog hair too long," and called "I Want to Hold Your Hand" a "distracting bore."

They obviously didn't know what they were talking about. But that didn't matter to me, anyway. No one could change my mind about how wonderful the Beatles were.

In the following weeks, Beatles merchandise appeared everywhere. Record stores had records, of course, and posters. Irv's had magazines and bubblegum cards. Halle's department store had T-shirts. We had to have them all. The May Company department store downtown even offered "The Beatle Bob Haircut" for two dollars and twenty-five cents in their beauty salon.

For us, life couldn't go on without knowing every detail about the Beatles. We learned they were from Liverpool, England. There were four of them: John, Paul, Ringo, and George. Every serious

fan had a favorite Beatle. Each Beatle was cute in his own way, with long, loose haircuts like nothing we'd ever seen before on a boy. They looked neat and tidy in their beautiful suits and ties. Their British accents were adorable, and we'd try to mimic them. Everything was "fab" or "gear," just like the kids said in England. There couldn't be anything bad to say about the Beatles.

I felt a growing sense of urgency toward *something*, but I wasn't certain what it was. Everything about the Beatles transported me into another world—a world that I wanted to be a part of.

Marty and I started having our own little Beatles festivals. We wrote new adventure stories of our lives with the Beatles: "Mrs. Paul McCartney," "When George and I Got Married," "John Was Singing to Me," or "You and Ringo Hand in Hand Walking Down the Street." We collected every record, poster, bubblegum card, and pin we could afford. We read every magazine we could find, like *Dig* magazine's "Special Beatle Issue," April 1964 (on the cover: "Over 1000 BEATLE Secrets" "The BEATLES' SECRET Address!") and *Teen Screen*'s "Special Edition: The BEATLES" (on the cover: "Complete Life Stories" "Exclusive Full Color Pinups" "How To Dance The Beatle!" "How To Have the Beatle-Cut Hairdo!" "Win A Phone Call From the Beatles").

"Marty, look at this," I said as I looked up from studying the latest Beatles magazine. "It says here the Beatles go to Soho in London all the time. They go to the music clubs there."

I couldn't believe my luck at learning this crucial bit of information. Marty looked at me blankly. I jumped up. "Don't you get it?" I said. "Now we know where to find them! Soho. In London. England."

"Okay," she said. Obviously, she didn't understand the magnitude of this huge golden nugget I had just unearthed and what it could mean for our future. I couldn't believe this was published in a magazine for everyone to read.

I lifted the needle off the Beatles record that was playing and rested the turntable arm in its cradle. "Look," I said, "you're

unhappy." I knew she missed her father, who lived out of state. "And I'm completely unhappy." I hated my life at home since Mac had died. Toots was sick all the time. I knew I stressed her out even more. If I left, she would have one less person to worry about. I was trapped by Margie's newly declared power over me. She seemed to delight in scaring me. "We should think about leaving home," I said.

"Leave home? You mean run away?" she asked.

"Not exactly. More like running *toward*—toward a new life. A happy life. An exciting future where we can live the way we want," I said.

"Oh, like New York City. I've always wanted to go there."

"Let's pretend we're in London, in Soho. We're in a club listening to a group and dancing. We look around and who do we see?"

"Who?" Marty asked.

"The Beatles, of course! Maybe we could say hi and they'd say hi back and invite us to sit with them."

"Oh yeah, I see that happening," Marty said. She rolled her eyes.

"It could happen. We just have to find out what club they go to. It doesn't say the name in the article."

"And then we could go to Liverpool to see the Cavern Club," Marty said.

"Neither of us has a driver's license, so we'd have to take the bus or the train there," I said.

"We could see the Mersey River," Marty added. She paused. "England. That's too far away. How would we even get there? What would I tell my mother?"

"If I could go, I wouldn't tell anyone," I said. "No one would care if I left. In fact, I'm sure they'd be glad I was gone."

I pushed the magazine in front of her so she could read the article about the Beatles hanging out in Soho.

She looked up when she finished reading.

"I have a college fund," she said. "Not sure exactly how much is in it, but college wasn't my idea. I want to get married as soon as

I meet the right boy. Since Dad moved out, Mom is hardly ever home. She might not miss me that much."

I knew she sometimes felt unhappy, but I didn't know until now just how bad she felt. We had more in common than our love of the Beatles.

"Maybe we *should* go to England and have a brand-new life," Marty continued. "My college fund would probably pay for our plane tickets and more."

"I have my savings account," I said. "Not much in it, but I'm happy to spend every penny for a chance to be near the Beatles. What do you think? A life in London around the Beatles . . . or a life in Cleveland?"

We looked at each other. "London!" we said together, without hesitation.

Marty held her hairbrush like a microphone, and I grabbed two combs for drumsticks. We sang "She Loves You" as loud as possible.

Yeah, yeah, yeah!

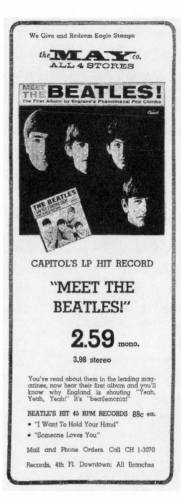

A May Co. department stores advertisement for "Meet the Beatles," February 9, 1964.

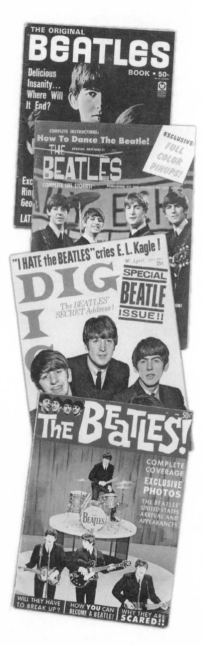

Just a few of the Beatles magazines I read in 1964.

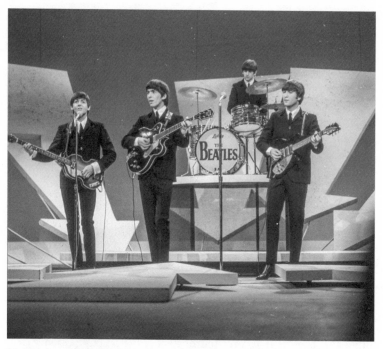

The Beatles on *The Ed Sullivan Show*, Sunday, February 9, 1964.
Tracksimages.com / Alamy Stock Photo

I bought Beatles trading cards and magazines at Irv's Deli.

Chapter 8

MUCH AS I LOVED my local Coventry Library, the step I was about to take into the unknown was so huge that it required a trip to the main library on Superior Avenue in downtown Cleveland. No one there would know me.

I took the Rapid downtown and walked through Public Square and one block east on Superior to the library. The building was as huge and beautiful as a museum. Inside, it had large open spaces with tall ceilings and intricate wooden and marble carvings everywhere. There was a librarian and a wooden card catalog in every room. I loved to pull the little metal handle on a card catalog drawer and reveal the index cards. But on this important day I wasn't interested in dillydallying. I was on a mission.

"I'm going to England and I need a passport. Can you help me find out how to get one?" I asked the librarian.

She found a pamphlet with an application and looked it over with me.

"Hmm. You're going to need to get two special-sized photos for your application," she said.

I knew just the place. I left the library and crossed Superior Avenue and entered the Arcade. There was a photography shop inside this ornate old indoor plaza topped with a glass roof five stories above the atrium. The sign outside the shop read, "Passport Photos—24 Hours a Day." I checked my reflection in the window to make sure I looked presentable. I added a touch of lip-

stick, adjusted my glasses, and made sure my hair hadn't moved a single strand since I left the house. Aqua Net hair spray never let me down. I squared my shoulders, went in, and got my passport picture taken.

One step closer to Beatleland.

Chapter 9

THE BEATLES ARE COMING to *Cleveland!*

WHK disc jockeys had been announcing the news day and night: a Beatles concert in Cleveland in September. Yes! I couldn't wait to see John, Paul, George, and Ringo—live, in person. I could barely contain myself—I wanted to scream out loud.

The only thing was, how to get a ticket?

On May 16, 1964, I got my answer. The *Plain Dealer* ran a news story headlined "Computer to Decide Who Buys Tickets for Beatles' Show Here."

My heart leapt, and I read rapidly:

> Frantic teen-agers and parents desperate for tickets to the performance of the "Beatles" in Public Hall on Sept. 15 can relax.
>
> For the first time in the history of show business and radio the audience will be selected through mail and automated IBM computer equipment.
>
> This random method of selecting the ticket purchasers—somewhat like playing roulette or drawing a door prize—was selected after consulting with city and police officials to avoid possibility of danger or bodily harm to children or parents who might be trampled in the rush at the box office.
>
> A conservative estimate is that more than 100,000 in northern Ohio and adjacent states want tickets for the Beatles' appearance in Public Hall, which seats only approximately 10,000.

The instructions for sending in a postcard to radio station WHK were simple. Only one card per person. If my postcard was picked, I'd receive a letter in the mail that I would then present at the box office, allowing me to purchase two tickets for the Beatles concert. All I had to do was copy the address exactly as it was printed in the newspaper onto a 4-cent postcard. The deadline was May 22.

To see the Beatles in person meant everything. Letter by letter I printed:

WHK RADIO

BEATLES TICKETS

5000 EUCLID AVENUE

CLEVELAND, OHIO 44103

My whole life depended on my postcard being selected.

Chapter 10

ON FRIDAY, JUNE 5, a plain envelope with no return address arrived, addressed to me. It could only be *the* letter. I immediately sat down on the steps, opened the envelope, and unfolded the single sheet of paper. It was!

This was it. This meant everything.

I read every word. The letter entitled the bearer to purchase two tickets to the Beatles concert at the Public Hall box office on June 13.

I was ready to purchase the most expensive seat, at six dollars and fifty cents. The letter said that we could purchase our tickets on a first-come, first-served basis only on Saturday, June 13, when the box office opened at nine a.m. I was sure there would be problems—like five thousand people with letters in their hands, all of them wanting tickets for the best seats. It would be impossible for everyone to have the best seats.

"We have to be first in line," I said to Marty.

I had a crazy idea how we could be first in line at the box office on June 13. It was a bold plan, but I couldn't see any other way. Together the two of us could pull it off perfectly. Of course, it involved telling a lie, but being first in line was worth it. God already knew how much I needed to see the Beatles, and I asked for forgiveness in advance.

On Friday, June 12, I told Toots, "I'm staying overnight at Marty's."

Marty told her mother, "I'm staying overnight at Janice's."

Around five, I walked from my house to Marty's. We took the bus to the Rapid station, and then the Rapid downtown. From Terminal Tower we walked to Public Hall at 500 Lakeside Avenue.

"I have enough money to buy two six-fifty tickets," I said, "in case we get separated." These tickets would be the best seats in the house. The Beatles were one of the only reasons I would withdraw money from my small bank account. This was exactly why I had been saving every penny I earned.

We were the first two people at the Public Hall box office. My plan was working perfectly. There was nothing to do but stand close to the box office, which would open at nine the next morning. I stood first in line, with Marty next to me, as we leaned against the Public Hall building. We had a long wait ahead of us, but it would be worth it.

Marty had received a letter too. We both checked for the hundredth time to be certain that we had our letters. We were so close to seeing the Beatles live. This was June, and they wouldn't be here until September, but the summer would go fast.

Our big plan was falling into place. On September 15 we would see the Beatles perform, and the next morning we'd be on our way to London—to Soho. After that, on to Liverpool and the start of our exciting new lives. What could be better than living in the very place where the Beatles had been born, had grown up, and had been inspired to write and perform such amazing music—the music that completely changed my world and the entire world?

Friday had started out warm, but as the sun set, it got cooler. I looked at my wristwatch: 8:55 p.m. Only another twelve hours to go. I was glad I'd brought a jacket with me. We huddled next to the building and watched as more and more people arrived and lined up behind us. I kept my eye on the box office. No one tried to step in front of me, but I was ready to defend my spot. I didn't even know what that meant, but I was ready, nevertheless. Some

girls sang Beatle songs and talked about their favorite Beatle: John, Paul, George, or Ringo. Some girls yelled out "Ringo for President!" and sang "We love you Beatles, oh yes we do." Police officers came around, and I admit I was relieved to see them there. Not that anything bad would happen, but it was a little scary being downtown at night.

At about ten, a Cleveland police officer with a clipboard walked up to me. "It's getting late," he said, "and there's a lot of kids out here. I better start making a list and write down your names. What's your name?"

"Number one, Janice Hawkins." He was writing my name. "Did you write down that I was number one?" I asked.

"Yes, I have you down as Janice Hawkins, number one in line."

It was official. I'd be the first person to purchase tickets, and I knew just the seats I wanted.

In case we got separated, Marty and I planned to meet at Woolworth's after we bought our tickets. We each had a letter, so each of us could buy two tickets.

"How could we get separated?" Marty said.

"You have to be prepared for anything."

Marty had lived a sheltered life. She didn't have the survival skills I'd honed out of necessity from my scrappy childhood. I understood.

Through the night, the line grew longer and louder.

Around eight a.m., newly arrived girls tried to push in front of girls who were already in the line. I clutched my handbag tighter with both hands. I stood steady and held my position. But there were too many of them. They were out of control. I was squeezed out of my precious number-one spot. *These girls can't be Catholic school girls.*

Marty was swallowed up in the crowd somewhere. I backed away from the growing mob. There was no way I could return to my number-one place in line. It wasn't nine, and the box office window hadn't opened. I remembered the Cleveland police officer

who wrote down my name. I frantically searched for him and saw that he was not too far away. I ran over to him.

"Excuse me, officer," I said. "Last night you wrote down our names on your pad. I've been first on line all night and now look at these girls. They've pushed me out of my spot. Can you check your list? You'll see I was number one. This isn't fair."

The officer checked his list.

"What's your name?" he asked.

"Janice Hawkins."

He looked at the large notepad.

"Here you are. The first name on the list. You're right. Follow me."

This wonderful police officer cleared a path among the crazy crowd and escorted me to the box office window, which had just opened.

"This young lady is first in line to buy her tickets," he told the woman at the window.

I was so grateful to him. I handed the woman my letter. It seemed to take forever for her to read it.

"What seats would you like?" she said.

I couldn't believe she wouldn't know.

"Front row center, please!"

She put two tickets, Row A, Seats 30 and 31, in my hand.

I rushed away as quickly as possible to avoid the yelling, crazed girls waiting to purchase their tickets. I paused on the corner and scanned the crowd for Marty. The "first-come, first-served" plan envisioned as problem solving by WHK seemed to have hit a major snag. Where was that IBM computer now? A huge crush of people bunched around the box office pushing and yelling. I couldn't see Marty, but I knew she was in the crowd somewhere bravely doing her best. I'd see her soon enough at Woolworth's.

I was exhausted after being up all night, but I didn't care—I was happy. I'd gotten the tickets. Best seats at Public Hall. I was going to see the Beatles in concert! Nothing else mattered at that

moment. It was worth waiting in line all night, and the battle for my number-one spot that morning. God bless that police officer.

I sat down at a table and faced the front door so I could see Marty walk in. I couldn't wait to show her the tickets.

"Coca-Cola, please," I told the waiter.

I decided to wait for Marty before I ordered something to eat. I hadn't eaten since dinner yesterday. Normally when I ate out, I ordered a dish of cottage cheese with extra saltine crackers, plus a Coke. No charge for the crackers. This was all that my budget could manage with the high price of the tickets. Two tickets at six-fifty each came to thirteen dollars, which was a lot for me. I took the tickets out of my purse and gazed upon them with loving eyes. All mine.

While I sat in the chair at my strategically selected table, I stared out through the coffee shop's glass doors onto the street and watched people walk by on their way to parts unknown. It was a bright, warm Saturday morning. I sang a Beatles song in my head, "Love Me Do." In a little over three months, I'd be starting my new life in London. Probably I'd spend a lot of time in Soho, where the Beatles hung out.

Marty finally dragged herself through the door, battle weary. Her yellow crocheted sweater was ripped at the shoulder, mascara streamed down her cheeks, and she only wore one shoe. She gripped her handbag and collapsed in the chair across from me.

She held up two tickets. "This was the best I could get." The tickets were gray and were for the back of the orchestra section. They cost four-fifty each. I smiled to myself, barely able to stop from blurting out the good news.

"Don't worry about it," I said.

I waited a second for her to catch her breath and order a Coca-Cola. I sat back in my chair. "Look what I have," I said. I held up my two tickets. "Front row center."

I think she cried.

We took the Rapid Transit to the bus back to Cleveland Heights

and got off at the Cedar and Coventry stop. This had been my street and my neighborhood not so long ago. It was hard to walk down Renrock Road and look up at the corner sunroom, my old bedroom. I missed Mac so much—I still cried every night—but I had to look up every time. The curtains in the six windows were different from mine. Nothing else on the outside of the house seemed changed, so I guessed it was in good hands.

I walked down Renrock and over to Coventry and continued down the hill past the beautiful homes until I reached the Coventry Library. On the way back home, I had been preoccupied with the success of my quest. I hadn't thought about the reality that I'd been away from home since Friday. As I approached Irv's Deli, I desperately wanted to stop in and have some matzo ball soup and a chocolate phosphate, but I was broke and tired.

With every house I passed, I became more depressed. I plodded along thinking about this being Saturday and knowing Margie was home. My chest and throat tightened just thinking about her. I would have to say extra prayers to the Blessed Virgin Mary for help walking into the house. I couldn't get to London fast enough. The Beatles spark burned brighter within my heart. I had something to live for.

Toots had given me my very own house key a month earlier. I had the power to come and go as I pleased, or so I naively believed.

I took the key out of my purse as I walked up the mahogany-stained wooden stairs to the second-floor landing and unlocked the front door that opened to the living room. Toots was sitting in her favorite chair, and Margie sat on the couch with a teacup in one hand and a cigarette in the other. I breezed past them and headed toward my bedroom ready to play my Beatles music and gloat over my tickets.

"Not so fast," Toots said.

I froze in my tracks. Neither of them ever paid much attention to anything about me, so I couldn't imagine what was going on.

"I had a call from Marty's mother last night at ten p.m.," she

said. "She asked me if Marty had been here and then told me to turn on the news on TV. The two of you were on the news with a lot of other girls who were in line at Public Hall for that silly Beatles music."

I took offense at her calling Beatles music "silly."

"Apparently the two of you were there all night."

I knew I might be in trouble, so there was no point in rolling my eyes or exhaling loudly. I'd learned in my early childhood that it was best to not say anything, to just wait until the person who was yelling at you stopped, and then see if you could get away somehow. The one thing that changed the technique was if the person started hitting you. When that happened, you had to try to escape; if escape wasn't an option, you had to wait for everything to stop and be sure not to cry because that would make you the object of ridicule. Toots didn't believe in hitting, so I was safe on that score. She never yelled either, but it was obvious she was angry.

"Do you have anything to say for yourself?" Toots asked.

Survival technique: When asked a question, answer with one word and then pretend you're invisible; if you're lucky, the other party will go away.

"Sorry," I said.

But this was serious business: the Beatles concert. I made up my mind that if she thought she could forbid me from attending the concert as punishment, it wasn't going to work. I was going no matter what.

Toots didn't go that far, though.

And Margie said nothing.

As soon as silence was the loudest sound in the room, I knew I was dismissed. I walked to my bedroom and put on a Beatles record. One good thing about Toots was that when she was finished having her say about something, she was done, and life went on.

When I went to my room, I had a pain in my stomach like

a small sword stabbing and twisting. I had no one to talk to or comfort me since Mac was gone. I still couldn't accept that he was never coming back. I was angry and sad at the same time. I looked in the drawer where I kept a little carved monkey he had given me years ago. Just looking at it made me feel Mac was still with me.

"A buddy of mine who works at the tennis courts at the park carves peach pits into little monkeys," Mac had told me. "I had him make one for you for your birthday, Janice. The green stones for his eyes are for your birthstone—emerald."

The peach pit monkey was about two inches high and dyed brown and lacquered to preserve it. Its little paws touched. A chain was attached so that I could wear it as a necklace. I put the necklace on and picked up my *Meet The Beatles!* album and carefully placed the record on the turntable. The black, shiny vinyl record spun round and round. I carefully lowered the arm and placed the needle on song number four, "It Won't Be Long," a Paul McCartney and John Lennon tune. I sang the words to myself and dreamed of London and Liverpool and seeing the Beatles in person. I looked at the leaded stained-glass window in my walk-in closet. The morning light reflected through the beveled blue, green, brown, and burnt-orange glass that depicted a bird, wings spread ready to take flight.

It won't be long.

IN LINE FOR TICKETS

70 Beatle Fans Camp Out at Public Hall

Girls in line to buy tickets at Cleveland's Public Hall on June 13, 1964. They were way behind me: I got there June 12. *Cleveland Public Library*

Chapter 11

I WAS AT HOME when the phone rang at about ten a.m. the following Thursday, June 18. I grabbed the receiver.

"Janice? It's Harry Martin from KYW."

I hadn't seen him since he gave me the tour of the KYW radio station. I didn't realize he had my phone number. Did I win a contest or something?

"Hey," Harry said, "the Rolling Stones are going to appear on *The Mike Douglas Show* this afternoon. I can get you into the studio. You can see them perform live."

I'd been listening to the Stones' album *England's Newest Hit Makers* over and over on my record player recently.

"Two things that are very important," Harry said. "Get dressed up and come alone. Get down here as fast as you can."

The Stones had crashed onto the radio like a tidal wave. Their sound was completely different from the Beatles and other British Invasion groups, like the Dave Clark Five, Peter and Gordon, and Gerry and the Pacemakers. The Stones were raw and gritty. They reminded me of some of the blues albums I got from the library. Of course, no one could top or replace my pure love for the Beatles. None of the girls I knew screamed for Mick, Brian, Bill, Keith, or Charlie. All my friends were Beatlemaniacs. But the Stones sound grabbed you in your gut and pulled you toward them.

I could hardly believe the Rolling Stones were going to be on

The Mike Douglas Show right here in Cleveland and I was going to see them in person. I'd better hurry!

The Mike Douglas Show was on KYW-TV, Channel 3, every afternoon. Douglas usually opened the program by singing a song, so I knew he liked music. Just the other day, I had seen Ruby and the Romantics on the show performing "Our Day Will Come." Now that I was on summer vacation, I guess I watched a little more TV than I realized.

The Rolling Stones! Television! Mike Douglas! I had to look perfect. I took my green and white A-line dress, with the hemline just above the knee, from my closet. The dress was clean and ironed, thanks to Toots. I took my princess heel shoes out of the box. The shoes were a Christmas present from my Aunt Grace, Toots's younger sister. She knew how important high heels were for teenage girls. Toots was against them, of course. I found my nude pantyhose with no runs. I usually wore pantyhose only for church on Sunday, but today was an exception. I put my wallet, lipstick, and house key in my purse.

My hair was already teased into a flipped bob, just like Jackie Kennedy, and coated with Aqua Net hair spray. That was a daily ritual. No chance that a breeze could move even a strand. I had enough babysitting money for the bus and the Rapid both ways, and for a Coke if I wanted to stop afterwards.

Toots was sitting on the couch reading the *Plain Dealer*.

"I'm going downtown to see the Rolling Stones," I said. "A music group. They're going to be on *The Mike Douglas Show* today."

"You and that music," she said without looking up from her newspaper.

My relationship with her had been like this since Mac died. I loved her, but I knew she was unhappy. I tried to cheer her up by washing her hair and putting it up in rollers sometimes. My efforts didn't make much of a dent as far as her mood was concerned, but I kept trying just the same.

I took the bus to the Rapid and the Rapid to Terminal Tower,

then walked through Public Square and on down Euclid Avenue to East 6th Street and the building where the KYW television and radio stations were located. The building was huge, with concrete columns above which was a clock that looked like it was also made of concrete. I walked up to the double doors at the front of the building and went right in.

Handsome Harry Martin was in the lobby. He wore a tight, shiny gray suit, white shirt, and a tie. He whisked me away toward the lobby.

"Let me take you to the studio," he said. "I won't be able to stay. Specs and I have to do a record promotion at Higbee's." He said he'd be back to record an interview with the Stones.

I dutifully followed Harry as he led me into the Mike Douglas studio. The room was smaller than I imagined. It was like a small movie theater, with rows of seats and a stage in front. He led me to a seat.

"Enjoy the show," he called out on his way down the stairs. He disappeared through a side door near the stage and left me sitting there alone and feeling confused why he asked me to the show and then left. Whatever the reason, I was ready to see the Stones.

I had a perfect seat. Of course, any seat was perfect if I could see the Stones live! I looked around, realizing I was all alone. The entire audience seating area was empty, and there was no one on the stage getting ready for the show. The nuns had taught us that being late for anything was beyond unacceptable. Apparently, I had taken that to the next level. Where was everybody else?

The side door near the stage opened. *Maybe Harry's coming back.* But it wasn't him. A huge bald man walked in.

He walked up the stairway toward me taking two steps at a time. He paused at the end of the row where I was sitting. "Where's your ticket?" he asked. Harry didn't say anything about needing a ticket.

"Oh, I don't need one. Harry Martin brought me in," I said. "You know, the KYW disc jockey from Martin and Howard." I was certain this would be all the information he needed. I imag-

ined his next words would be something like, "Oh, okay. Well, enjoy the show."

"I don't care who brought you in. Without a ticket you have to go."

I continued to sit. I didn't come all this way to be thrown out before seeing the Rolling Stones.

"Let's go," he said.

Since Harry was at the department store promotion, I had no way to contact him. Had he been here, he could have straightened out this misunderstanding. I felt certain of that. I wondered why Harry didn't know I needed a ticket.

The huge man escorted me to a different door, opened it for me to walk into a lobby, and disappeared back into the theater without a word as the door closed.

It can't be over just like that! I didn't get to see the Rolling Stones play one single song. Life was so unfair. I looked around the lobby. There were small groups of people standing around and talking. None of them looked like they could be helpful in this situation. I wasn't angry, but I wasn't leaving. I wasn't going to be pushed out just like that. I had to figure something out on my own. Fortunately, I was good at that.

I noticed a door with a doorknob—some of the other doors didn't have them—and headed straight to it. I grabbed the doorknob, turned it, and pulled. The door opened, and without looking back, I walked right into a narrow, carpeted hallway. I heard the door close behind me. I kept on walking.

Good thing Harry had told me to get dressed up and come alone; I didn't stand out as someone who didn't belong. There were lights and wires and curtains everywhere. I must be backstage. I had been in a school play in the auditorium and this setup reminded me of the stage and curtains there.

A short, wiry older man with gray hair, dressed in an open-neck polo shirt and khaki slacks, hurried over to me. I braced myself to be kicked out again.

"Are you on the show today?" he asked.

"Yes," I said, without thinking. It wasn't true, but it was the right thing to say at the time.

"Come on. I'll show you where the dressing rooms are."

He bustled along with me following behind him until we reached the entrance to another hallway. He pointed and said, "I don't know which one is yours, but walk down here and you'll find your dressing room."

"Thank you," I said.

I was in the inner sanctum of *The Mike Douglas Show*. I was walking along the same hallways as famous people who had been guests on the show, like Ruby and the Romantics, who had just appeared in April and performed "Our Day Will Come." This was the place where the stars dressed up, had makeup applied, and had their hair styled and perfected for the cameras.

The lessons of the Ursuline nuns were coming in handy: Stand up straight and no talking in the hallways. I glanced in every dressing room I passed, each filled with lights, mirrors, chairs, clothes, benches, dressing tables, and trays of pop and snacks. Some rooms looked larger than others. None of the rooms had windows. There were a few people in some of them, but, again, no one paid any attention to me.

I could see the end of the hallway looming. It would be the end of a fascinating peek into another world. I supposed I'd have to turn around and go back out the way I came in. I sighed heavily. This was not the plan at all. This was not even a close second to seeing the Rolling Stones perform live.

I reached the end of the hallway and looked into the last dressing room on my left. Bill Wyman, bass guitarist for the Rolling Stones, sat on a chair facing the doorway and cradling his reddish mahogany bass guitar to his chest like he was holding a baby. He wore a white shirt, dark vest, and jeans. His dark hair framed his face, and when he smiled, his big brown soulful eyes crinkled like stars. He looked at me standing just outside the doorway. He was

playing something, but I couldn't tell what because it was only the bass line.

This is the Rolling Stones' dressing room! I shouldn't be here. But I couldn't move. Time stopped.

"Are you on the show today?" Bill Wyman asked.

"No," I said.

"Are you a singer?"

"No," I said again.

"Are you with the radio station?"

"No." I couldn't think of a single word other than *no*.

"Ah," Wyman said, "you're a fan!"

Finally, a second word came out of my mouth, "Yes." I was relieved he figured it out.

"Well, come in and sit down," he said.

Fortunately, I was able to walk on Bill's command. I sat down on a chair to his right. His guitar neck rested on his left shoulder as he fingered the metal strings. I looked into his big brown eyes. Bill smiled and acted as though this was the most natural event in the world. I suppose a girl popping into their dressing room was just another day at work for the Rolling Stones. He continued to play his guitar as I sat next to him.

I looked around at each band member.

Mick Jagger was wearing a suit. He placed a chair on top of a desk, sat on the chair, and looked down at me.

"I'm tired, hungry, and sexually unfulfilled," he said.

Since I seemed to be capable of saying only "yes" or "no," and neither was a good response, I looked away for a moment before I looked up at him again. He was incredibly handsome, with animal magnetism that didn't quit.

Charlie Watts wore a dark suit, white shirt, and a thin dark tie. He sat quietly tapping a beat on a chair with his drumsticks. Keith Richards sat on a chair close to the desk where Mick had elevated himself. He was focused on playing something on his guitar and didn't pay attention to anything else. Brian Jones wore a light blue

and white seersucker jacket with dark pants. He walked back and forth and talked and sang to himself. Sometimes he waved his hands in the air and scrunched up his face. He looked stressed, confused, and restless—like a wayward angel who was trying to get back to heaven but couldn't remember how. He was beautiful to look at, with his fair complexion and blond hair.

They didn't have the sweet "Liverpool Lads" appeal of the Beatles. The Stones were from London, and big-city boys seemed dangerous. They were the bad boys that young girls were told to stay away from, but we didn't.

Bill stopped playing his guitar and turned toward me.

"In a little while," he said, "some people from the radio station are going to come in and take us up to record an interview for the radio. You'll be here by yourself. Just stay here. If anyone comes in while we're gone and asks you who you are, say you're with us."

The door to the dressing room opened. Three smiling men came in and one said, "Ready for your interview?"

Bill placed his bass in the case and closed it. All the Rolling Stones filed out and the door closed behind them.

Oh my gosh. Bill's guitar case was on the floor right behind me. I was all alone in their dressing room. I heard a roar of nonstop screaming and yelling from outside the building. Fans were going crazy out there. The building shook, and I hoped it would survive the assault.

I looked around the dressing room but didn't move from my chair. I might have stood up just to look around, but I didn't want to betray the band's trust and especially not Bill Wyman's. Scattered around the room were guitars, guitar cases, clothes, 45 rpm records, cigarette packs, maracas, harmonicas, a British bobby helmet, a straw hat, sunglasses, pens, pencils, wrapped presents, papers, and notes. There was a dressing table against one wall, with a large mirror surrounded by light bulbs that looked like globes.

The door burst open and a large, friendly looking man leaned in, holding the door open with his right hand. He practically filled

the entire doorway. I sat still and tried to look like a part of the Rolling Stones' scenery.

"Who are you?" he asked.

"I'm with the Stones." I was too scared to be nervous. At least it wasn't the same man who'd escorted me out of the studio.

"Oh good," he said. "Don't leave the room. We've been finding kids hiding all over the place. Girls in boy's bathrooms, boys in girl's bathrooms. Kids hiding under the seats in the studio. Stay put. If you leave, you may not get back in."

"Thanks," I said. *Oh my gosh, that actually worked.*

The Stones returned to the dressing room a few minutes later with two or three other guys. No one sat, so I stood up. I was going along with whatever would happen next. Mick picked up the maracas, Brian took his guitar and harmonica, and Charlie got his drumsticks. Keith fastened his guitar strap, put it over his head, and braced his guitar against his chest. Bill did the same.

"Listen," Bill said to the other Stones, "if anyone wants to know who she is, just say she's with us."

At that moment, Mick, Keith, Brian, Charlie, and Bill all looked at me and said loudly in unison, "She's with us!"

Mick was standing close to me and I looked up to see his incredible lips forming the words. My heart beat out of my chest.

"We're going onstage to perform now," Bill said.

He and I stood facing one another. We were just about the same height, five foot six. I liked how accessible he felt. We were on the same level.

"Come on," he continued. "When we're onstage, just stand offstage and you can watch the whole performance."

I marched along with them. *I'm with the Rolling Stones.*

Mike Douglas stood at the entrance to the stage. Bill and the other Stones and I clustered around Mike. He shook each one's hand and when he got to me, he smiled and said, "And who is this?"

"She's with us," all the Stones said in unison. Mick Jagger looked right at me. I was beaming inside and out.

"Well that's just fine," Mike said.

I stood offstage with Mike Douglas and watched the Stones perform. Because I had listened to their album over and over, I knew all the words to every song: "Carol," "Tell Me," "Not Fade Away," and "I Just Want to Make Love to You." Bill stood on stage nearest to where I was standing. During "I Just Want to Make Love to You," he glanced at me for a second. I felt electricity.

While the Stones were onstage, I'd seen guys carrying bags and guitar cases along the hall behind me. When they finished their set, Mike Douglas thanked "the boys," and they exited the stage and started heading in the same direction as the guys who had carried their things. I realized they were headed in the opposite direction of their dressing room. They weren't going back. They were leaving. It was all over.

Bill Wyman was the last. He stood in front of me, took my hand, and looked into my eyes. "Come with me," he said.

"Where are you going?" I asked. He told me they were leaving Cleveland, off to continue their tour. I had about thirty seconds to give Bill an answer.

I couldn't imagine going away with him just like that. I had plans. Big, life-changing plans. Nothing could get in the way—not even Bill Wyman or the Rolling Stones. No, I had worked too hard and too long, and as much as I was flattered and intrigued by Bill's offer, I couldn't say yes.

As Bill paused for my answer, I knew I didn't want to hurt his feelings. He was adorable and had been so nice to me. *She's with us* echoed in my mind on a continuous loop. My mind swirled as I tried to think how to tell him I couldn't go. *Think of something!* It seemed ridiculous because who wouldn't want to join the Rolling Stones on tour?

I was in summer school. I had to keep my terrible grades up if I

wanted to graduate from high school. Nuns and teachers pounded into our heads all the time that without a high school diploma there would be no future. They never said what the future would be *with* a diploma. The next day was Friday, and I wasn't sure if I had class, but I felt certain Bill would understand the importance of school.

On the other hand, only losers went to summer school. I couldn't tell him that. I didn't want him to think I was an underachiever. But I did have a summer job. That sounded a lot better.

"I have to work tomorrow. I'm so sorry. I can't go with you," I finally said. Yeah, that made me sound so much more mature. The Stones were on their first tour in the United States, headed from Cleveland to somewhere in Pennsylvania.

I started to look down, but Bill was fast enough to quickly kiss me—on my lips. Being about the same height as me, it was easy for him to swoop in like he did. I've always thought it was sweet the way he did it—so innocent but so intent on getting that kiss.

He smiled, turned toward me for a few seconds, and gestured in a way that said *See ya later. It's been nice to meet you. I wish you were coming with me.* Then he hurried away.

I watched him catch up with others as they headed toward their tour bus. I stood there and felt so alone. For a little while, I had been part of something wonderful.

I made my way out of the studio and back onto East 6th Street. I felt lightheaded. *Bill Wyman, bass guitarist of the Rolling Stones, kissed me—on the lips!* It was possible I might see him again in England. I didn't give up that easily.

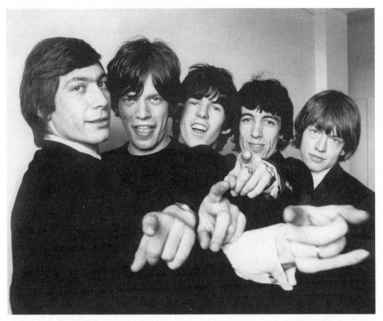

"She's with us!" they said. The Rolling Stones, 1964: Charlie Watts, Mick Jagger, Keith Richards, Bill Wyman, Brian Jones. *Trinity Mirror / Mirrorpix / Alamy Stock Photo*

Chapter 12

WITH BEATLES concert tickets in hand, our planning continued. The concert was September 15. There was no point in staying in Cleveland after the concert, so we agreed to leave for London on September 16. Next, we would need money, plane tickets, and passports. On Thursday, July 2, Marty closed her college fund account. It was a lot of money—$1,980. We walked from the downtown bank to the TWA ticket office at 915 Euclid Avenue. There were two ticket agents, both young and so beautiful they could have been on the cover of *Teen* magazine.

"Hello. Can I help you?" one of them said with a smile.

"We'd like to buy two one-way tickets to London, and we want to leave September 16th," Marty said.

"Oh, how nice," the ticket agent said. "Your parents are sending you to London for a trip."

"Yes," we said in unison. Survival technique: Give one-word answers and never volunteer information.

The ticket agent found flights and explained that we would have to fly from Cleveland Hopkins to Kennedy International Airport in New York. There would be a layover for our connecting flight to London. Marty paid the $230.50 for each ticket. We went to another bank, and Marty deposited the rest of the money in a new account for safekeeping until it was close to the time for us to depart. We were so excited we could barely act normal.

I had applied for but hadn't yet received my passport. I felt sure

it was on the way. After consulting with the librarians at the main Cleveland Public Library downtown, I'd done everything the application asked for.

We were almost set to start our new lives in England. We had the Beatles concert tickets, the TWA tickets, and the money. All we were waiting for were our passports.

Chapter 13

I FOUND THE Beatles Fan Club address in one of my magazines, *The Beatles Are Here*. This was perfect. A London address! Now that I knew for sure I was going to London, it was time to write a letter to Brian Epstein, the Beatles' manager, to ask him for a job, and to Bill Wyman to let him know I was moving to London.

I addressed the letter to Brian Epstein, Beatles Fan Club, First Floor, Service House, 13 Monmouth St., London, WC2, England. There was even a phone number: Covent Garden 233. This could come in handy in London. In the letter, I told him that a friend and I would be moving to London on September 16, 1964, and would be interested in working for him. I added that I knew how to type and file and could provide references.

I found the London address for Bill Wyman in another teen magazine. It was the Rolling Stones Fan Club in London. I was positive Bill would get my letter there. I had a box of light-blue stationery that I received for Christmas, and I had a special pen with two hearts on it.

Bill Wyman
in care of Annabelle Smith
Rolling Stones Fan Club
93–97 Regent St.
London, UK

Dear Bill,

It was so nice to meet you at the Mike Douglas Show on June 18th in Cleveland and I am so sorry I could not go with you after the show.

I wanted to let you know I'm moving to London on September 16th and I hope to see you there. I don't have an address yet but will let you know when I do. I would also like to join the Rolling Stones Fan Club.

Chapter 14

MY PASSPORT ARRIVED in the mail on Tuesday, August 4. Marty received her passport, too. It was time to start packing.

A clever plan for moving my clothes from my house to Marty's house involved several steps that included keeping Toots distracted. While Marty kept Toots busy chatting in the living room, I went to my bedroom, put some clothes in a bag, peeked into the living room to make sure Toots wasn't looking in my direction, and, with catlike moves, stole down the back staircase, put the bag on the downstairs landing, dashed back upstairs, sauntered through the kitchen and into the living room as cool as you please. That was the signal to Marty that the deed was done.

"Toots, I'm going over to Marty's house for a while." We walked down the staircase to the front of the house. I ran up the driveway to the back of the house and grabbed my bag, and the two of us walked to Marty's house.

Over the summer I found other ways to sneak my clothes out of the house, and I hung things I no longer wore on hangers to fill the empty spaces in my closet so that Toots wouldn't notice that my clothes were slowly disappearing.

Marty's mother and sister both worked during the day. Those after-school hours gave us plenty of time to plot and prepare. I stashed my things under her bed because Marty assured me, "My mother never looks under there." I had a brown suitcase that I painted with white and yellow flowers that I brought over, too.

* * * *

The Vogue Theatre was large and ornate, and its screen was vast—at least two stories tall. I was in my seat waiting for the Beatles to appear, larger than life. For months, I had been reading in magazines that they were filming their own movie in England—*A Hard Day's Night*. Now, it was finally here. And so were we. The movie wasn't playing at our local theater, the Cedar Lee, so Marty and I traveled to the Vogue in Shaker Heights—two buses and a Rapid ride from home. I was used to longer rides each way to school. No distance would be too far to see the Beatles.

Seeing the Beatles perform live on Ed Sullivan had been beyond exciting. But I wanted more. Marty and I would be at their concert in September (front row, center!) and then leaving the next day for London, but that was too far off. *A Hard Day's Night* would give us more Beatles *now*. The soundtrack album was already at Disc Records. I wanted to buy it, but I was saving all my pennies for the big trip to Beatleland. I *had* to see this movie, though.

The Vogue had one screen, and the Beatles were on it all day, from the first show at two p.m. to the last at nine thirty, with screenings every hour and a half in between. The theater was packed with mostly girls, but there were some boys who were Beatle fans, too. Marty and I found seats, sat tight, and waited. There was no way to predict how exciting it would be to see the Beatles—three times life-size—on the big screen. I almost cried. It didn't matter that the movie was in black and white. I didn't need to be dazzled by color; the Beatles themselves were dazzling enough for me.

The movie presented a silly, madcap day in their life. Much of it took place on a train and then in the recording studio. When not on a train, the Beatles evaded screaming girls, who were just about everywhere. In the theater, I did my best to tune out screaming girls who were in just about every seat around me. I melted into the faces of John, Paul, George, and Ringo, and into the music. I was more in love with them than ever—especially with Ringo.

Paul's troublemaking grandfather (a "mixer," they called him), put "notions" in Ringo's head to go off on his own (so he could use Ringo's invitation to a gambling club, which he'd stolen), and Ringo went off on his own sweet but sad adventure. Eventually, the Beatles performed to a screaming crowd of girls for a television show. George sang lead in "I'm Happy Just to Dance with You." I loved it. Usually, John and Paul took the solos.

The movie was so good, I had to watch it a second time. Marty and I hid out in the ladies' room until the next showing was about to start. Then, we grabbed two seats closer to the front. We looked at each other and laughed, knowing we'd be in England ourselves in a few weeks. I hoped we'd have a fun adventure like the one onscreen. When I thought about our trip, my heart pounded in anticipation. I was more resolved than ever to start my new life in a place that was beautiful and fun and filled with music—and the Beatles.

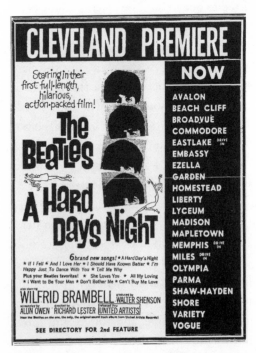

Movie advertisement, August 14, 1964.

Chapter 15

ON SEPTEMBER 13, 1964, the *Plain Dealer's Sunday Magazine* section featured a full-page, color cover picture of the Beatles, scheduled to appear September 15 at the Public Auditorium.

> WHK and KYW-AM deal largely in the sort of music that appeals to teen-agers, have the largest radio audience in these parts . . . In the WHK lobby you can nearly always find two to four bright and giggly girls, some with braces on their teeth, advocating the candidacy of Ringo Starr for president.
>
> Ringo Starr, mind you, is not in the station. He is not even in the country. In spite of his absence, various young girls (some carrying signs, some merely wearing large buttons) have been on this vigil for several months.

The article discussed the Rolling Stones' appearance on *The Mike Douglas Show* in June. Several girls who didn't get to see the Stones perform managed to get a tour of the set after the Stones left. One of them even kissed the ground where the Stones had stood. I had to laugh. No offense to those girls, at all. I understood everything—except kissing the ground. But my story was a billion times better than that. I'd hung out with the Stones in their dressing room that day. Best of all, Bill Wyman had kissed *me*.

As great as my Rolling Stones story was, though, my best adventure was just around the corner.

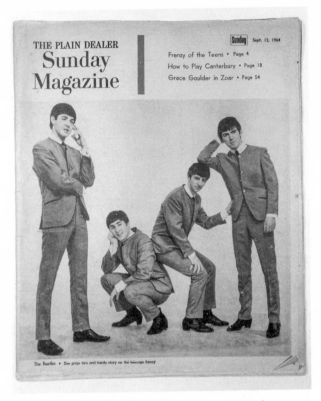

The Plain Dealer Sunday Magazine cover story on September 13, 1964 promoted the upcoming sold-out concert.

Chapter 16

THE BEATLES CONCERT on September 15 at Cleveland's Public Hall was the last event—and the main event—before the next stage of our plan. The concert was supposed to start at eight p.m. As kids and adults began filling the hall, we edged through the crowd and made our way down the aisle. Hearts pounding, Marty and I found our seats: front row center—best seats in the house. There was no way to get any closer to the Beatles than we were. We were so excited! It was hard to just sit and wait to see them, knowing they were right behind the curtain.

The place was completely packed. The opening acts were the Bill Black Combo, the Exciters, Clarence "Frogman" Henry, and Jackie DeShannon. All we wanted was the Beatles. Where were the Beatles? The Fab Four, those lovely Liverpudlian British-accented lads. We had waited for this moment for months.

"I love Paul."

"George!"

"Ringo is so cute."

"John is so handsome."

The stage was covered floor to ceiling with a heavy, red velvety curtain with the call letters for the radio station WHK and the word BEATLES spelled out in something glittery against the backdrop of the curtain. The Exciters finished their set, and we held on for the Beatles.

Ringo's drums sat like a crown on a stand draped with light-blue

pleated fabric. In front of Ringo stood Paul on the left of the stage, George in the center, and John on the right.

Oh my God! They were there, onstage, right in front of us.

Girls screamed, cried, and lost their minds.

"George!"

"Ringo!"

"Paul!"

"John!"

The screaming was so loud you could barely hear anything the Beatles sang or played. The first song was "Twist and Shout," followed by "You Can't Do That," then "All My Loving." I watched and adored. My heart pounded.

In the middle of "All My Loving," the crowd of fans, mostly girls, unable to contain their excitement, started rushing down the aisles. The Beatles had performed for only about ten minutes. Screaming, yelling, and crying filled the auditorium. I put my hands over my ears. It was the loudest, most continuous screaming I'd ever heard in my life. A mob of Beatle fans stampeded toward the stage with outstretched arms flailing in the air and wildly waving signs. A tsunami of Beatlemania crushed the wall of police officers who tried to hold them back from the brass rail about ten feet from the stage. A few girls got through and clambered onto the stage, still screaming as they headed for the Beatles. This was not the "delicious insanity" that described crazed fans in the *Original Beatles Book* magazine, which was one of my favorites. This was complete—even dangerous—insanity. I held on to my seat, terrified of what the crowd might do next.

Fortunately, the Cleveland police officers at the front of the stage worked hard to control the crowd. I stayed in my seat, as did the other girls in the front row. I was angry and disgusted at the out-of-control girls who ruined the concert. We went through so much to get these tickets, and they had disrupted everything. Men in suits and police officials walked back and forth talking to one

another on the stage. The police tried to stop the show, but the Beatles kept on playing.

One policeman took the microphone from John Lennon.

"The show's over!" he yelled.

A second policeman grabbed George's arm and led him off the stage. The Beatles were supposed to play twelve songs, and officials stopped the show in the middle of the third song.

A third police officer took the microphone and said to the crowd, "You can yell all you want, but you'll have to remain seated."

Another official-looking man took the stage. He announced that the concert would continue if everyone remained in their seats. When the Beatles left the stage, it seemed to be a wake-up call to all the unruly kids. Girls sitting in the rows behind me sobbed loudly.

Harry Martin and his sidekick Specs Howard rushed onto the stage. Specs tried to reason with the mob and asked if we wanted the concert to be canceled. Of course, everyone yelled "No!" He said he was going to count backwards from three, and by the time he got to one everyone should be in their seats. It worked. At number one, everyone calmed down, and the auditorium was relatively quiet. It was a magical moment.

The concert could go on.

Harry Martin told us to tune into KYW radio on Monday morning, and he and Specs would play three Beatles songs in a row. The crowd roared in delight. Anything about the Beatles was magic. Just say the word "Beatles" and the world was immediately at your feet. Just sing "Yeah, yeah, yeah" and everyone knew you were singing a Beatles song.

The Beatles came back onstage. One of the police officials spoke to George. George spoke to Paul.

"Good," Paul announced into his microphone so the crowd could hear. "Thank you," Paul continued. "We'd like to carry on with a song that was on our first Capitol album. We hope you

enjoy the song. The song is called . . ." The Beatles went on to con-
tinue to play "All My Loving." Paul acted as though nothing at all
had happened. John, Paul, George, and Ringo never missed a beat
after that crazy interruption.

The crowd of crying and weak-kneed youngsters settled down.
The Fab Four performed "She Loves You," "Twist and Shout," "You
Can't Do That," "Things We Said Today," "Roll Over Beethoven,"
"Can't Buy Me Love," "If I Fell," "I Want to Hold Your Hand,"
"Boys," and "A Hard Day's Night." Even though I barely heard
them above the crowd, I saw their lips moving. I knew the words
to every song and sang along with them. They were real, and they
were all right in front of me.

Finally, Paul announced, "Now for our last song of the night
. . ." and the Fab Four did one of the wilder songs, "Long Tall
Sally." Paul sang lead. He stepped right up to the microphone and
screamed the words while playing his bass, smiling, and shaking
his head back and forth. "Ooh ooh ooh, baby!" he sang.

George and John played guitar. Ringo smashed out an unstop-
pable beat on his drums while lowering his head and shaking his
hair. During that last song, a few girls tried to storm the stage to
get at the Beatles, but the police caught them before they could do
any damage.

When the concert ended, we shuffled along with the crowd
toward the exits, picking our way through broken chairs and
ripped signs with messages to Paul, George, Ringo, and John.
Aside from some girls who fainted and had to be carried out of the
auditorium, there didn't seem to be any other injuries. At last I'd
gotten to see Paul, John, George, and Ringo in person. They were
everything I hoped for. I stepped out of Public Auditorium into
the fresh air.

The next day was to be the biggest day of my life. On Wednes-
day, September 16, 1964, at eight a.m., I would call a taxi and take
my suitcases, passport, and one-way Trans World Airlines ticket
and escape to London, England.

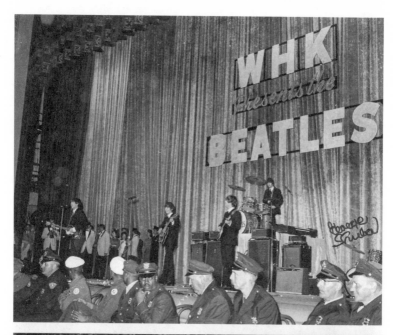

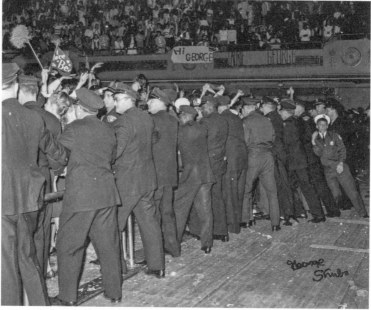

Ten minutes into the Beatles' performance, fans rushed toward the stage. Auxiliary police officers pushed them back. Marty and I are right behind that wall of officers— front row center. *George Shuba*

Screaming Beatle Fans Stop Show 10 Minutes

By DON ROBERTSON

It is not enough to call last night's Beatle concert madness or hysteria.

BEATLES press conference story by Jan Mellow, concert review by Robert Finn and story by Plain Dealer teen-age reporter

for those few seconds the whooping girls almost broke through. Had they done so, there is no telling how many

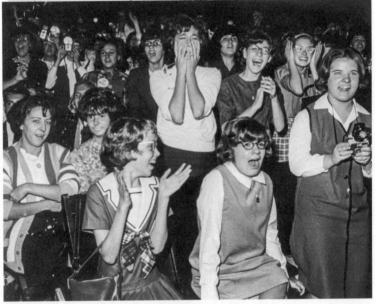

Fans at the concert at Cleveland's Public Hall on September 15, 1964. The screaming was so loud we could barely hear the Beatles. *Cleveland Public Library*

Chapter 17

INSTEAD OF GOING to school, I walked to Marty's house, where all my things were packed and ready to go. One major potentially horrifying thing could happen. The whole plan could be ruined shortly. I wouldn't know until I got closer to Marty's house. What if either her mother or sister didn't go to work for some reason this morning? What if one of them was sick? We would be completely ruined. They always left for work together at 7:15. We were cutting it close. I walked as fast as I could to Renrock Road and looked for a car in the driveway. No car. We were free!

Inside, we got the phone book, found the number for Yellow Cab Company, and called. We dragged our suitcases to the front door and waited. It seemed to take forever, but about fifteen minutes later the cab pulled into the driveway. The driver put everything we had in the trunk as we slid into the back seat. *Maybe we didn't need to bring practically everything we owned.* But we were leaving Cleveland forever.

"You girls are going to the airport, right?" he said.

I was a little nervous. It had taken too long to get all our things in the cab. We need to hurry. If any of the neighbors saw us getting into a taxicab instead of going to school, they might wonder. Teens did not travel to school with suitcases and Yellow Cabs.

"What airline are you going to?" the cabbie asked.

"Trans World Airlines," Marty said.

He didn't say a thing about school. We didn't say a thing about going to London to be with the Beatles.

<center>*　　*　　*　　*</center>

At Hopkins Airport, we checked in at the TWA desk and gave our suitcases to a lady in a TWA uniform.

"Do you think anyone at school noticed we're not in class?" I asked Marty. I had only attended Cleveland Heights High School for a few days since transferring from Ursuline, but Marty had been there longer and would know better than me how things were handled.

"No, they won't notice for a few days."

I was shocked. At Ursuline Academy, there were about twenty-five girls in my sophomore class. If I didn't show up for first-period homeroom, Mother Superior would have called Toots.

Once our bags were checked, there was nothing to do but wait for our flight. This was the first time I had ever been on a plane, and I didn't know what to expect. The plane was scheduled to depart at 11:05 a.m. and arrive at John F. Kennedy International Airport at 12:20 p.m. Our flight from Kennedy, TWA flight 700, was departing at 8:00 p.m. We'd arrive in London at Heathrow Airport the next morning, at 7:40 a.m. London time.

While we waited, I reflected on my phone call to Harry Martin that morning. I had called him at the radio station studio from Marty's to say goodbye. His show with Specs Howard was on the air, but they must have been playing a record or a commercial, because he answered.

"Hi, Harry. It's Janice," I said. Since he had given me a tour of the studio and called me at home to see the Rolling Stones on the *Mike Douglas Show*, he would have had a hard time not remembering who I was. "I just want to say goodbye. I'm flying to London today and wanted to let you know I'm not coming back. I hope to see the Beatles there. By the way, the Beatles concert was great last night."

Silence. I wasn't sure he heard me.

"Harry, can you hear me? I said I'm going to England for good."
More silence.

"I'm not coming back to Cleveland. I just wanted you to know."

He finally said that it sounded like fun, and he hoped I'd have a good time. "Have fun, gotta go. I'm back on the air in three seconds." Then he hung up.

I held the receiver in my hand and looked at it in disbelief. Did he hear me right? I was a little disappointed in his answer. It seemed strange that he didn't share my enthusiasm. I assumed he would, since he was a Beatles and a Rolling Stones fan. He was onstage with the Beatles last night at the concert. Why wouldn't he be just a little interested in my trip? Maybe he didn't remember me. It could be just that simple.

I knew Toots wouldn't believe me—or care if I left—but I still felt it only right to tell her anyway. I had picked a night about a week before Marty and I left. Toots and I were in the kitchen, standing at the sink washing the dinner dishes—a nightly ritual. I loved standing next to her doing the dishes. Toots was short, round, soft, and plump. I loved that about her.

She usually wore a white apron with a bib that had red piping around the edges and red cherries printed all over it. I loved her so much and just wanted to hug her, but she wasn't the hugging type. I wasn't positive, but it might have been a small sin, a venial sin. It was impossible to find out, since questions were forbidden, too.

But how should I tell her about England? I couldn't just blurt out, "By the way I'm going to England and I'm never coming back." Just more foolish talk about those "silly Beatles" as she called them. She had heard me listening to Beatles music and talking nonstop about them with Marty for months and tuned me out on that subject.

Toots washed the dinner dishes in hot, soapy water in a dishpan in the sink. Plates, cups, and silverware were pulled one by one from under a thick blanket of white bubbles to be scrubbed and

rinsed under hot water from the faucet. She handed me a dish to dry and place in the dish rack on the counter to my right.

"I'm going to England," I said.

She finished washing the last dish and handed it to me. "How are you going to get there—swim?" She dried her hands, removed her apron, and walked away.

Mixed in with the truth of my announcement that I was leaving for England, I did my fair share of storytelling, too. When I knew that my passport was arriving, in case Toots wondered why I received an envelope from the State Department, I mentioned I was expecting something in the mail for a school project. She was used to me receiving mail and never questioned it. I always sent away for things from cereal boxes and comic book ads when I was younger, and as I got older, I ordered items from teen magazines, like Beatles pictures.

I was watching for other mail, too. I hadn't yet received an answer from Brian Epstein to my letter asking him for a job, or an answer from Bill Wyman to my letter telling him I was moving to England and asking to join the Rolling Stones fan club. I hoped to get their letters by September 15, the day of the Beatles concert; otherwise it would be too late.

What if Mr. Epstein wanted to interview me? How would I know in time?

Chapter 18

FROM MY WINDOW SEAT I had a perfect view of the wing of the plane. I watched the plane's propellers whirl around so fast they were a blur. We taxied, took off, and climbed through the clouds and into the blue sky above Cleveland. The buildings and trees disappeared beneath us. Marty and I looked at each other and let out a sigh of relief. We'd made it out of Cleveland.

By the time we were scheduled to fly out of Kennedy Airport at eight p.m., school would have long been over and we both would have missed dinner at home. When I'd left that morning, I had pretended I was going to school as usual. Normally I'd get home around three, unless I was going to stop at Marty's house before coming home for dinner. But today I needed to delay my expected time home by as much as possible.

"I'm trying out for a play after school, so I'll be late."

It was going to be the last time I ever saw Toots, and I wanted to hug her so much it almost hurt. I wanted to say goodbye and to tell her I loved her, but that wasn't something I ever would do before going to school, and I had to act as normal as possible.

When we landed at Kennedy, Marty and I walked around the TWA terminal. It was so futuristic, it reminded me of *The Jetsons*. We decided to buy a carton of Newport menthol cigarettes. You couldn't describe what we did as smoking. It was more like trying to inhale without coughing, choking and gasping for air. Holding

a lit cigarette about shoulder high would tell anyone that we were definitely mature and very cool.

"Maybe they don't sell Newports in London," I said. That became our rationale. We figured that ten packs of cigarettes would be more than enough, so we bought a carton.

Marty had about fifteen hundred dollars left from her college fund. I had about eighty-five dollars of my own money after closing my savings account. We had no idea how much things would cost in London or even what kind of money they used. A desk in the terminal had a sign—something about money exchange.

"Let's go find out what sort of money they use in England," I said.

"Pounds sterling," said the lady at the window. "Did you want to exchange your American money for pounds sterling?" She explained we couldn't use American dollars in England, so we'd have to exchange it at some point anyway. We both exchanged all our money. I wished I had more money, but buying Beatles magazines and records and Rolling Stones records—not to mention buying my own eyeglasses and clothes—had used up quite a bit of my hard-earned savings.

We thought Marty's college fund should last us until we got jobs working for Brian Epstein, the Beatles' manager. I had not heard from him after writing to him in July, but I was sure he was a busy man. Besides managing the Beatles, he also managed Gerry and the Pacemakers. I loved their album *Don't Let the Sun Catch You Crying.* Their song "Ferry Cross the Mersey" was so beautiful. He also managed Billy J. Kramer and the Dakotas. They sang one of my favorite British Invasion songs, "Little Children."

All the groups were from Liverpool. We had to get to Liverpool to see where the Beatles had been born and raised. We wanted to see the Cavern Club and the Mersey. Mr. Epstein, I thought, could probably use some help. I could type and file, which was a marketable skill for a girl. Also, I was used to working after school and at summer jobs, whatever I could get. I was worried about Marty,

though. She didn't have to work after school, and I didn't know if she could even type.

As we waited, I recalled how I used to sit on the piano bench and play the piano in the basement of the apartment building where I lived with my parents when I was five. When I was living with Toots and Mac and we moved to Renrock Road in Cleveland Heights, our next-door neighbor had let me play her piano. She was such a kind lady, and I used to wish she had been my mother. She started propping a "learn to play the piano" book on the piano for me when I came over to visit her and her cute little dachshund. Across the street at St. Ann's Church I had sung alto in the church choir and loved it.

I especially thought about my ninth-grade music teacher at Ursuline Academy, Sister Mary Agnes. I maintained a B average in music thanks to her. She was a dynamo—a tiny, music-loving storm, filled with enthusiasm and always smiling. Her love of music was easy to see, and she taught us to love it too.

"Now," she would say. "I want you to listen to this first. And then we're going to sing it." I watched, barely able to wait for her to put the record on the record player in the music room. She knew a lot about timing and how a pause in a piece of music generated anticipation. She waved her arms back and forth like a conductor, and the long black sleeves of her habit flowed along willingly.

"Let's read the words first so we can understand what we're going to sing." She made everything sound exciting. When Sister turned, her black habit swirled in a circle like a vinyl record as she wrote the words on the blackboard using a large piece of white chalk. She twirled around again and faced us with a big smile. Sister explained the meaning of the words in a non-boring way, somehow. I'm quite sure it was her twinkling eyes that kept me riveted to what came next. I pictured her at the piano doing some hot jazz numbers. She could even do a jazz version of "Sumer Is Icumen In," and she'd have everybody up and dancing.

She told us that the words to the song "Sumer Is Icumen In"

were written hundreds of years ago in medieval England. They told how everyone was so happy that summer was finally arriving. The sound the cuckoo bird made was the same sound heard in cuckoo clocks. The two-note tune was sung by the male cuckoo over and over.

A round, she explained, was a song where one singer began the song, a second singer started to sing the beginning of the same song just as the first singer got to a certain point, and the first singer kept on singing. Although everyone was confused by this at first, after Sister divided the class into three groups and we got the hang of it, I could have continued forever.

Over that semester, Sister Mary Agnes filled the classroom and our souls with her love of Bach, Beethoven, and the Mass sung in Congolese called the *Missa Luba*. When we heard it sung the first time, I was transported as the Congo and the Catholic Mass mixed together. The beautiful singing of the Congolese boys' choir accompanied by simple musical instruments lifted me to an angelic stratosphere I hadn't dreamed existed. Sister walked back and forth smiling. She understood the universal magic of music. I was positive she would love the Beatles almost as much as I did.

After this reverie, I looked around the airport and wondered again if the police would show up. So far so good. We got in line to board the plane to London. It was hard to believe we'd made it this far. I wouldn't feel safe until the huge plane was in the air, flying over the Atlantic Ocean. It didn't seem possible that an airplane could do that, but I knew people flew across the Atlantic every day. The Beatles had flown from London to New York. But would the police be waiting for us when we arrived at Heathrow at 7:40 a.m. London time? I hoped not, but it was a possibility.

I looked out of the TWA terminal windows toward the planes on the tarmac. I was already in love with flying. The sky was dark, and it looked cold outside. We walked along a covered jetway to get to the plane.

I didn't dare look behind me. I tried to act casual in every way as

I hurried along with everyone else walking to Flight 700. I tried to erase the image in my brain of someone calling out my name, my turning around, and then our being dragged back to Cleveland.

No, that can't happen. Not now. We've come too far. We're so close!

We boarded the plane and took our seats. I had the window. We fastened our seat belts, London bound. The plane taxied down the runway. Soon we would be breathing the air that the Beatles breathed, and I would be free.

Next stop: Beatleland.

Trans World Airlines Boeing 707-331, JFK Airport. Same as our flight to Beatleland.

Jon Proctor collection / GNU Free Documentation License

PART TWO

Beatleland

Chapter 19

I DOZED AS WE FLEW across the Atlantic Ocean, but awoke as we approached Heathrow. It was Thursday morning in England. The dawn sky just breaking on the horizon was luminous in purple, yellow, and white, like a Post-Impressionist painting I'd seen at the Cleveland Museum of Art.

We walked through Heathrow Airport to customs. A tall man in a blue, official-looking suit took my passport and opened it. Was I going to be taken into custody now?

"How long are you staying in England?" he asked.

"Two weeks," I lied.

"What is the purpose of your stay?"

"Vacation," I replied. That was partly true. My heart pounded, but I remained calm. I scanned the area beyond the customs man, looking for any signs that might mean we'd be taken into custody. I hoped to make it over the customs hurdle, into the Heathrow terminal, and onto the unfathomable land of George, Paul, John, and Ringo.

He handed my passport back to me with the book open to a page stamped with red ink: CHECK IN AT THE NEAREST POLICE STATION. The customs man offered no explanation.

Marty was right behind me with the same instructions stamped in her passport.

"We're not doing that," I whispered as soon as we were out of earshot. "We need to find a hotel."

We walked as quickly as we could while dragging our suitcases. I was so tired I could have lain down right there. Why did we have so many suitcases?

I searched for someone who could help us find a hotel. Someplace in Soho.

A woman who worked at the airport pointed us in the direction of the taxi stand. "Just ask the taxi driver," she said. "He'll be able to help you."

We needed to get out of the airport terminal as fast as possible. No telling who might be on to us now.

Of course, I'd seen the Beatles' movie, *A Hard Day's Night*, and knew that in England taxis were black and elegant looking. I noticed that they drove on the wrong side of the road. The steering wheel and the taxi driver were on the right side of the car instead of the left, like at home. We got into the huge black taxi and pulled our suitcases in with us.

"Where to?" he said.

"We were hoping you could recommend a hotel," I said. "We want to be in Soho in London."

"Right," he said. "I can recommend an exceptionally good hotel for you American young ladies. The Cumberland Hotel is near everything you want to see, and pretty reasonable."

"Okay, let's go," I responded.

The Cumberland Hotel looked beautiful and old. We didn't know how much the taxi cost, so Marty held out some pound sterling notes, and the taxi driver took the fare. He seemed honest, and we were sure he was trustworthy. He was, after all, English and we were in London. Nothing could go wrong.

Our room was small but pretty and had twin beds. We didn't plan to spend much time in the room. We'd soon be out exploring Soho, searching for the Beatles.

First, though, we had to unpack a few things. We each hoisted a suitcase on our bed and selected a couple of outfits to wear, hanging them up hoping some of the wrinkles would fall out on

their own. We arranged toothbrushes, make-up, hair rollers, and hair spray on a small porcelain table decorated with an ornate blue floral pattern.

Now that we were settled in, I noticed that our successful escape from Cleveland had left me strangely exhausted.

Marty said she was tired, too. "Let's rest up and get an early start tomorrow."

"Let's order room service!" I said. I had only seen that done in movies. I picked up the phone, and a man with an extremely polite British accent answered.

"Can we order two hamburgers and french fries and have them brought to our room?" I asked.

"You must mean crisps," he said. He paused. "All you Americans insist on calling crisps french fries."

"Well, I don't know, but in Cleveland we usually have french fries with hamburgers."

Speaking very slowly, he said, "You're no longer in Cleeeeveland."

"Never mind, just two hamburgers. And Coca-Colas."

"Yes, Miss."

He's right, I thought. *We're no longer in Cleeeeveland. We're in Lonnnnndon!*

After we ate, we looked through our pounds sterling, made sure we had our passports handy, and got into our beds. I closed my eyes, inhaled deeply, filling my lungs with lifesaving Beatleland air, and drifted off.

I slept like a rock.

The next morning, we awoke when someone came into our room with a tray that had toast with each piece upright in its own little metal stand surrounded by jars of jam and something called "marmalade." I didn't know what marmalade was, but it was orange. There was tea in a pot, cups, cream, and sugar. I'd hoped for eggs but there were none. It was enough food to get us started, though. Our suitcases overflowed with clothes, shoes, hairbrushes,

hair rollers, underwear, pantyhose, socks, and cans of hair spray. We came prepared.

After breakfast, we walked out of the hotel in search of lunch. London was huge, crowded, and loud. We walked and walked and walked before we spotted something familiar: a Woolworth's. By then, it was late enough that lunch was closer to dinner. We ate some tasteless chicken and a bland side dish. And, of course, we drank Coca-Cola. The rest of the evening we widened the perimeter but stayed close to the hotel. The beautiful Marble Arch was down the street. We decided to rest up and prepare to venture out the next day, Saturday, to find Soho. Saturday night would be the perfect time to find the Soho music clubs. Maybe the Beatles were already there. They didn't perform in Soho because they were so famous. But according to what my Beatles magazines said, they hung out there.

We had arrived at last. Beatleland. After months of careful planning, we made it. London felt like home.

Chapter 20

"MARTY," I SAID, "we can't keep staying at a hotel. It's way too expensive. We'll run out of money in a week or so. We have to find an apartment. It'll be much cheaper."

We went to the front desk of the hotel and asked how we could find an apartment. We were directed to an apartment rental place nearby, where we found a real estate agent, Gwen.

"Well," she said, "we have to find you two lovely American girls an especially lovely place to stay. You want to be able to get to Soho quickly, so we need a place near the tube station."

She picked us up at the Cumberland and drove. She told us about the areas as we drove through them, including a nice section of London called Holland Park and the big area called Hyde Park. Houses attached to each other lined many of the streets. We were going to see a flat on Lansdowne Road.

"I think you're going to love this," Gwen squealed. "It's perfect."

The apartment house was attached to houses on either side of it. Each building had flowerpots, and bushes surrounded by little wrought-iron fences. I guess no one had a car, because there were no driveways.

A sign outside of the building said, "Flat To Let."

"Yours is a first-floor studio flat," Gwen said. "It's in the front, so you have sunshine and a lovely view of the street." She said not to worry about noise because it was a quiet street.

We followed Gwen up the front steps and into the narrow

hallway. With a key in her hand, she stood smiling, ready to make a grand announcement.

"Ready?"

I could tell it was not going to be the Royal Palace, but the hallway was tidy.

She opened the door, but it was dark inside the flat.

"Not to worry." She was cheery as she put some coins into a little box on the wall, just next to the inside of the door on the right. She turned a knob on the box, and the lights came on in the flat.

"What's this?" I asked.

"Ah, yes," she said, "you Americans have electricity all the time. Here we pay for electric and gas in advance as we go along."

Having never paid an electric or gas bill in my life, I had no idea what she was talking about. I supposed Toots and Margie paid those bills. They never mentioned how the system worked, but we certainly didn't have any little boxes on the wall. We just had electricity with the flip of a switch. Just one more reason why they were probably happy to have me out of their house. They would pay less, as I wouldn't be using my bedroom anymore. Toots wouldn't have to cook any extra food either. She had told me too many times that there was no money for things I needed, like eyeglasses and clothes. I hoped Toots would be relieved not having to think about me anymore and how she couldn't provide for me besides bed and board.

"Do you have any shillings?" Gwen asked. I figured we must have some shillings because we both had coins from change we received at Woolworth's. I unzipped my little plastic orange change purse, dumped all the coins into the palm of my hand, and showed them to her. She pointed out the coins we would need to keep the electric and gas going.

"It's a good idea to keep some coins in a dish or a jar right near the box so you never run out. The lights could go out, and if you have no coins you'll be stuck until you get some change."

I loved this idea. So far, except for the food at Woolworth's lunch counter, I loved everything about London.

"Well, now that we have that sorted," Gwen continued, "come in and let's look around."

It was a studio apartment with a kitchenette and a shower but no toilet. Larger than the hotel room but smaller than I imagined a studio might be. In my imagination, a studio was like the one I saw in a movie about an artist in Paris who lived in her art studio. It had huge windows and skylights, a painting-in-the-works perched on an easel, and her paint, drapes, and brushes scattered on the floor. It was very romantic. This was nothing like that.

"The WC is down the end of the hall," she said.

"WC?"

"Water closet," she explained. "That's where the toilet is. You share with the one other person on this floor."

This was getting to be interesting. Sharing a toilet called a water closet with a stranger.

"Here's the shower," she pointed out.

I was relieved I wouldn't have to share a shower down the hall with a stranger too. The shower and the kitchenette were literally back to back and shared the same little hot water tank, which was on the wall.

"Isn't it brilliant?" She was extremely excited about this. I could see how it did save space. I'd never seen a hot water tank inside a room before. At home, I thought the water came from a tank in the basement, but I could have been wrong.

Gwen began opening the cupboard doors in the kitchen.

"See? It comes with everything you'll need for cooking and eating." Gwen even made dishes sound exciting. "You can prepare your own meals on the little cooker. Isn't it darling?" she continued. "Make tea, toast . . . and here's a little refrigerator. You girls won't need anything. You'll probably be out having so much fun, you'll barely be here to cook much anyway. Except for breakfast, of course." She laughed.

Gwen swept her arm toward the largest part of the room.

"See the drapes?" she asked. They were magnificent: deep purple, velvety, heavy drapes that filled the entire wall and covered the windows floor to ceiling. She opened and then fully closed them to demonstrate how no sun could peek through. There were twin beds, a small table and four chairs, and a dresser and a wardrobe for clothes. There were blankets, pillows, and covers. There was no television set, no radio, and no record player. We wouldn't need any of those anyway. We'd be in Soho at the clubs listening to British Invasion bands.

"Now," she went on, "you girls want to get to Soho every day, and one of the reasons I'm sure this location will be perfect is because the Holland Park tube is just down Lansdowne Road. It's only about a ten-minute train ride to the heart of Soho, Oxford Street, Marble Arch, Piccadilly Circus. All the clubs and restaurants and shops are right there."

She converted the weekly lease amount from pounds sterling to dollars. It was affordable. We could live here for a while anyway.

I'd seen signs for the Underground, which I figured had to be the tube. I was used to taking the Rapid Transit train back and forth to Ursuline Academy and downtown Cleveland. How different could it be?

Our own apartment! We were Londoners now. Gwen drove us back to the Cumberland Hotel. Tomorrow we'd check out of the hotel, get a taxi, and take all our stuff to the new place. Tonight, we'd celebrate with an early (and cheap) dinner at Woolworth's. Then, we'd find Soho.

Chapter 21

WE PUSHED OUR packed bags to the front door, ready to check out and move to our fab Holland Park flat. First, one last boring but cheap and filling dinner at Woolworth's chased down with a life-saving Coke.

I had to admit it, I missed Toots's cooking. We had the traditional Irish dinner Monday through Friday: boiled potatoes. She'd let me peel the potatoes sometimes, but I was much too slow.

"You're cutting away too much of the potato," Toots would say. "Give me that." I'd hand over the potato and peeler and watch the expert cut the potatoes into one-inch chunks. The salted water boiled with the potatoes dancing in the bubbles until Toots stuck a fork into a chunk and declared they were done. At least she would let me turn off the gas on the stove. This was Toots's kitchen, and I was just a wanderer who hoped to steal snippets of information about her technique.

Besides the obligatory potatoes, there were always two other things on the dinner plate: vegetables and some kind of meat.

Sometimes on a crazy Saturday, she made fried bologna sandwiches on white bread. It looked easy. I begged her to let me fry the bologna.

"Don't burn the place down," she said as she handed over the spatula.

Sundays were mind-numbingly boring. I could not understand why I failed to pass out on the floor and die. But as far as food

was concerned, Sundays were special. After attending Mass at St. Ann's, we came home and had coffee cake from Hough Bakery— the yummy crumbly kind—with orange juice and tea.

I was thankful that everything was peaceful on Sunday mornings. Not that anyone was happy. Toots always seemed as though she was just tolerating everything as she bustled about, changed out of her church clothes, put on her regular clothes and apron, and dutifully put breakfast together. Margie smoked her cigarettes and waited for food to be put on the table. I waited for everything to be over so I could get back to my bedroom, play my records, listen to my transistor radio, read Beatles magazines, and do my homework—in that order.

Sunday dinner always consisted of mashed potatoes, vegetables, and a roast or ham. The roast or ham was important because Toots made sandwiches for the following week with the leftover meat. She used a meat grinder to grind the ham and some sweet pickles together, added mayonnaise, and created the most delicious minced ham sandwiches ever made on the planet. Her roast beef sandwiches were slices of heaven.

* * * *

Once Marty and I got to our apartment, I knew we would be able to shop and then cook for ourselves in our little kitchenette. We could make sandwiches and tea. But I wasn't sure what else.

That night, though, we went out looking for food. We walked from the hotel to Oxford Street. We had been to Woolworth's on Oxford several times. We decided to stroll over to look at Marble Arch and do some people watching. Oxford Street was crowded with people walking hurriedly in every direction.

We made our way around and looked for Soho Street. Along Oxford Street, we saw red double-decker buses, lots of black taxis, motor scooters, and bicycles. This was much bigger and faster than downtown Cleveland, where all the major department stores were located.

Along the way, we saw the huge department store Harrods. We decided to go in and look around and compare clothes styles we had seen in Cleveland to British styles. There was no comparison between Harrods and any of Cleveland's downtown department stores. Harrods was magnificent! I decided to buy an umbrella there, because we were told to always be prepared for rain in England. I bought a long beige one with a curved handle.

We continued walking along Oxford Street and found a Wimpy's hamburger place. We wanted to try it, but we were on a quest for Soho. The neighborhood was much farther than our taxi driver had said.

"You'll be right down the street from Soho," he had told us.

After walking for almost an hour we finally came to Soho Street. The street was near the London Underground station Gwen told us about. Gwen was right. We would be a quick train ride from our flat to Soho.

"Do you think the Beatles will be around tonight?" Marty said. "It's Saturday."

"It's probably too crowded. They might get mobbed," I said, "They probably want to go home to Liverpool first after a long tour in the U.S."

We weren't sure when they would be back, but we remembered hearing on the radio that after they finished their U.S. tour, they would head back to England. That could be any time now. We both started singing Beatles songs as we walked along: "It won't be long . . ."

Chapter 22

BEATLEMANIA LURES 2 RUNAWAYS TO LONDON

The Plain Dealer—September 19, 1964, page 1

Beatlemania has led two 16-year-old Cleveland Heights girls on a junket to London, police said yesterday.

The two, . . . both juniors at Cleveland Heights High School, disappeared from their homes Wednesday.

Cleveland Heights Police Chief Edward F. Gaffney reported that the two flew to New York and took a Trans World Airlines plane from there to London, arriving Thursday.

Chief Gaffney said he believed the two girls were headed for the Soho section of London. He has asked London police to search for them. . . .

Chief Gaffney said he learned from immigration authorities in Washington that Janice and Martha had made application for passports and received them Aug. 4.

Cleveland Heights Police Capt. Harry Murphy said TWA officials told investigators that the two girls bought one-way tickets at $230.50 each.

SEARCH BEATLES' LAIR FOR
2 CLEVELAND GIRLS

The Cleveland Press—September 19, 1964

The U.S. State Department moved to locate and return two Cleveland Heights girls who flew to England Thursday, ostensibly to visit the Beatles home town of Liverpool.

They reached London Thursday and are believed to be in Liverpool. The Cleveland Heights girls are believed to be plentifully supplied with funds for their Liverpool adventure.

According to Cleveland Heights police, Martha withdrew more than $1900 from her savings account.

The Heights girls are apparently in England legally, according to John Banford, British consul here. Speaking in the absence of Alastair Maitland, consul general, he said there is no British law which prohibits visits by unaccompanied minors as long as they have passports and sufficient funds to maintain themselves. . . .

A TWA spokesman said company policy was not to issue international tickets without an adult's consent. Nonetheless, the girls were able to buy tickets on their own representations.

Chapter 23

WE HAD SO much to do and so many places to go. We hadn't heard any live music yet. That was on the agenda for Monday night. Once we'd gotten settled into our new flat, bought some groceries, and made our own dinner (whatever that might be), we would be fine.

That afternoon, we took a taxi from the hotel to our flat. The taxi driver helped us take our suitcases up the stairs to the front door. Did we have to bring all this stuff from Cleveland? Winter was on the way. We'd need sweaters, hats, gloves, and heavy coats.

We'd been gone from Cleveland since Wednesday morning and it was now Sunday—four days already. Everything was fine, so far.

"Do we have any messages?" I had asked as we checked out of the Cumberland. There weren't any. It was true: I was on my own. I was sure it would all work out, but I hadn't planned for much beyond arriving in London and finding the Beatles.

I unlocked the door to our flat and turned on the lights. The shillings Gwen had put in the little box were still working. I didn't know how long it would be until the room went dark. I went into the kitchen, found a bowl, put the coins that matched the ones Gwen showed us in it, and put the bowl near the entrance as she suggested.

"Let's go find a store and get some groceries," Marty suggested.

As we walked, I noticed that a lot of streets were named Lansdowne. There was Lansdowne Road, Lansdowne Mews, Lansdowne Walk, Lansdowne Rise, and Lansdowne Crescent. *How confusing.*

We walked past parks and lush trees. It was calm and peaceful, a good place to call home. We found a little corner store and bought bread, milk, tea, spaghetti, spaghetti sauce, eggs, sugar, and butter.

"Do you have peanut butter?" I asked the shopkeeper.

"It's not popular here, but don't worry, love, we keep a few jars for you Yanks."

This was England. Couldn't expect everything to be the same.

Marty held out paper and coins, and we started to figure out the amount to pay the shopkeeper.

"Don't you worry," she said, laughing. "You'll catch on."

We walked back to our flat and unpacked a lot of our things. I had hoped there was an ironing board and an iron, and I found them, thankfully. Our clothes had been through the ringer, so to speak, from my closet to under Marty's bed, to suitcases, airplanes, taxis, and the hotel.

The water closet took a little getting used to. It was at the other end of the hall. I had to walk past the door to the flat behind us to get there. Just the toilet occupied the small room—no sink. There was a large mahogany box with a chain and a wooden handle situated above the toilet. When you pulled the handle, the water flowed from the box above the toilet down a pipe into the toilet and the toilet flushed. A thing of wonder.

Dinnertime. I had never cooked spaghetti before. At Toots's house, we never varied from the meat-vegetable-potato combination. But I'd gone to the New York Spaghetti House restaurant in downtown Cleveland for my ninth birthday, so I knew what spaghetti and meatballs looked and tasted like. Since I was highly skilled at boiling water for potatoes, I should be able to boil water for spaghetti. Boil the water, put the spaghetti in, and cook it for however many minutes spaghetti was supposed to cook.

The noodles were in a long opaque wrapper. I had to break them into pieces to fit in the pan. There was barely room for two pans on the burners. I also didn't know how to operate the burners on the stove. Gwen forgot that part. I suppose she assumed stoves

operated the same way in the States. After several frustrating tri-al-and-error attempts, I figured out that matches were needed when the pilot light wouldn't ignite the burners.

With spaghetti cooked and drained and spaghetti sauce heated, we were ready for our first meal in our flat. We clinked our water glasses together.

"Congratulations to us," Marty said. We chuckled, then yawned. We were so tired! After pulling the heavy purple drapes tightly together, we were ready for a good night's rest.

Our flat was on the first floor front, with a little garden bordered by a low wrought-iron fence that had been painted white. It was a peaceful night in Holland Park. After dinner, with no television to watch or radio to listen to, I fell into a deep sleep. When I awoke, I peeked through the drapes, and it was dark outside. I had been dreaming about the Beatles. We were in an airplane. John, Paul, George, and Ringo and I were singing "A Hard Day's Night" together. The trip must have taken more out of me than I realized.

Next thing I knew, it was Monday, and I wasn't at school. I was in my own flat in Holland Park, London, England—for the week, anyway. Gwen had let us lease on a weekly basis, which was great as long as we still had money. Thanks to Marty's former college fund, we did have a lot of it, and we felt we could hold on for a long time.

I was never one to jump out of bed in the morning ready to embrace the challenges of the day. "If a bomb went off, you'd sleep through it," Toots always said as she called out for the millionth time, "Janice, you'll be late for school!" As I lay there in the flat, I also thought about the fact that I hadn't gone to church the previous day, which meant I missed Holy Communion. That was a sin right there. Probably just a venial sin, the Catholic Church's version of a sin that I wouldn't go to hell for if I died right now on the spot without going to confession. I hadn't gone to confession either. The sins were piling up. I'd have to be on the lookout for a Catholic church. As long as I prayed, I should be okay—after all, I'd been lucky enough to be born Catholic. But you also had to

believe that the Catholic Church was the "one true church." In addition, you had to believe that non-Catholics would go to hell when they died. What about my friends who were Jewish or Protestant? They were good people. It didn't make sense.

Once, I made an appointment to meet with a priest at St. Ann's to ask this question. Even though I was just a girl, he agreed to see me. I was so determined to get an answer that I wasn't even nervous, although I probably should have been. I hadn't told Toots because she probably would have forbidden me to do such a thing. This was a shocking move.

"Father, is there any hope for my Jewish friends?" I asked. "Why do they have to go to hell, just because they're not Catholic? I've never seen them committing any sins. Doesn't that count?"

He barely looked at me. "Read the Bible. Everything you need to know is in the Bible." He stood up from his ornate wooden chair in the church rectory and indicated the conversation was over.

The Bible? I wanted *him* to give me the answer. He was supposed to be the priest and give me the answer . . . or something. I couldn't contradict a priest. Nobody did that. I stormed all the way home, confused, angry at the entire Catholic Church. If you couldn't trust your priest, where did you go from there? I had no idea.

Now, still trying to wake up, I decided I had to find a church in London, and soon.

After a meager breakfast of buttered toast and hot tea, we gathered our pounds sterling, shillings, and pence, and our coats, and headed for the Holland Park tube station to take the Central line to the Soho area for our first true afternoon of checking out London. The train ride would be just like taking the Rapid Transit to downtown Cleveland and back, only a much shorter trip, according to what Gwen told us.

"Only ten minutes," she said.

We saw the stop for Oxford Circus and decided that sounded like a fun place to start our tour. We got off there and started

walking. We were free as birds. We could go anyplace we wanted and stay out as late as we felt like. I loved to walk. I wanted to see everything. London was so exciting.

I felt like everything in the world was there. I knew I never wanted to leave, but I had no idea how I would stay. That was something to think about another time. For now, we had to keep our plan of finding the way to Soho, then remember how to get back to the tube station, and where to get off so we didn't get lost on our way back to the flat.

Lansdowne Road, Notting Hill, London, circa 1964. It's hard to be sure so many years later, but that might be our flat on the right, first floor. *London Metropolitan Archives (City of London Corporation)*

Chapter 24

RUNAWAY BEATLE FANS ARE
LOST BY ENGLISH POLICE

Cleveland Press—September 21, 1964

The trail has been lost of the two Cleveland Heights girls who flew to England in hopes of seeing the Beatles in London.

The U.S. State Department has notified Cleveland Heights Police that the last report on [the two] came from Heath Row Airport in London.

That was last Thursday when the two girls arrived via TWA trans-Atlantic jet and passed through customs where their names were recorded from their passports. The U.S. Embassy in London has recruited the aid of authorities in England in locating the girls.

MISSING PERSONS

MARTHA SCHENDEL
16 Years
5' 6" — 125 lbs.
Blue Eyes — Brown Hair
Wears Horned Rim Glasses

JANICE HAWKINS
16 Years
5'6" — 130 lbs.
Hazel Eyes
Dark Brown Hair

Missing From Cleveland Heights, Ohio, U.S.A.
Since Sept. 16, 1964

REPORTEDLY ARRIVED HEATHROW AIRPORT, LONDON ENGLAND 7:30 a.m.
SEPTEMBER 17, 1964. AVID BEATLE AND ROLLING STONES FANS, HAD
SUFFICIENT CURRENCY FOR EXPENSES. MAY BE IN AREA OF SOHO
DISTRICT AND / OR REGENT ST. W 1, LONDON, ENGLAND.

If Located, Notify Collect, E.F. Gaffney,
Chief Of Police, Cleveland Heights, Ohio, U.S.A.

This poster was distributed by Cleveland Heights police to police stations and post offices in London. *Cleveland Public Library*

Chapter 25

ON TUESDAY, our sixth day in London, we took the tube from Holland Park to Tottenham Court Road station and came out of the tube onto Oxford Street. Oxford Street was busy and bustling, and I liked it. London was starting to feel like a comfortable place to be. We walked along Oxford Street to Soho Street, made a left, and arrived at Soho Square, a lovely little park.

St. Patrick's Cathedral was just across the way on the corner. It was small for a church called a cathedral, but it was Roman Catholic. It would have to do. I needed to go there and explain to God what I was doing. I never failed to pray every day. I had needed a lot of help from God to get through my life so far, but since we'd left home, I hadn't prayed at all. I hadn't thought of God or Jesus or Mary one single time. A cloud was appearing on the horizon. Catholic guilt. You didn't have to know what you had done wrong, but it was probably something. Time to hand over a demerit card. I started thinking about my high school diploma. I'd never get one now. Marty planned to meet the right boy and get married; she wouldn't need a diploma for that. I didn't know what my next move would be.

We went inside the small church. Its beauty and serenity made up for its size. I was used to St. Ann's back home, which was a large, ornate church. St. Patrick's Cathedral was beautiful and perfect. I felt at home right away. All my favorite statues were there: Jesus,

St. Joseph holding baby Jesus, and the Blessed Virgin Mary. I knew they all still loved me. I knelt, bowed my head, closed my eyes, and prayed for a while. I felt God was with me as he always had been, and I felt everything was going to be okay. The Catholic guilt cloud disappeared and the sun shone again.

I didn't know if Marty was praying too or just resting. She sat in the pew but didn't kneel down. We never talked about God or religion. I knew she wasn't Catholic, because although we lived on the same street just across from St. Ann's, she and her family didn't attend Mass. I realized she was going to hell when she died. It wasn't fair.

She wasn't Jewish either. I knew that. When I went over to my Jewish friends' houses in Cleveland Heights, the kitchens were divided into meat and milk: sinks, refrigerators, dishes, dishcloths, and cutlery. They didn't do that at Marty's house. At my Jewish friends' houses, meat and milk couldn't be mixed at the same meal. If you had hamburgers for lunch, you had to drink pop. But if you had scrambled eggs, you drank milk. One of the kids accidentally washed a meat knife with the milk dishes, and the knife had to be buried in the backyard to make it pure again. I liked my Jewish friends' families. Sometimes, when I was younger, I wished I'd been born Jewish, so that I could have parents like my friends did. My life would have been completely different. But then, of course, I'd be going to hell.

We left the church and continued walking. It was a lovely warm day for September. Hunger was beginning to set in, but there was no Woolworth's in sight. We were in the Soho area, but we didn't know where the clubs were. We ambled through Soho Square, a small city park surrounded with a black wrought-iron fence and gates. There were a few big old trees dotting the grassy areas. People sat on benches and on the grass. Some were lying on the grass relaxing. Others sat on the benches talking, smoking, reading, or eating. There was a little brown and white house with a brown thatched roof in the middle of the square. It didn't seem to have

any purpose. As we stood and examined it more closely, I asked a woman who was sitting on a bench nearby if she knew what it was.

"Ah, yes," she said, "it's the mysterious Gardener's Hut." She explained that it had had many uses over the years and had even disguised a bomb shelter beneath it during World War II, but was now used to store gardeners' tools, hence the name.

A direct path cut through from one side of the square to the other. We joined the steady stream of purposeful walkers taking the shortcut to whatever street was on the opposite side of the park. The park was a place for respite from the endless crowds and connected buildings. We walked through the square to Dean Street, then on to St. Ann's Street to Wardour Street. The small streets were charming and lined with all sorts of little shops.

"Wardour Street," I said when I saw the sign. "This street name seems familiar. I think I read about it. There might be a club along here."

We turned right onto Wardour Street, kept walking, and wound up on Oxford Street again. Everything led to Oxford Street. Even our Underground station, Tottenham Court Road, was on Oxford Street. London was way bigger than Cleveland, but it was easy to get around. If you can find Oxford Street, you're practically home.

"I can't go on," Marty said. "I have to eat, and I mean now."

As we walked along, I kept lookout for that old familiar place, Woolworth's, but we never found one. Fortunately, we did find a little café. It was time to branch out and try some English food. We ordered the least expensive sandwiches on the menu and Cokes. We sat outside at one of the small round tables next to the café windows. There was just enough room to put our plates and drinks on the table. People walked by as we ate. Some of the streets were so small that there wasn't enough room for everyone to walk on the sidewalks, so people casually wound their way from the sidewalk to the street and back to the sidewalk again.

At the Cumberland Hotel, I had picked up some brochures of places to see in London. One brochure listed coffee bars and music

clubs. I had asked the front desk person what a coffee bar was, as I'd never heard of anything like that in Cleveland. He said that, unlike a music club, a coffee bar didn't serve alcohol; it sometimes had live music and dancing and usually stayed open late.

"Most of them are in Soho," he said.

Coffee bars sounded exactly like what we were looking for, a place where the Beatles might hang out. We had to go to the coffee bars.

"Do you know the names of any?" I had asked.

Fortunately, this man lived to serve. He offered to find out for us and said he would ask some of the younger people who worked at the hotel. When he returned, he handed me a piece of paper with two names of the "most popular" clubs: the Marquee Club and the 2i's, both in Soho. The Marquee Club was located at 90 Wardour Street W1, and the 2i's was at 59 Old Compton Street W1. Apparently, I gathered, in London it was important to add the W and a number with every address. The Marquee Club and the 2i's were both in the W1 section, so that should make them easy to find, I guessed.

After lunch, we crossed Oxford Street and realized we had walked in the wrong direction. We doubled back and finally found our way to Wardour Street. London had so many confusing little streets. Would we find the Marquee Club before it got dark? In September, the sun would set earlier. I was certain the Beatles had their own cars and drivers, so it wouldn't matter what time of day or night they went anywhere. No Underground to contend with for them.

I felt as though I'd been walking forever, not knowing where I was going. I tried to make mental notes of the streets we walked so I could remember how to get back to Tottenham tube station, but there was no guarantee I could do that. I hoped the tube ran all night. But we'd made it all the way here from Cleveland on our own, so I was sure we could figure it out.

The Marquee Club didn't look like much from the outside.

There were several black doors and a large sign that said "Marquee." I knew I was in the right place, though. Some teenagers milled around the outside smoking cigarettes.

"Do you know what time it opens?" I asked the small crowd, not looking at anyone in particular.

"Hey!" said one of the guys. "American girls, right?"

"Right," I answered.

"So, New York City or L.A.?" he said.

"Cleveland, Ohio," I said.

Silence. "I met a bloke from Cleveland last year," the same guy said. "He came right here to the Marquee. Drummer, I think. Maybe you know him?"

"What's his name?" I asked.

"Got me there, I'm afraid," the guy said. We all laughed.

"The Beatles just played a concert in Cleveland, and we were there," I said.

"Ooh, the Beatles, right," he said.

"We love the Beatles," I said. "They're from Liverpool."

"Ah, yes. I think we heard that somewhere," one of them said as he laughed.

"They're coming back to London from their American tour tonight," his friend said. "Loads of birds fainting at Heathrow most likely."

I couldn't believe it. The Beatles back in London, England, this very night. Our timing was excellent.

"So, are you two on holiday?" the cute one asked. His accent sounded just like John, Paul, George, and Ringo's, and I was mesmerized. He was dressed in a black leather jacket and black pants. His dark-blond hair was long and loosely rolled up on the top of his head, and draped a little over his forehead. I tried to figure out how he got it to stay that way. The only thing I could imagine was a lot of Aqua Net hair spray.

We introduced ourselves—first names only: Janice and Marty; Mick and John. Mick was about an inch or so taller than me. John

was several inches taller than Mick and had dark-brown hair done in the same style as Mick. They were both clean-shaven. I didn't know why I was attracted to Mick. Maybe it was his friendly personality; maybe it was his accent; maybe it was those devastating blue eyes. I looked down and saw that he wore black ankle boots with one-inch flat heels. The Beatles and the Rolling Stones wore the same style of boots. I wondered if they were musicians too.

The four of us stood together talking and laughing. Mick took a pack of Woodbine cigarettes from the inside pocket of his leather jacket; with his right hand he tapped the pack against his left palm and one cigarette popped out.

"Care for one, Janice?" he said.

"No, thanks," I said, even though I felt I should take one whether I smoked or not.

"Don't smoke, eh?"

"I smoke an occasional cigarette," I explained, "but I've never seen a cigarette without filters like yours."

He lifted his face heavenward, blew out the smoke after one heavy drag on his cigarette, and laughed.

"Aren't they terribly strong?" I was curious.

"I've smoked since I was a lad in school." He shrugged. His deep blue eyes gazed into mine searching for something I couldn't identify.

I gazed back. He smiled, and I felt as though we were the only two people standing outside the Marquee Club. All the others, including Marty and John, seemed to disappear into the air.

As the sun set on Wardour Street, casting dark and light stripes along the pavement from the shadows of the buildings, the crowd started to move slowly but steadily into the Marquee. Boys were dressed in black polo shirts and jackets, with some wearing shirts and ties and slacks; girls had on dresses, with teased hair puffed up, all ready for a night out. Everyone looked sophisticated and fun. I felt like I was a part of London and wanted to stay forever.

I took out my change purse to pay to get into the club. As I was

examining the coins, Mick laughed. "Put away your coin purse, Janice. The night is on me and Johnny." I loved to hear him say my name. I obeyed and we made our way into the club.

"Have you heard of the Rolling Stones?" Mick asked me.

"Of course," I said. "And, yes, I love them. I have their record album that was released in the States in April. I play it all the time."

Mick explained the Stones had played at the Marquee a couple of weeks earlier.

"Did you see them?" I asked.

"Oh yeah," he said. "They were great. I wouldn't miss them."

I didn't tell him I had met them during the summer and hung out with them in their dressing room, or that Bill Wyman had asked me to go on tour with him. I didn't want Mick to know that about me. It might seem like I was bragging, and it might be too American. I wanted to blend in and get to know Mick more—a lot more. What else could a Beatle girl want? He was British with a beautiful accent; he dressed in black, wore ankle boots, had the coolest hair I had ever seen on a boy, and smoked cigarettes with no filters. If that wasn't the very definition of fab, I didn't know what was.

When we got inside the Marquee, a band was already onstage. Mick got a table for the four of us, which wasn't an easy thing to do as the crush of people poured in. He got us Cokes, put them down on the table, and pulled up a chair next to me. Cigarette smoke filled the air, and the sounds of guitars and drums, and voices singing, talking, and laughing bounced around the room. It was so cool.

"Do ya dance, Janice?" Mick asked.

Every time he said my name, a shiver when down my spine. He couldn't say it enough times.

"Sometimes," I said.

"Well, come on then. Let's make this one of those times," he said.

He stood up, and I pushed my chair back and followed him onto

the dance floor. He made his way through the crowd so we could be near the stage. Mick knew the band members. The singer gave him a nod, and Mick nodded and smiled back. I turned around to see if Marty and John were dancing, too, but they sat at the table bobbing their heads to the beat of the music and seemed content to watch the scene. I knew Marty could dance, but I couldn't tell if she wasn't dancing because she didn't like John, or if he just hadn't asked her. Without Mick and John, we'd still have come into the Marquee Club, but I knew I wouldn't be having nearly as much fun. The Marquee felt like a magical place. All I knew was that I was having the best time of my life tonight. I was a lucky girl to have met Mick. Plus, he was great dancer. He had moves I'd never seen before, not even on *American Bandstand*. I followed as best I could.

Some other people on the floor called out to him, "Mick! Hey, what's going on?" Mick seemed to know almost everyone at the Marquee.

We sat down at the table after a couple of dances. The floor was crowded, and the room was small and stuffy and seemed to be getting hotter by the minute.

"So, where are you girls staying?" Mick asked.

"We rented a flat in Holland Park," I explained.

"Ooh, fancy," he said.

"You know the neighborhood?" I guess I didn't realize what a special neighborhood we had moved to.

"Sure. Everyone knows Holland Park. Right next to Notting Hill. Very posh," he said.

"Where do you live?" I looked at Mick and then at John.

"Liverpool," John finally spoke up.

I could hardly believe they were from Liverpool, just like the Beatles.

"Are you musicians?" I asked.

"I mess about with guitar," John said, "but Mick here, he can play. Isn't that so, Mick?"

"Don't believe him," Mick said. "Johnny plays well." The two of them laughed.

The night was getting better and better.

"Do you know the Beatles?" I figured since they were musicians and from Liverpool, then they must know the Beatles.

"We don't know them like mates," John said. "But we've all played at the Cavern Club and been there when the Beatles played."

"Do you think you could introduce us?" I asked.

"They're big and famous now," Mick chimed in. "They don't play at the Cavern Club anymore."

My heart sank. We were so close.

"Where do they play when they're home?" Marty asked.

"The big venues like the London Palladium," John explained. "Not to mention they played in front of Queen Elizabeth and Princess Margaret at the Prince of Wales Theater in London last November. No, they're much too big now for the little people. They play all over the world now."

I had to accept that. But at least I was in London breathing Beatles air.

"Don't you think they at least go home to Liverpool to be with their families?" I asked. "And to take a breather after a big tour?"

"I'm sure they do," Mick said. "But we don't hear about what they're doing as much now that they're famous."

Mick was now officially the most fab boy I could have met in London. I could hardly contain myself. He wore a gold chain with a gold medallion around his neck. The gold chain and medallion lay flat against his black turtleneck shirt. The gold brought out the highlighted blond color in his hair. I was in love.

"Your parents are here staying at the flat as well?" John asked.

Marty and I looked at each other.

"No, they're back home. We're here on holiday by ourselves," I said.

It was technically true. The parental types were back home. And we were on a vacation of sorts—but we wanted to make it a perma-

nent situation. I didn't explain further. The two of them looked to
be older than we were, maybe seventeen or eighteen. No one had
asked our age when we came into the Marquee, since no alcohol
was served at the coffee bar. Maybe they weren't that old either.

Earlier, Marty and I had agreed we wouldn't stay out too late.

"We should be getting back," I said. "It's late and this is our first
night out."

"How are you getting back to your flat?" Mick asked.

"We're taking the Central line from Tottenham Court station to
Holland Park, right down the street from our flat," I said. "Would
you mind pointing us in the right direction to the station?"

Mick turned to John and said something I didn't hear, and John
nodded. The two of them stood up.

"We can't let you girls walk that far alone on your first night
here. We'll walk with you," Mick said. "Make sure you don't get
lost. We know the way."

That was a relief. I had no idea the best way to get to Tottenham
Court station.

The two boys were perfect gentlemen and walked on the
outside, nearest the traffic on the streets. It seemed that Mick and
I, and Marty and John, had paired up. Mick walked with his left
hand in his front pants pocket with his thumb resting outside the
pocket. With his right hand, he held a cigarette, but not in the
ordinary way—balanced between the first two fingers. Instead, he
held it tightly between his thumb and forefinger. I'd seen people
do that in movies, but never in real life. Mick just got cooler and
cooler in my eyes as the night progressed.

As we got closer and closer to the Tottenham Court Under-
ground station on Oxford Street, I felt a bit nervous and won-
dered if this was all I would see of Mick. I would hate to not see
him again. But if not, I'd just had one of the greatest times of my
life—a dream come true. We all came to a stop at the station.

Mick turned to me. "So what are you girls doing tomorrow
night?"

My heart skipped a million beats. He wanted to see me again.

"We don't have any plans yet," I said.

The four of us made plans to meet outside the Marquee Club at about five the next day, Wednesday.

"Oh my gosh!" I said to Marty once we were on the train. "We have dates with two Liverpudlians! Aren't you glad we came?"

By the time we found our way back to our flat, it was too late to cook any spaghetti, but we had the makings for peanut butter sandwiches and cups of tea.

Riding the tube, 1964. A typical scene in the London Underground.
© *TfL from the London Transport Museum collection*

Chapter 26

BEATLES JOIN HUNT FOR TWO
AMERICAN RUNAWAYS

Daily Mail (London)—September 23, 1964

The Beatles joined a Transatlantic search last night for two American teenage girls who have run away from home to see them again.

Beatlemania gripped [the] 16-year-olds . . . after seeing the Liverpool group in Cleveland, Ohio, on Tuesday night.

They laid their plans carefully, drawing 1,980 dollars (about £700) from Martha's education fund to pay for their 4,000-mile flight.

Now they are somewhere in Britain with £500 left for pocket-money.

But last night Scotland Yard, Liverpool police—and the Beatles—could not trace them.

At first American police thought the girls had bought flight tickets on the Beatles' plane, which left New York on Monday.

Later they learned that the girls had left two days before the Beatles.

Cleveland Heights police chief Edward Gaffney said: "The girls flew to New York and then took another flight from there to London, apparently heading for Soho."

Last night a Scotland Yard spokesman said: "We have been told about these girls, but we have not been able to trace them."

In Liverpool, detectives mixed with teenagers at local dance halls and coffee bars trying to pick up a lead.

At the Beatles' London headquarters a spokesman said: "We have heard nothing about these girls, but we will be keeping our eyes open."

Chapter 27

"DO YOU THINK they'll show up at the Marquee Club?" Marty asked. We were taking the Central line from Holland Park back to the Tottenham Court station. From there, we walked over to the Marquee Club. Mick was leaning against the building smoking a cigarette, talking with John and a few others.

"Here we are," I said to Mick and John.

"Ah, here they are Johnny," Mick said. "Looking lovely."

Mick said he and John wanted to take us to a different club. Since we had liked the Marquee, they thought we might enjoy the Crawdaddy Club.

"Too far to walk," Mick added, "but we can take a taxi."

"Have you girls taken a taxi in London yet?" John asked.

We told him about the taxis we'd taken and how much we liked them. So much more elegant than taxis back home.

Along the way, Mick and John told us that the Rolling Stones had played the Crawdaddy Club many times.

"They used to be the house band," John said.

It seemed like the Stones played in so many London clubs.

The Crawdaddy Club was bigger and dressier than the Marquee. Some of the boys wore suits, and the girls wore dresses. We didn't get a table but walked around with soft drinks in hand enjoying the music. Mick again knew some of the people there. He stopped in front of one heavyset man wearing a gray suit, a white shirt, and a tie. Mick greeted him and introduced him to us as Tony.

"Tony's trying to be our manager," Mick said, and he laughed. Tony rolled his eyes. "What's on for us, Tony lad?" The two of them walked away and John joined them.

For me, it was another great night of live music and dancing around and around. Mick and I had so much fun; I found it hard to believe it was real. Marty and John were dancing, too. I was glad to see her having fun. She had seemed a bit distracted during the last couple of days, but she hadn't said if something was bothering her. We were friends, former neighbors, and the best of Beatle pals, but we had never spent so much time together before.

Around ten, the four of us finally sat down at a table together after several dances and caught our breath. A group called the T-Bones was playing.

"The Rolling Stones played here as a regular band," Mick said. "After they took off and got big, a group called the Yardbirds took over as Crawdaddy's regular band, but they're taking off now, too."

"Have you heard of the Yardbirds in the States yet?" John asked.

I said I wasn't sure, but the name sounded familiar.

"Don't worry," he continued. "You'll be hearing about them a lot when you get back home."

I gave Marty a quick look. What were we doing? I wondered to myself. Should I tell Mick the story and the plan to stay here for the rest of my life? I was tempted.

After a bit Mick announced, "Tony is going to drive us all home. We'll drop you girls off first and then we'll go on."

I was a little surprised. This seemed so sudden. How could the night be over so quickly? Easy for me to say. I didn't have to be anywhere in particular the next day. When he said "home," I also wondered if he and John were going back to Liverpool. I didn't know how far Liverpool was from London, but it wasn't just a tube stop away, I imagined.

As we rode, Mick explained.

"Johnny and I have a couple of music gigs out of town. We'll be away for two, maybe three, days."

I felt a pang of anxiety in my chest. What did this mean? Was I getting dumped? I looked out the window and did not look at Mick. For this one long precious moment, I just enjoyed sitting close next to Mick. I felt the warmth of his body next to mine. I glanced at him out of the corner of my eye whenever I noticed him looking out the window, as he made sure we were headed to Lansdowne Road.

"Tony, this is the girls' place," Mick said. Tony pulled up in front of our flat. I was heartbroken thinking this might be the last time I saw Mick. I wanted to get out of Tony's car and run into our flat.

"Good night and thanks for a great time. I had so much fun," I said to Mick although I barely looked at him.

"Steady there," he called out. "Janice, where are you running off to?"

I turned around.

He held out a piece of paper. "Now, this is Tony's telephone number," he said. "It's the only way to contact me."

"But we don't have a telephone," I said.

"Love, haven't you noticed the red telephone boxes all over London?" Mick laughed. "They have doors and windows and telephones!" He seemed surprised when I told him I hadn't made a single phone call since we arrived. Londoners adored the color red. Phone booths, mailboxes, and double-decker buses were all red. "Now don't lose it," Mick said.

He'd called me "love." My heart soared.

"Call me in about three days," Mick continued. I finally breathed. "You'll still be here then, won't you?" His beautiful blue eyes looked right into my eyes.

I told him yes, I would be.

"Okay!" he called out with a big smile as he got back into Tony's car. Off they went.

I practically skipped up the stairs to our flat.

Chapter 28

WE WOULD HAVE Thursday, Friday, and possibly Saturday all to ourselves. There was so much to do. We had to go to the 2i's Coffee Bar, shop along Carnaby Street, walk through Piccadilly Circus. We wanted to see the sights. Meet more Londoners. It still hadn't rained yet. I looked forward to opening my new Harrods umbrella and walking along the streets of Soho in the rain.

We would have a wonderful two or three days until the boys returned. It dawned on me that I had no idea where they were going. It didn't matter. I was walking on air. Speaking of walking, we decided we needed to get boots to wear around. Many girls in London wore boots, and we didn't have any. I wanted to get black slacks and a black top, plus boots, so I matched Mick's look. How cool would that be? The two of us going into the Marquee looking so Soho. I loved the idea. I had my own money to spend, but Marty's money paid for the big expenses.

"Thanks, Marty," I said.

"For what?" she asked.

"For using your college money to pay for my airline ticket. We wouldn't be having this great trip without it."

"It's no big deal. I never wanted to go to college, but my mother insisted," she said. "I'm glad to spend the money on a new life in England. So much more practical. Plus I wouldn't mind marrying a boy from England. Especially if he was a musician."

"We'll soon be able to get jobs, and we'll be okay," I said. I wondered if Brian Epstein had received my letter yet. He should have by now. I wrote it in early July. Maybe it takes months for mail to travel from Ohio to London. But I sent it air mail, so it should have been delivered by now.

"I will pay you back," I said. I still had money from my savings account. All my money I had earned myself, every penny. I saved everything that I could and watched my tiny savings account grow from two dollars and twenty-five cents to well over eighty-five dollars. I was proud of my hard work and accomplishment. I learned to save every penny by watching Toots save nickels, dimes, and quarters in those little coin-sized tubes she kept in the dining room buffet.

I unfolded the paper Mick had given me and looked at Tony's telephone number. I assumed this was Mick's handwriting. He'd written the number in ink. I wondered when he'd done that. Not while we were in the taxi, and I didn't see him with a pen and paper in the Crawdaddy Club. It wasn't on a napkin from the club, either. He must have written this before we met that night. His handwriting was very neat and clear. The numbers were large and straight and even from top to bottom. I folded the paper carefully and placed it in my wallet.

I knew he liked me. My heart skipped several beats again. When it was time to call, I would need change for the telephone. I'd have to find out how much it cost—shillings and pence, or just shillings?—to make a phone call. I had been so wrong about him. He couldn't have known how close I was to running into the flat before he had a chance to give me Tony's phone number. But I had been afraid I liked him more than he liked me and that he would drive off. I'd never see him again, and I couldn't face it.

On Thursday, we took the tube to the Carnaby Street station. Clothing shops for men and women lined the streets. The clothes were different from the department stores in downtown Cleveland. They were striking, bold, and colorful. There was a men's

shop called Lord John and another one called John Stephens. So many boutiques for men. A beautiful black and silver Rolls Royce was parked on the street. I hoped one of the Beatles might be shopping on Carnaby. Maybe this was their Rolls.

After seeing the movie *A Hard Day's Night*, I was convinced anything was possible for the Beatles. They were good at dodging crowds and seemed to think it was all a game. But that was just a movie. The big Beatles question was beginning to weigh on me. I'd been here since September 17, almost an entire eight days, and hadn't heard a peep about them except that they had returned from America to Heathrow Airport on September 22. The same airport where we had arrived. We were definitely in the world of the Beatles. I knew they had to be in London, somewhere—but where?

Carnaby Street could make you forget anything troubling you. A man walked past playing bagpipes like it was St. Patrick's Day, people sold bow ties on the street, artists sat on chairs on the side-walks and sketched portraits. Folks ate ice cream as they strolled along window shopping. There was a long line of people waiting to get into some of the clothing shops.

"Let's get in line and see what's going on," I suggested.

Marty agreed. We wanted sunglasses, black turtlenecks, black slacks, and black boots. For our Carnaby purchase we settled on "fab" sunglasses, and then headed for the 2i's Coffee Bar, which had been recommended to us by the man who worked at the hotel. We consulted our London street map as we walked along, turning left onto Broadwick Street. Every street had rows of shops and attached houses with flower boxes under the windows. London was beautiful. I knew I would be happy here.

"Oh look!" I said to Marty. "It's Wardour Street. That's where we went to the Marquee Club."

I stopped to check my wallet. There was the precious paper with Tony's phone number, safely tucked away. But it was much too early to call. I had to wait two days. I decided to call Saturday

morning. Maybe we could all meet on Saturday night and go out to another club, hear live music, and dance again.

"We haven't listened to any Beatles since we got here," I lamented.

"There hasn't been time, plus we don't have records or a record player, or a radio, or even a television set," Marty said.

"What Beatles song would you most like to hear right now?" I asked.

"So many," Marty said. "But right now, I'd give anything to listen to 'Till There Was You.'"

Even though John and Paul didn't write it, Paul sang it beautifully. "Till There Was You" was one of my romantic favorites.

"What about you?" Marty asked.

"'I Call Your Name.'" The song was on *The Beatles' Second Album*. I thought about how hard I had worked to save enough money for my record player. Gone forever now. But we had live music to listen to now. What could be better than that?

I kept hoping to see the Beatles, but still no sign, even though we were right in the heart of Beatlemania. I was starting to feel a little down, or maybe I was only tired and hungry. We'd walked and walked and hadn't eaten a decent meal since we got to London. I was used to breakfast, lunch, and dinner at home.

We turned onto Old Compton Street from Wardour Street.

"There it is!" I said as we rounded the corner. "To the left on the other side of the street."

The 2i's Coffee Bar didn't look splashy. Maybe it was supposed to be inconspicuous on purpose. The street looked safe enough. The sign on the front of the building said, "Coffee Bar" with a "Drink Coke" sign above it on either side of a large handwritten italic "2i's." Little music symbols danced above the "Coffee Bar" sign. There was a large window, and I saw a counter like the counter at Irv's Deli inside. A sign at ground level read "Dancing, 7 Nights a Week, Top London Groups." Sounded great. I sighed. I wished Mick were here. There was one glass door leading into and out of

the 2i's. The symbols for Pepsi and 7-Up were attached to the glass door. Thank goodness they served Coke.

We decided it was a little early to go in and that we should have something to eat first. To the left of the 2i's was another place called Heaven & Hell. The nuns at Ursuline Academy would frown on me going in there.

"Which part is Heaven and which part is Hell?" I asked a couple of girls and boys standing outside. I was in one of my amusing moments. Sometimes I could be quite witty.

"Oh, Hell is downstairs of course!" one girl announced through her cigarette smoke. They all laughed at her joke. I decided to skip the place. Why risk it? There were too many other clubs to see.

We still hadn't had any "chips." In America, we knew "chips" were potato chips. In London, potato chips were called "crisps." I learned that bit of confusing information when I tried to buy a bag of potato chips at a corner store near our flat.

"Where are the potato chips?" I asked.

"Oh no, love, we don't serve chips here," the clerk said.

I couldn't believe it. What little corner shop wouldn't carry potato chips? England was so weird. As I walked to the door of the shop and pondered how different things were in England, I saw a rack filled with bags of potato chips—except they were labeled "crisps."

Potato chips! At last I found you! I didn't care what they called them. I was comforted to know that England was truly a normal, civilized nation. In Cleveland, we had tins of potato chips delivered to our door—Charles Chips. The longer I was away, I realized, the more I missed certain things.

Besides chips versus crisps, there were other language differences too, which I learned as I went about asking for ordinary things and finding no one knew what I was talking about. I spoke English but not the "Queen's English," as a cashier in a clothing store on Carnaby Street pointed out while laughing (in delight, I assumed) at "you Americans."

I needed a sweater. The temperature was dropping a bit at night. "Where are the sweaters?" I innocently asked.

"The what?" the clerked laughed. I quickly learned that a sweater was called a jumper.

A cookie was a biscuit. Gwen called our stove a cooker. We had already learned that an apartment was a flat. An elevator was a lift. A line of people was a queue. A subway was a tube. We learned *that* right away from Gwen, too. I laughed to myself whenever I said something in the Queen's English as if I had lived here all my life. I was starting to feel very Beatlesque, but my American accent gave me away every time.

Finally, we saw a little restaurant with a "Fish and Chips" sign.

"Here's our chance to find out what chips are. Let's try it," I said to Marty.

Chips turned out to be french fries. We learned something new every day here. And we learned chips were very tasty. All I needed was . . . do they call it ketchup? Much to my relief, my favorite condiment was called ketchup in England, too. Fish had not been on Toots's menu, other than maybe canned tuna in a casserole. We were meat people. But I found the fish part of fish and chips—battered and fried—to be delicious, too.

When we got back to the 2i's, we found it was small and very crowded. At the counter, people ordered either coffee or soft drinks. The music was downstairs. We made our way down and saw a tiny stage with a band struggling to get all their equipment in place. The drums took up most of the postage-stamp-size stage. Then there were guitars, and the band members were trying not to bump each other off the tiny stage. Teenagers packed together and milled around smoking cigarettes, laughing, and talking while waiting for the band to start playing.

Even though it was late September, the temperature inside was warm. I couldn't imagine how hot it might get once everyone started dancing. We ordered soft drinks and watched the crowd.

"You girls are American," one of the guys said. *How could so*

many people know just by looking at us that we were from America?
"I heard you ordering your drink," he added, as if he'd read my mind.

I looked in the direction of the voice. A tall, handsome, slender, cigarette-smoking guy and his friend stood next to us. Was this how it was going to be everywhere we went? Handsome men falling all over themselves to talk with two American teenagers? If so, sign me up for more. His accent was different from Mick's and John's. Their accents were Liverpudlian, but these two sounded as though they were straight from an English movie. Must be Londoners. Very upper class. Pip-pip, cheerio, and all that. I couldn't wait to hear them say more of . . . anything at all.

"So, are you on holiday?" the handsome one said. There it was again. "Holiday" was the Queen's English for vacation.

"Yes, we are," I said.

"Music lovers. What a wonderful thing," he said. He offered his hand and introduced himself and his friend. "I'm Paul, and this is Roy."

Roy also pushed his hand forward. We all shook hands. "Are you two musicians?" I asked.

"God, no!" Paul looked heavenward, blew out a stream of cigarette smoke, and laughed. "I took piano lessons as a boy, but that's as far as it got. Music lover, though. All kinds." He didn't say what he did for a living, and neither did Roy. They were both wearing gray suits, vests, white shirts, and ties, and looked like they worked in an office or a bank. Both were tall and good-looking, with finely chiseled chins and noses. Paul had a cleft in his chin just like sexy movie stars. They offered us cigarettes.

"Know anything about the 2i's?" Paul asked.

"Just that our hotel clerk recommended it as a fun place to go in Soho," I said. We were starting to get jostled by the growing crowd.

"It's small, but it's one of the greatest places in Soho for live music," Roy said. He explained that the club started out as an espresso bar in the 1950s before it was bought by a wrestler known

as "Doctor Death." The place was famous for musicians hoping to make it into the big time.

"A lot of bands who've played here already have made it," he continued. "But you probably haven't heard of them in the States."

"Have the Beatles played here?" I asked.

"No, never here. You have to go to Liverpool to see all the places they played, such as the Cavern Club," Roy said.

"The Beatles are much too big to play in a small club like this," Paul said. "Once you get to the London Palladium, you've reached the pinnacle in England."

I was disappointed to hear that they were too big to play in Soho. But I still believed that they must be in London somewhere. But where?

I was thrilled to speak with Brits who knew so much about the Beatles and the music scene. This was my kind of town. Instead of listening to records on my record player, I could go to Soho to hear live music played by musicians who might be as big as the Beatles someday. Of course, that would never be possible. The Beatles were the ultimate. But maybe more British Invasion music groups would form right here at the 2i's. I wondered if Mick and John would someday be part of the British Invasion.

Music bounced off the walls and the floors and took over the room. I saw Paul's lips moving, but the band drowned out his words. I had to strain to hear anything he said. The only way to communicate was to dance. I danced with Paul, and Marty danced with Roy. It was impossible to move around without bumping into everyone else, but I didn't mind. The music was so good. Catholic high school mixers were nowhere near as interesting as this scene.

Around nine we had to leave. It was getting late, and we had a long way to go to our flat. Paul and Roy walked with us up the stairs.

"How about another Coke before you leave?" Paul asked. They insisted on paying. I wondered if all the boys in Soho were as sweet

as the ones we'd met so far. If this was going to be the way it was, why would I ever want to go back to Cleveland?

"Why don't the two of you come back to the 2i's tomorrow?" Paul said. "Meet us here and we can show you some other clubs you might like. More room to dance and not so stuffy."

"We can get something to eat as well if you're interested," Roy added.

I looked at Marty. She shrugged her shoulders, signaling *Why not?*

"Okay, we'll meet you here," I said. "How about five o'clock?"

We decided to take a taxi to the Tottenham Court Road tube station. It was late, and we were tired. We'd been walking all day long. I made a mental note of some of the places Paul and Roy suggested we go. We already knew Oxford Street, but we hadn't seen Trocadero Center, Piccadilly Circus, Leicester Square, or Covent Garden.

"Let's branch out tomorrow and see some different parts of London," I said. We had a tourist book of things to do in London. We skimmed through the pages on our short tube ride back to Holland Park.

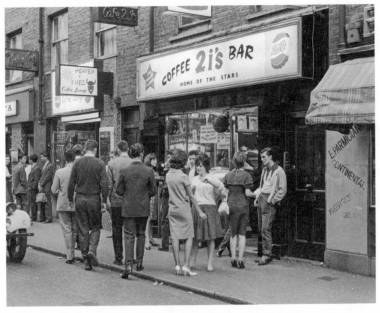

2i's Coffee Bar, 59 Old Compton Street, Soho, London. It didn't look splashy, but a sign read "Dancing, 7 Nights a Week, Top London Groups." *Getty Images*

Carnaby Street. The clothes were so different from the department stores at home— striking, bold, and colorful. Fab! *Pictorial Press Ltd / Alamy Stock Photo*

Chapter 29

DEEJAY ENLISTS IN SEARCH FOR
MISSING BEATLE FANS

The Plain Dealer—September 26, 1964

Harry Martin, morning KYW deejay, is working hard to locate the two Cleveland Heights girls who allegedly have gone to Liverpool to stalk Ringo Starr and the other Beatles.

Harry has advertised in both the London Daily Mail and the Liverpool Post asking the girls . . . to call him collect because "I want to hold your hands even if it has to be by telephone."

Harry has also taped a plea to the girls to return to their worried families. The tape is being broadcast by the pirate-radio station off Britannia's limits in the Atlantic.

"We would have broadcast it by BBC," Harry explained, "but the BBC doesn't broadcast Beatles records, so we figured the girls won't be listening to it. The pirate station does broadcast Beatles and rock."

Chapter 30

EVEN THOUGH I had planned to call Mick on Saturday, I was so
excited about seeing him again that I wanted to call on Friday. If
he wasn't there, then no harm done—only a one-day difference. If
I lost my nerve when someone answered, I could just hang up. No
one would know it was me. But I didn't want to call too early in
the morning. They were probably out late all Thursday night.

"Just call," Marty said.

But it wasn't like calling from home, where I walked into
the kitchen in my pajamas, picked up the receiver, and dialed. I
needed time to shower, get dressed, and make breakfast before
I went outside to find a phone booth. Then I realized it seemed
a little chilly in the flat. And no hot water. Oh yes—we needed
to feed the box on the wall! We had to wait for the water to heat
up to take a shower and wash a few dishes that were sitting in the
sink. That would be a while, so I put my coat on over my pajamas
and walked down the hall to use the WC. What a polite name for
a toilet—so terribly British.

The red phone booth, or phone box as the Brits called it, was on
the corner near our apartment building. I brought all my change
with me. I opened the door and stepped in. The whole phone call
process was a mystery to me. The phone had a dial and two slots
for coins. I felt that was an excellent start. Of course, we had pay
phones in Cleveland, but I had never needed to use one because
we had a phone at home.

I took a wild guess and fed some coins the size of the two slots into the phone and dialed the numbers from the piece of paper. I heard ringing through the receiver. The Beatles tune "Till There Was You" played in my mind. They had sung it on *The Ed Sullivan Show* last February. Of course, I had sung every word along with Paul as he performed so sincerely and sweetly. The phone rang and rang and no one picked up. I gave up, pressed the right button, and got my coins back. I would have to try again later. There were red telephone boxes all over London. I hoped this really was Tony's telephone number. Mick had seemed honest and sincere, and if he didn't want to see me again he would have just said good night when they dropped us at our flat.

A Friday in London—to me, just the sound of the phrase was like sunshine. We made some peanut butter and jelly sandwiches to take with us. We decided to be like tourists with our packed lunches, map, and my umbrella. We took the tube to Tottenham Court station. This station was our rock. As long as we could get there, then we could get back home.

We left the train station and walked along Oxford Street toward Marble Arch. Marble Arch was within walking distance from the hotel where we had stayed when we first arrived, but we hadn't gotten a chance to go there yet. As we walked under Marble Arch, we were surprised to see a chubby man dressed in tails and a tall hat standing on a wooden box talking loudly about the government. He was extremely passionate about whatever it was. I was surprised he could go on like that for so long.

People would stand around listening for a bit and then walk away. I looked in our tour book and wondered if this was Speakers' Corner, which was part of Hyde Park. The tour book explained anyone could come and talk about the issues of the day, but only on Sunday. Since this was a Friday, I figured this must be some other Speakers' Corner. I was sorry I had missed the gathering on Sunday. I imagined Londoners standing in line waiting to give their opinion about almost anything.

We walked on through the park. Hyde Park was beautiful and seemed the perfect place to sit down and eat our sandwiches. We purchased cans of Coke and bags of crisps, so we were all set.

"How do you think things are going with your mother and sister?" I asked Marty as we ate.

"I don't know," she said.

"Did you happen to send them a postcard?" I was only half joking. " 'I'm in London having a wonderful time. Wish you were here.' "

We both laughed, and Coke sprayed out of Marty's nose, but she looked away. Maybe it wasn't so funny after all. Apparently, no one was looking for us, or I figured they would have found us by now.

After lunch, we continued walking through Hyde Park, past the large lake called the Serpentine, on which people were boating. I knew horses had been in the park because I saw the indentations of U-shaped shoes. I hoped to see some go by, and I was not disappointed, as several people soon rode by on their horses. I'd loved horses as long as I could remember; the Cleveland Police Department had police horses, and I'd seen them downtown. Hyde Park had everything.

We headed back to Marble Arch. I saw a red phone box and thought I'd try calling Mick again. I didn't think anyone would answer in the middle of the day. I was now expert at making a call from a phone box. I dialed and let it ring, ten times, but still no one answered. Toots had cautioned me that it's not polite to let a phone ring more than ten times, and even that can be excessive. Five should be plenty. I went the full ten every time I called Mick's number.

We strolled along, following the map, and found Piccadilly Circus. Crowds of people were everywhere. One thing we'd learned was the importance of looking for oncoming traffic in the opposite direction than what we were used to as we prepared to cross the street. I had to keep reminding myself to look right for

oncoming cars, buses, and motor scooters. Looking the wrong way could be a deadly mistake. I imagined a headline in the newspaper: "American Teenager Mowed Down in Piccadilly Circus by Red Double-Decker Bus." That was not the way I wanted to go.

Piccadilly Circus was surrounded by tall, beautiful old buildings, theaters, large shops, and crowds of people (who seemed to be from all over the world) walking in every direction around us. Traffic moved fast. Everyone seemed to be in a hurry to get somewhere. There was a huge fountain with steps leading up to an ornate sculpture, where people sat talking, smoking, reading, and having a snack. Billboards were everywhere. Crowds of people huddled together waiting for the right time to cross the street. It was impossible to tell where anyone was headed. Many were camera-carrying tourists talking in French, German, and other languages I didn't recognize.

I was in love with it all.

We both almost forgot we were to meet Paul and Roy at the 2i's at five. We weren't dressed for a night out. Oh well, they would just have to take us as we were or leave us. I could've kicked myself for forgetting about meeting up with them. But that didn't mean I didn't want to. They were native Londoners and knew the best places to go. They were the types that were fun to chitchat and joke around with.

I wanted to try calling Mick again at Tony's phone number, but it was too noisy on the streets, plus there were long lines for the phone boxes. I didn't think it would be late enough for anyone to be at Tony's. I didn't know where Tony lived, or if this was his office or home number. Maybe it was too early if Mick and John were playing in a band someplace. The four of us hadn't spent enough time together to learn much about each other. We were American teenagers on holiday, and that was all they needed to know. And it was all I was willing to reveal.

Paul and Roy were good-looking, polite, and fun. They seemed to think we were interesting because we were Americans. I under-

stood that—we found them interesting because of their lovely British accents.

Back in Cleveland during the summer, a young man with a British accent had visited one of my neighbors. *Oh my gosh, he has a British accent*, I thought. *He might be a musician. Maybe he knows the Beatles.* I made a point of being outside when I saw him leave the neighbors' house. I ran down the stairs and burst onto the sidewalk in the most casual way I could.

"Hi!" I called out. He turned toward me. He wasn't particularly handsome, but the accent overrode that. "Are you from England?" I asked.

"Obviously," he answered. He wasn't particularly nice either, but the British accent gave him a pass on politeness.

"I could show you around, if you're interested," I said. I was so bold I shocked myself.

We went on a date to the movies. He wasn't a musician, but he was from someplace in England. That was good enough for me.

"Yes, the Beatles," he said and seemed annoyed. "Everyone I meet wants to know if I know the Beatles. Sorry, I don't."

He was no substitute—not even close—British accent or not.

Paul and Roy were standing outside the 2i's having lively conversations with their friends. "There they are!" Paul called out as he waved in our direction.

We waved back to let them know we saw them. We crossed the street and stood with them on the sidewalk in front of the 2i's. A group of teens stood in front of the ground-level sign. The line to get in grew. We weren't standing in the line, and neither Paul nor Roy made a move to get in it.

"Have you heard of the Flamingo Club?" Roy asked us.

We just looked at him, waiting for more information. Roy seemed to have taken on the role of tour guide. "It's a real nightclub, but they don't serve alcohol," Roy said. "You can get something added to your Coke, if you know what I mean."

Cherry Cokes at Irv's Deli were delicious.

"I'd love a cherry coke!" I said.

"No dear, it's not cherry flavoring. Something a bit stronger," Paul said.

"I had a Shirley Temple once or maybe twice." I tried to sound sophisticated. "Now that was a colorful drink—and it had a whole cherry in it."

"Good enough," Roy said. Roy and Paul exchanged glances.

"But we're not dressed for a nightclub," Marty said.

"You both look fantastic," Paul said. "Come on. It's just around the corner on Wardour Street."

We walked to the corner, turned right, and walked past St. Anne's Churchyard gardens, past Shaftesbury Avenue, past Dansey Place, and there we were. It was the Flamingo Club all right.

"You'll be happy to know that the Beatles have been here, not to perform, but just as a place to come to," Roy said.

"This is the place!" I said. "I read they hung out in Soho. Thank you, thank you, Paul and Roy!"

"We thought you'd like it," Paul added with a big smile on his face.

"The Rolling Stones come here, too," Roy added.

Even before we went in, I was in love with the Flamingo Club. The entrance was sandwiched between two storefronts. There were signs all over. The sign next the front door read "Flamingo and Allnighter Club." I was comforted by another sign advertising a familiar soft drink. Several young men stood near the entrance and leaned against the building. Some smoked cigarettes, and they were dressed in a variety of ways: suits, shirts and ties, polo shirts, light dress jackets, dark slacks, leather boots, leather shoes, and outer coats.

Paul asked if we'd ever heard of a group named Georgie Fame and the Blue Flames, but we hadn't heard of that one back in America. "They're well known here for their rhythm and blues. They play here."

"Do you think the Beatles might come here tonight?" I asked.

Paul looked up at the sky and laughed, "Anything is possible at the Flamingo. All the greats either play here or come here for the music. Never know when you're going to be watching another Beatles or Rolling Stones."

"This is the place to be," Roy added.

I wondered if Bill Wyman would be here, hanging out, tonight.

As much as I wanted to go in and search for a hidden Beatle or Bill Wyman, I was famished.

"I need food first."

"The ladies need food, Roy," Paul said.

"Then food the ladies shall have," Roy said with a sweeping gesture of his outstretched hand. They led the way to a coffee shop. I had fish and chips again. This was my new favorite. I could eat it every night. I was surprised that the dish had green peas in addition to fish and french fries.

"What is this?" I asked Paul.

"Ah, you're being introduced to a British epicurean delight called mushy peas," he said and laughed.

Mushy peas turned out to be delicious—another wonderful British surprise.

It was almost dark when we got back to the Flamingo Club.

"How are we ever going to get home from here?" I whispered to Marty. "A taxi is out of the question."

"Now what are you two ladies conspiring to do?" Paul said.

"We're worried how we're going to get back home after this," I said. "It's dark out already."

"Not to worry," Roy said. "When the evening is done, I have my trusty steed who will carry the ladies anywhere."

Down into the basement we all went, where the room was already getting crowded, the band was playing, and everyone was dancing. We jumped right in and danced the night away. Time didn't exist while there was live music.

"Care for something to drink?" Paul asked.

"That would be great," I answered. The exciting nightlife was like running a marathon, and I loved it.

"Just a Coke, or a Coke with a splash of something?" he asked.

"A splash?" He must mean a Shirley Temple or something like it. "A Coke with a splash. Something colorful, please." Marty and I looked at each other and giggled.

Paul brought back a bottle of Coke with a straw. I took a sip. It was not a Cherry Coke. "This is so bitter. I'm not sure I can drink it," I said.

"You said a splash, right?"

"Yes, but isn't a splash the same as a British Shirley Temple drink? It's so colorful, like a Cherry Coke."

Paul looked up and laughed so hard it looked as though he was going to fall over. "A splash is liquor, my dear."

"Liquor as in alcohol?" It did taste a little better if I sipped a tiny bit at a time. Before I knew it, the clock said it was two a.m.

"Janice, we should be getting these two to give us a ride home," Marty said. "Look at the time!"

I had two, or maybe more, Cokes with splashes. I no longer kept count.

Roy drove all of us to Lansdowne Road. I got out of the car and felt quite light and happy. We all called out our good nights and thanks for the great night.

"We'll be at the Flamingo tomorrow night. Meet us there, will you?" Roy called out.

"We will!" I said. "See you tomorrow."

When we got inside, the shillings were still doing their duty. The lights were on and the hot water still available. I walked down the hall to the WC and when I was finished and pulled the handle with the chain to flush the toilet, I pulled it completely off the water box and accidentally dropped it into the swirling water of the toilet. Down it went. I couldn't stop laughing, but at the same time I realized how important it was not to get caught. I tried to

muffle my laughter all the way back to the flat. I didn't even tell Marty. I had no idea how anyone could flush the toilet after this.

I think I might be a bit sloshed.

I was inspired to call Mick. I found the paper with Tony's telephone number, got the correct amount of coins, and went outside to the phone box. All the coins fell from my fingers. That was so funny I almost lost my balance while picking up the coins from the ground.

Tony's telephone rang. "Yes," a male voice answered.

"Mick?" I asked.

"No, this is Tony. Who's this?" he said.

"Tony, this is Janice. You know, from America. Janice from America." I started laughing. "Is Mick there?"

"Janice, do you know what time it is?" Tony did not sound pleased.

"I'm sorry, I don't have my watch with me," I said and laughed again.

"It's three a.m., for God's sake!" Tony said. "The boys stay at my place when they're in London. They'll be back Sunday. Call back then. Go home and sleep it off, dear girl." He hung up.

I held the receiver in front of me and looked at it in disbelief. Did he hang up on me? "Hello? Hello, Tony?" But he wasn't there anymore.

I went back to the flat, but I couldn't open the door. I hadn't taken the key with me. I guessed it was late. Tony said it was three o'clock in the morning. I stood on the sidewalk and wondered how I could get Marty's attention without disturbing the neighbors. The windows were completely dark, and the purple drapes pulled tight.

"Marty!" I called out in a loud whisper. She didn't answer. I climbed over the little wrought iron fence in front of our flat. Careful not to squish any of the greenery, I stood up on my tiptoes, gripped the window ledge as much as I could, and called out again. No answer. I knocked on the window of our flat.

"Wake up!" I continued to knock. My knuckles started to hurt.

Finally, she pulled the curtain partly open, peeked out, saw it was me, and went around and opened the door.

"They'll be back Sunday," I said.

"Who'll be back on Sunday? The Beatles?"

"No," I said and realized I was fading.

"Roy and Paul?"

"No. Mick and John. Tony said so."

"Tony?"

I slid a pillow off the bed, lay down on the floor, and fell asleep.

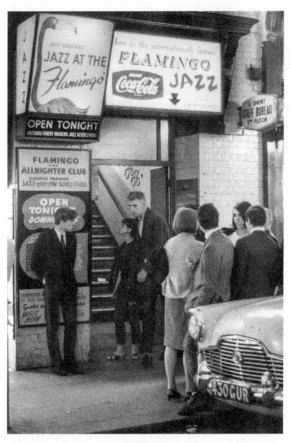

The Flamingo Club, 1964. Time didn't exist while there was live music and dancing. Before I knew it, the clock said two a.m. (Musician Georgie Fame stands at far left.) © *Val Wilmer/CTS Images*

Chapter 31

"NOT FEELING THAT GREAT this morning," I announced. My head was pounding. Either it was the drinking, or a drum from one of the bands last night had gotten stuck in my head. "I think I was drinking alcohol last night," I said. "If this is what it feels like, I'll never do that again."

I decided, based on the experience at the Flamingo, that I would stick to plain soft drinks. No more splashes. I wasn't certain what the splashes were. The drinks started off tasting bitter, but as the night went on, they tasted better and better.

Lots of tea plus toast with a ton of butter and gobs of peanut butter on it for breakfast might help. Oh my gosh. I remembered that I had called Tony at three in the morning. And there was the little matter with the handle in the water closet. I had to go down to the WC anyway. To my great delight, the chain and handle were there. What a relief! I realized now that I hadn't dropped them into the toilet and flushed them away but merely dropped them on the floor. There was no note on our door, so I guess whatever happened, if anything, had been resolved and it was okay. Never again.

It was Saturday. We realized we'd been gone for about nine days and no one was looking for us, as far as we knew. Everything was great. Tonight, we were going back to the Flamingo Club to see Paul and Roy.

We decided to go to Soho early and try to get some shopping

in. I was practically dying to get a black outfit and black boots. I
had enough money to cover it if we went to a regular department
store. Buying an umbrella at Harrods had been extravagant, but it
had been so much fun.

I checked my notebook, in which I'd written down the names
and locations of stores that had looked appealing and that I
thought we might want to find again: Mary Quant, 21 Shop, Biba,
and Selfridges. Selfridges was huge. It reminded me of the stately
department stores in downtown Cleveland: Halle's, Higbee's,
and Sterling Lindner—but bigger. We also needed to see Covent
Garden, Leicester Square, Abingdon Road, Mayfair, and Porto-
bello Market.

"I hope Paul and Roy will be there," Marty said.

We continued walking to Wardour Street. Paul and Roy stood
in front of the Flamingo Club. They spotted us and started waving
madly to get our attention.

"We've been keeping our eyes peeled for any Beatle or Rolling
Stone trying to slip into the club," Roy said. "We assumed they'd
be in some sort of a disguise—a derby hat, a mustache, beard,
glasses. But not a one yet."

In *A Hard Day's Night*, Paul, George, John, and Ringo had run
around doing a great job of dodging fans. I was sure they could do
the same thing at the Flamingo Club.

"We can always come back to the Flamingo, but we thought
you might like to see another place tonight," Paul said. "Ronnie
Scott's is more a jazz club. Sometimes rhythm and blues. But you
might like it. Lots of good music."

We walked there, and Paul and Roy led the way into the base-
ment to the actual club. The jazz band consisted of a piano, guitar,
and two saxophones. No one danced. Tables and chairs were
packed with people smoking cigarettes and swaying to the smooth
music. We stood around for a while listening to the music; I knew
it was good, but it was just not my style. I looked at Paul. He read
my mind.

"I guess there's no dancing right now. Let's pop out for a coffee, shall we?" Paul said.

We walked to 22 Frith Street. "Bar Italia," Roy announced.

"I'm a tea drinker," I said.

"Yes, but you'll want to taste this coffee," Roy said. "The owners are from Italy, and their coffee is like nothing you'll ever taste in your life."

"An additional incentive, musicians come here all the time. It's practically a ritual," Paul said.

"Yes, even the Beatles are rumored to have stopped in," Roy said.

I'd been to the Little Italy neighborhood in Cleveland, even though all the kids had been warned not to go. "If you don't want to get beaten up by the Italians, stay away from Little Italy." My St. Ann's school friends and I wanted to see for ourselves and walked down the hill from Cleveland Heights into the "forbidden zone." No one got beaten up that day. Later, we learned that it was black kids who weren't welcome there. I never went back.

At Bar Italia, no one was getting beaten up. It was beautiful inside, and the coffee was delicious. It was called espresso.

I was enjoying people watching while we were there, but the boys wanted to move on.

"Let's go to the Scene Club," Roy said.

"What's the Scene Club?" I asked.

Roy continued in his role as our tour guide. Although the quieter of the two boys, he was the most knowledgeable about the clubs in Soho.

"Actually, it's not that easy to describe," he said. "I don't want you to be put off when you see it's sort of in a grungy spot."

"Sounds exciting," I said.

"Knew you girls would feel that way now that you're all Soho and West End," Paul chimed in. "By the way, how long are you on holiday for?"

"Couple of weeks," I lied.

"Are you staying in London the whole holiday?" he asked.

"London, and we want to go to Liverpool."

"Ah, Beatles of course!" Roy said.

"Of course! Beatles!"

"Cavern Club?"

"Of course! Have you ever been there?" I asked.

"Never been to Liverpool, but that would be a great trip," Paul said.

"You know so many music clubs and coffee bars," I said. "I'm surprised you've never gone to Liverpool to see the Cavern."

"Believe me, we intend to someday," Paul replied. "But work makes it difficult to get away for holiday I'm afraid. We're quite content with all the live music right here. Soho is where it's at."

I didn't want to ask what they did for a living. If they wanted us to know, they would say so. And no one had asked us what we did in Ohio; all they knew was that we were on holiday. Londoners didn't ask a lot of probing personal questions. I liked that about them. We were free to enjoy the moment and celebrate what we had in common—a love of London and Soho and the music scene. This was, I decided, probably part of what made the Beatles so appealing. It was all about the music. I wanted to stay forever.

"We don't have much of a music scene in Cleveland," I said.

"Well bugger that!" Paul seemed astonished. "Don't go back then. Stay right here."

Paul had no idea that already *was* the plan. Yet how could I manage to stay here forever? We were watching our money supply slowly dwindle.

"You started to tell us about the Scene Club," I said to change the subject.

"Ah yes, the fabulous Scene Club. Absolutely one of the best in Soho," Roy said.

"Roy, you say that about every club you've taken us to—Crawdaddy, Ronnie Scott's, the Flamingo," I said, laughing.

"They're all great, in their own way," Roy countered. "Soho . . . can't get enough."

I knew just what he meant. I could go out every night. Soho was the place to live the music life—where I wanted to be, no matter what.

My hopes were still high for running into one of the Beatles or one of the Rolling Stones at the Flamingo Club. If only I could see Bill Wyman again. I wondered if he got the letter I wrote to him. He hadn't answered by the time we left Cleveland, but I understood that. He was extremely busy performing all over the place. If he asked me to go on tour with him again, though, I still wouldn't do it. Well, maybe I would think it over. That would be fair, especially since it would be the second time.

We arrived at the Scene Club, which was in an area called Ham Yard.

"Ham Yard?" I turned to Roy.

"The name may seem a bit odd, but a long time ago there were a lot of sandwich shops here," he explained. "People named their shops after the most popular item, hence 'Ham Yard.' You knew what to expect."

"Are there ham sandwich shops in Ham Yard?" Marty asked.

"Ha ha! No, that was a couple hundred years ago," Roy said. "Do you know where the word *sandwich* came from?" He went on to tell the story of the Earl of Sandwich, who didn't like to interrupt what he was doing, so he would order a piece of meat between two slices of bread. That way he didn't have to waste any time cutting up his meal.

"Roy, this is another thing I'm beginning to love about London," I said. "History goes back ages."

"Yes, we're just loaded with ages upon ages of history," Paul said, laughing. He really did like sharing what he knew about Soho. And we ate it up.

We stood outside the club entrance for a while, talking, as Paul and Roy smoked. These clubs were all so crowded and noisy, it was hard to have a conversation once we went inside.

The Scene was located at 41 Great Windmill Street.

"Before you ask, there used to be a great windmill here long ago. Hence the name Windmill Street," Roy told us.

"I'm beginning to see a pattern," I said.

"Used to be all jazz-like," Paul said. "The deejay, Guy Stevens, loves rhythm and blues and American records. You'll go mad when I tell you the Beatles and the Rolling Stones have been here to hang out and listen to the R&B records."

This was one of places the Beatles hang out in that I had read about in my Beatles magazine!

"If the *Ready Steady Go!* people are here, maybe you'll get lucky and be asked to be a part of their audience," Paul said.

"*Ready Steady Go!*?"

"Oh, right," Paul said. "It's like your *American Bandstand*."

"Guy has a regular R&B disc night at the Scene, but I don't think this is the night for it. Now he's a true mod, Guy Stevens," Roy explained. "Not sure if the *Ready Steady Go!* people are only here when it's totally crazy during one of Guy's R&B nights."

"The Beatles were on *Ready Steady Go!* in March," Paul said.

"The Stones were on, and loads of other big names. You'd love it," Roy added. "It's on Friday night. Haven't seen it in an age because Paul and I have been out clubbing every Friday while the weather is still good."

"There's no time for TV when there are so many great places to go in Soho," Paul said.

I didn't care. I'd seen the Beatles live at Cleveland Public Hall and hung out with the Stones in their dressing room. I didn't come all the way to London to watch television.

"Maybe we can come back to the Scene Club on Monday for Guy Stevens's Rhythm and Blues Disc night?" I said.

"Not recommended," Roy said. "Sometimes the crowd gets a bit rowdy. A few little unpleasant things have happened outside the club—and inside, too. Nothing too bad recently, but drinking and doing drugs has led to some pretty crazy behavior."

"Drugs?" I said.

"Amphetamines. Uppers," Paul added. "Some of the trouble-makers have been partying from Saturday to Monday night. They have a good time, and going home and getting a rest is the last thing on their list. They take the amphetamines to keep the party going."

I took Paul and Roy's words as gospel. I was not music crazy enough to intentionally put myself in danger. This wasn't my town, so I didn't know where *not* to go.

"Actually, during the summer the mods and rockers had some huge rows, but not near here, so not to worry," Roy said.

"Mods and rockers?" I asked.

"Mods are young people like yourselves, like us, who enjoy dressing stylishly, listening to the Beatles, and driving around on scooters," Roy continued. "Rockers are a scruffy lot who wear blue jeans, heavy leather jackets—like Elvis Presley—and tear around on motorcycles. That's the simplest way I can put it."

"Never been an Elvis Presley fan. I'm too young for that," I said. "Why would they fight over who wears a nice suit jacket or who wears a leather jacket and whether you like the Beatles or Elvis Presley?" I did wish I could afford a dressy leather coat, though. "So you're saying we're all four of us mods? Oh, I like the sound of it. So cool." I laughed. "Except where are your scooters?"

They both shrugged their shoulders and laughed.

"Roy's got a car. We don't need a scooter," Paul said. "Don't think you'd want to ride a scooter from Soho to Holland Park, right?"

"I've never been on one," I said. I was intrigued, though.

"Sounds cold and windy," Marty said.

The crowd of mods outside the club was growing. Now that I knew I was a mod myself, I started to feel right at home.

"It'll be okay tonight," Paul said. "I don't see any troublemakers around. Let's journey down to the depths of the Scene Club, shall we, ladies?"

He led the way as we walked past a neat line of parked scoot-

ers and pushed past the green doors that led to the Scene Club and headed down the stairs to yet another basement club. Music filled the room, and kids danced like they were at an endless party. Slow-dancing mods in love. Fast dancing. Cigarette smoking, laughing, and talking. As they say in London, it "seemed a bit of all right." We all had soft drinks. Paul and Roy smoked cigarettes.

"Paul, I hate to be a wet blanket, but after last night I'm running out of steam fast."

"We're here to serve," Paul said. "Roy, let's run these mod gals back to Holland Park."

Back outside our flat, we got out of Roy's car.

"Tomorrow's Sunday and I'm so sorry, but I need my allotted day of rest," Paul said.

"I need mine too," Roy added. "I just want to get a good night's sleep and be ready for Monday."

"Not sure what we're doing Monday," Paul said, as he wrote his telephone number on a card—again—and handed it to me. "Call me if you want to do something Monday."

I stood on the steps and watched their car until it disappeared into the night. It wasn't even that late in the evening.

"They'll probably just go to another club. It's too early for them on a Saturday night," Marty said.

We made cups of tea and sat down.

"What do you think is going on at home?" I asked Marty.

"I have no idea."

We both sighed a bit.

For me, it was not so much because I missed anyone, but because I wished I knew what was going on. I hadn't been at school or at home for days, and I hadn't telephoned anyone back home since we arrived ten days ago. Why should I call anyone, though? And who would I call anyway, Harry Martin?

I took a shower, put on my pajamas, and sat with another cup of tea while I looked out the huge window of our flat. A few cars,

two scooters (*must be a couple of mods*), and a motorcycle (*must be a rocker*), drove by.

"Much as I'm not into television," I said, "I wouldn't mind having one to look at tonight just to mindlessly unwind before drifting off."

"I agree," Marty said.

"I just remembered," I said as I jumped up.

"What?" Marty asked.

I pulled my wallet from my purse.

"I hope I didn't lose it."

Paul had paid for everything, so I had never gotten my wallet out. Why didn't I leave it at the flat so it would be safe? I opened my wallet, and there it was, the piece of paper with Mick's telephone number. Well, Tony's telephone number.

"Tony said to call Sunday because the lads will be back in London then," I said.

"The 'lads'? Aren't you becoming a little too British?" Marty laughed.

I started to drift off to sleep thinking about Mick. That Liverpool accent! He wasn't a Beatle, but everything about him was exciting. I pictured him with his gold chain and round medallion, black clothes, black boots with Cuban heels, blond pompadour, and unfiltered cigarette. I'd never met anyone like him in my life, and I loved it.

Of course, running into one of the Beatles or even seeing them hanging out somewhere in Soho—that was my real dream. It was going to be a major challenge. But my chances were still much better in London or Liverpool than Cleveland.

Yes, coming here was the right decision.

Oxford Street, our daily walking route. It was busy and bustling and I liked it: red double-decker buses, black taxis, motor scooters, and so many people! Marty and I sang Beatles songs as we walked.
© *Historic England Archive*

Chapter 32

"I WONDER IF I should call Mick."

It was much too early in the day. I put the kettle on to make tea. I had the tea-making thing down. At home, Toots drank tea. She would boil water, pour it from a kettle into a teacup that held a tea bag on a string with the tag draped over the side of the cup. I never learned how long the tea bag should stay in the cup, but when it was ready, Toots would use the tag to lift the bag out of the hot brown water, place it on a spoon, then wrap the string around the bag on the spoon to wring the last drop of tea from the bag. Then she added sugar and milk. Usually for lunch, along with the tea, Toots would take two slices of white bread, spread butter with a butter knife evenly across each slice, and layer strawberry jam across the butter.

She'd spread the newspaper in front of her on the kitchen table and read while sipping her tea and munching away on her strawberry-topped slices of bread. Sometimes I sat next to her and watched her out of the corner of my eye. I enjoyed the peaceful time together. When she finished, she would stand up, fold the newspaper, clear the table, and wash her dish and teacup before she headed off to another chore. She was a domestic whirlwind. At least when Mac was alive.

I felt confident in London. I knew I'd gotten us this far, and I could figure things out as we went along. So far everything had gone better than I could have imagined, but I wasn't able to plan

for anything beyond going to music spots and looking forward to being with Mick. I was always the planner, the girl with the ideas. But for some reason I didn't have any more plans, and that worried me.

We slept in late. It was almost noon when I awoke. Marty was still asleep. We were exhausted. It seemed like we hadn't stopped moving since our feet touched down on the sacred land of the Beatles. I "put the kettle on" to make a cup of tea.

"Marty, wake up." I called out.

"No."

We decided to take the day off and relax in our flat. We'd barely spent any time in it. I looked around and realized it was really cute. By the time we cleaned the place up and washed and ironed our clothes, it was time to make dinner. Spaghetti with spaghetti sauce again. With bread and butter and soft drinks it was a feast.

"I'm going to the telephone box," I called out. It was about eight o'clock. Maybe "the lads" were back in London by now. It seemed like a reasonable time to call Tony's number and find out.

"Hello Tony this is Janice how are you is Mick there?" I managed to say all in one continuous sentence. I held my breath. My heart pounded. I did my best to put on a smile so that I would sound upbeat if Mick was there and not too depressed if he wasn't.

Why was it taking so long for Tony to answer me? Was he still even there, or did he hang up on me again? I heard something, but it wasn't clear.

"He was here, but he's just popped out," Tony said. "Can I give him a message?"

"Will you tell him Janice called? Janice from America," I said.

"Right. Janice from America. Got it. Is there a telephone number?"

"Just the one on this phone in the telephone box."

"Give me the number," Tony said. "I'll see if I can get him to ring you back."

I read him the numbers printed on the phone dial.

"Can you wait by the phone box? Only thing—don't know when he's coming back."

"Thanks, Tony." I hung up. I waited for a little while, but it was getting chilly and dark. How long could I wait? I stared at the telephone. *Please ring, please, please ring.* Nothing.

I started to walk back to the flat taking the tiniest steps possible, then stopped, turned around, and stared at the red telephone box, hoping for a sign of life. Still nothing. A motor scooter was parked outside our building. I sat on it, hoping maybe that would bring me a bit of mod luck. The seat was cold, and I felt ridiculous, so I stood up and went inside—after one more glance at the red telephone box.

The next morning, I jumped out of bed, visited the WC, hurried back to the flat, showered, dried, and styled my hair (securing it with my trusty Aqua Net, of course). After a quick breakfast of tea and toast I was out the door. A sense of urgency propelled me toward the phone box. I didn't care if it was too early. I had to know what was going on. It had been days. The phone rang forever. A voice that was not Tony's answered.

"Hello."

"Mick?"

"Janice?"

"I was going to ring the phone box number," he said, "but when I found out you called, it was too late. I didn't think you'd still be waiting out there on the street when I found the note Tony left me."

"Oh, of course not," I said. "I just thought I'd take a chance and call you now before we get going today."

"Great. Great. How've you and your friend been doing?" Without waiting for an answer, Mick asked if we'd like to get together later with him and John. "We could meet for lunch," he said.

"That would be great!" I could hardly wait to see Mick. I had so much to tell him.

As I floated up from the Tottenham Court Underground station, there they were. Mick looking so Liverpudlian handsome in his all-black outfit and smoking a cigarette as always, hair perfectly in place, chain and round gold medallion resting against his black turtleneck. Just the way I remembered him.

"Hey!" Mick said. He gave me a quick hug. "Now how would you two like a bit of London sightseeing? Thought we might walk along toward Buckingham Palace. You shouldn't miss that spectacle. Have you seen it yet?"

Given the uninspired groceries in our kitchen, I was looking forward to having lunch.

"Will we stop for lunch before Buckingham Palace or after?" I asked.

"Of course!" Mick laughed. He was such a kidder.

We all started heading toward Buckingham Palace. We paired off, me and Mick, Marty and John. I turned around and noticed Marty and John lagging behind, deep in conversation. Before I knew it, they were father and farther behind us until they disappeared from my view.

"Don't worry about them," Mick said. "We'll all catch up later."

I had questions for Mick—where had he been, what had he done, where had he played, and every question a girl had for a boy. However, my childhood prepared me to ask no questions. So I just took in all the sights, not knowing where we were headed—other than Buckingham Palace and lunch somewhere along the way, I hoped. I was incredibly happy at that moment.

Mick and I both enjoyed walking. We strolled along lovely streets and skirted large parks. We hadn't made it to Buckingham Palace yet, but we could see it in the distance. I loved the connections to history that were everywhere in London. Aside from having Irish ancestry, I was sure I had English too. After all, my last name, Hawkins, was very British. I had wanted to know about my ancestors, but family members refused to talk about my "disgraceful" mother or the "drunken hooligan" she'd married, who

happened to be my father, so family was considered a topic best left alone. For me, it was another Irish Catholic mystery.

"There's the Thames." Mick pointed at the river.

"Where's Big Ben?"

I was having such a wonderful day. We even stopped at a food stand that had ice cream.

"You want ice cream?" Mick asked. He laughed. "Now, you haven't had a proper lunch yet. You'd best wait." He bought the ice cream anyway and handed it to me. His eyes twinkled like the sun, and his smile was warm and accepting.

We never actually got to Buckingham Palace, but that was okay. What mattered to me was spending every second together.

We stopped for a sandwich at an outdoor café. After lunch we walked about aimlessly and enjoyed watching what was left of some fluffy white clouds slowly glide across the blue sky. In late afternoon, we walked back along the river, looking at London Bridge.

"I'd like to walk across the Thames," I said.

"Ah, I knew there was something extraordinarily special about you," Mick said. "You can walk on water, can you? I'd like to see this." He laughed, and it was like music playing.

"Don't be such a silly!" I said. "I want to cross London Bridge."

"Oh, I get it," he said and laughed again.

I listened to myself and felt like I was in a British movie. When had I ever said that someone was "such a silly"? Never. I didn't know what was happening, but it was wonderful. I didn't remember feeling happier. There was a breeze coming across the Thames, and I closed my eyes to remember the moment.

Cherishing the moment reminded me of something that happened when I was in the second grade at St. Thomas Aquinas. My teacher was Miss Miller. She was beautiful and had the voice of an angel. In our geography lessons, one of the places we learned about was Rio de Janeiro, the capital of Brazil. When Miss Miller said Rio de Janeiro meant "river of January," it was like a beauti-

ful prayer. I closed my eyes and said to myself, "I will remember that Rio de Janeiro means 'river of January' all my life so that I will always remember this moment in Miss Miller's second-grade class."

Later that year, my heart was broken.

"Class," Miss Miller said, "I want you all to know that, as much as I love being your teacher, I'll be getting married soon, and I won't be teaching you anymore. I'll miss all of you very much. But you'll have a new teacher. Isn't that exciting?"

I didn't want to lose Miss Miller. She was kind and nice and beautiful. At that time she was the only good person in my life. She looked at me with a smile on her face all the time. No one ever did that before.

After school, I was inconsolable. I couldn't stop crying. I didn't know what I would do without Miss Miller in my life. I cried all the way home, and when I got home I even cried in front of my mother. I didn't care that she and her friend sat at the kitchen table drinking and making fun of me. My mother even called Toots. I must have been quite a spectacle. The next thing I remembered was that someone had called Miss Miller on the telephone, and the receiver was handed to me.

"Janice?" Miss Miller said, in her beautiful voice. In my mind, she was sitting in a lovely room in front of a window with lace curtains. Light-blue bows held the panels on either side of the window back just enough so I could see a tree with a bluebird sitting on one of the branches. A gentle breeze moved the curtains slightly. "Janice," she said my name again. "I hear you're terribly upset that I'm leaving."

"Oh, Miss Miller, please don't leave," I begged. "Please don't leave."

I sobbed and pleaded at the same time. I didn't think I had ever been this devastated. She explained she and her new husband had to move away from Cleveland for an especially important job, and that was the only reason why she wouldn't be able to teach at

St. Thomas anymore. She asked me to try not to be too upset, and she said that the new teacher was someone she thought I would like very much.

That never happened, though. I never had another teacher like Miss Miller. I still missed her. I was lucky to have known her.

I didn't know why Mick and the breeze off the Thames made me think of the beautiful Miss Miller. *I will never leave England*, I promised myself. *I will never forget this moment.*

"Well." Mick's voice broke my reverie. "It's been a lovely day, but John and I have had no sleep. We've been playing in Manchester. It's a bit far, but I wanted to make sure to see you as soon as I could. Why don't we plan on getting together tomorrow and hear some music somewhere?"

I told him that would be wonderful.

"Since you've been gone," I said, "we've been to the Marquee, the Flamingo, the Crawdaddy, Ronnie Scott's, and the Scene."

"Well, no grass is growing under your feet, eh?" He laughed.

"I heard that the Beatles go to the Crawdaddy and the Scene sometimes," I said. "Or is it the Flamingo? I can't recall. It's been a whirlwind."

"Pick one or two, and we'll go there again," he said. "There's always new groups, and you never know, maybe the Beatles will show up." He winked at me.

We headed back to the Tottenham Court Road tube station and found Marty and John sitting on a bench. They were sharing chips that were wrapped in a cone-shaped paper.

"We've been waiting for you two to show up," John said.

"Didn't you say half four?" Mick asked.

"No, we said to meet at four, but we don't mind, do we?" John said as he looked at Marty.

We all agreed to meet back here the next day at six and walk to Soho together. Mick and John faded into the distance as Marty and I walked down the stairway to wait for the train back to Holland Park.

Chapter 33

MICK AND JOHN were waiting for us outside the Tottenham Court Road tube station at six p.m. as promised. The day was a little chilly, and in about an hour it would be getting dark. I was concerned about getting back home on the tube if we stayed out too late—we hadn't ridden it late at night yet. But we should be able to stay out long enough to go to a couple of clubs anyway.

As we walked, I suddenly remembered Paul and Roy. Uh-oh! We were supposed to call them last night. Both Marty and I forgot. They knew where we lived and Roy had a car, so they could have driven by if they were concerned. Which they didn't. They could have left a note. No note, either.

But there was another concern: What if the four of us ran into the two of them tonight? Was there any chance they might all know each other? I doubted it. The pairs obviously came from different worlds. Mick and John were musicians and Liverpudlians. Paul and Roy were Londoners with regular jobs. No chance. Nothing to worry about.

I wondered when would I see Mick play. It was hard to hold back from asking Mick all the things I wanted to know about him. Where was this going? Girls always ask that. Except in my case. I had never met a boy who I wanted to know where anything was going with.

Usually it was the other way around. I got the questions. Where have you been? What have you been doing? What do you want to

do? All the questions made me feel like I just wanted to disappear.
I didn't want to lose Mick.

"What club do you fancy tonight?" Mick asked.

I left it up to him to choose because he knew all the fab clubs in
Soho. I hoped for the Marquee, but any club would be great with
Mick.

"How about the Marquee?" Mick said. He could read my mind.
I'd better be careful what I was thinking.

We went to the Marquee, where Mick and I listened to music
and danced a bit. He also talked to others who seemed to be in
bands.

"That's my mate, Rory," he explained. "We've played together
here and there."

There was a steady string of other mates he either pointed out
or introduced. "This is Janice. She's on holiday from the States,"
he said.

"Oh yeah?" one said.

"You know Mick, eh? Good bloke," another assured me.

The night went on like that. We went back to the 2i's for a
while. John and Marty talked and walked with us. The sidewalk
was crowded with mods talking, smoking, laughing, and taking
breathers from the hot, packed club basements. I was having the
time of my life, living in London, and hanging out in Soho where
everything was happening. I still hadn't spotted any of the Beatles
or Bill Wyman. But I was positive it could happen at any moment.
I was ready.

Around nine we started to walk back to Tottenham Court tube
station. The four of us walked along Oxford Street singing a few
Beatles tunes.

"Here's one of my favorites," Mick said. "It's all love songs and
fun with the Beatles. It's hard to pick a favorite, but I like 'It Won't
Be Long.' We used to go to the Cavern for lunchtime shows. Start
at about noon and go to about two. Then the evening would start
at the Cavern and go till about eleven thirty."

He turned to me.

"Have you been to Liverpool yet?"

"Not yet," I said.

"Well, what are you waiting for?" he asked with a laugh. It occurred to me that there was something behind that question and laugh.

I had a feeling we were going to Liverpool very soon. I held my breath, and my eyes got very wide. I stared at Mick. I started to smile. Mick continued to hold my gaze while he waited.

"Ahhhh! We're going to Liverpool," I said.

"Yes, love, we are," he said, "but there's sort of a situation about it."

"It won't be long—yeah," I sang out to the heavens. Finally, we were going to the birthplace of John, Paul, George, and Ringo: Liverpool.

"Wait! Situation? The situation is that I'm going!" I said.

"Have you ever hitchhiked?" he asked.

That set me back on my boot heels. I barely knew what hitchhiking was. I remembered a movie on Ghoulardi's *Shock Theater* where a woman tried to run from an alien monster. She tried to get a ride with a stranger to get away, but she tripped on a tree branch and fell. She just stayed on the ground and screamed and screamed. Not a great memory. But just a movie. I was quite sure I'd read in one of my *Teen Beat* magazines that Paul and George hitchhiked together as an adventure when they were teenagers. These young Liverpudlians were no strangers to hitchhiking, it seemed. Another of my other fave Beatles magazines, *The Original Beatles Book*, reported that John, Paul, George, and Ringo hitchhiked frequently. I never knew anyone who hitchhiked, but it must be common among Liverpudlians.

"Hitchhike?" I asked Mick. My enthusiasm was waning. I was adventurous, but I had never considered hitchhiking, not ever. I never needed to. In Cleveland there was plenty of public trans-

portation. I only recalled traveling farther than the suburbs once, when Margie drove us to visit Mac's son in Massillon, Ohio.

"I know how much you and your mate want to get to Liverpool and see the Cavern Club," Mick said. "John and I want to get you there. Between the two of us we have no car, and the train would be costly and you two are counting your shillings."

He was right. I had told him we had a limited pot of money, and we'd soon be looking at the bottom if we weren't careful.

"Tony would drive us partway outside of London at least, and we'd hitchhike the rest," Mick continued. "Hitchhiking is quite common here. Besides, you shouldn't go on your own to Liverpool anyway. It can be a bit dodgy."

"Dodgy?" I said.

"If you don't know your way around, it could be a bit confusing," he explained. "It's not all modern there in some places. A bit rough. There's some unruly kids about."

"I trust your judgment on all things Liverpool," I said.

Mick cast his baby blues down a bit. Was he blushing? Oh, he was so sweet. Anyone who loved the Beatles and knew about Liverpool and the famous Cavern Club was special in my book. Got to get Liverpool and the Cavern Club into my life. If hitchhiking was good enough for the Beatles and Mick and John, it was good enough for me, too.

Liverpool was where the Beatles had been discovered by Brian Epstein and where the River Mersey flowed. I knew this from all the magazines I'd read back home in Cleveland. I had also read in *The Original Beatles Book* about the beat scene at a Liverpool club named the Jacaranda. The Jacaranda came before the Cavern, so it was part of the development of the Beatles. But the Cavern Club on Mathew Street was the main site for the birth of the Beatles. The Source. The teens in Liverpool had it made. They'd been able to listen to the Beatles from the very start. They could go to hear them play during their lunch hours. Can you imagine being able to

go to the Cavern Club and dance to the Beatles and then go back
to work or school?

"Mick, when are you thinking of the trip to Liverpool?"

"Me and John have been working that out," he said. "I think we
have it. But first let's get on over to a club you haven't seen yet. The
100 Club."

"Let's go."

We walked over to 100 Oxford Street and entered the 100 Club.
It was packed with people listening to music and dancing. The
stage was small. Next thing I knew someone from the stage called,
"Hey, Mick! Where've you been, mate?" He gave Mick a hand up,
and Mick grabbed a guitar and played with the band for a few
tunes.

"Oh my gosh, you're fantastic," I said when he jumped down. "Is
that your band or what?"

"I play with them a bit here and there, but I'm not a regular.
That's sort of what I do—play around with different groups, here
and there for now, until I get settled in one. I played down at the
Cavern the same way. One of my mates and I had hopes of getting
something going, but he got married and became a regular bloke."
Mick laughed. "There's loads of blokes wanting to become profes-
sional musicians in Liverpool. Don't know, maybe it's the water in
the Mersey?"

"I think the Mersey might be the holy water for musicians,"
I said. "Just think of the British Invasion coming ashore in the
United States. The Beatles, Gerry and the Pacemakers, and all the
rest."

"Yeah, well, I'm doing studio work right now and liking some
of the technical bits. That's why I'm staying with Tony in London."

I was beginning to put some of the pieces together. I was glad I
hadn't asked Mick any probing questions from the start.

"Are you up for an adventure?" he asked.

"I think so, but I'd like to hear more of the plan," I said.

"Okay, well, Tony's got to go and see his mum in Birmingham,"

Mick explained. "He can drive us that far, and we can pick up a ride all the way into Liverpool. Easy to do. Birmingham's about halfway.

"The part I'm not happy about is that I have to get back to London the next day," he continued. "There might not be enough time to see the Cavern open. But no worries, me mate George is going to drive you girls back. If we don't make the Cavern this time, we can come back. Tomorrow around four, we'll pick up you girls and we'll be on our way," he said. "Dress warm, wear walking shoes, and don't worry—we'll take care of you."

I was very sure of that.

Chapter 34

"ARE WE SERIOUSLY doing this? Hitchhiking and this crazy overnight trip to Liverpool?" Marty said.

"Well, of course," I said. "This is our big chance to see a little something of Liverpool and hopefully the Cavern Club. It's not that crazy—look at all the adventures we've had already in just fifteen days! Plus, once we get jobs, we'll have enough money to take a train to Liverpool and stay a few nights at a hotel. It'll be fantastic. At least this way we can get a preview of Liverpool."

"Jobs?" Marty said. "You have an actual plan now for getting jobs?"

"Well, not yet, but I'll be working on that next," I said. "I'm still hoping Brian Epstein might need someone or maybe even George Martin. They're so busy they probably need extra help."

I didn't believe a thing I had just said. I had no plans for jobs. There were no plans beyond today and tomorrow. There was no point in thinking about that right now. The only thing I planned for was breakfast.

The next morning we ate breakfast, cleaned the flat, and prepared for our journey on the road.

"Liverpool and the Cavern Club—yes. But hitchhiking? Uh-uh. I'm not going to do it," Marty announced around lunchtime. "It's too cold, and I just don't feel up to it."

"Miss out on the Cavern Club and Liverpool? You can't be serious," I said, surprised. I studied her for a moment and real-

ized she was serious. "You'll have to explain it to John. You know they're doing this just for us."

I was not happy about this sudden decision.

"Well, I'm going," I said.

About five thirty, a bit later than anticipated, the lads drove up. Mick and John got out of the car. They both wore long coats with capes attached. I got in and waited for some fallout when Marty explained to John she wasn't going. John must have been very convincing, because Marty went back inside then and came out dressed in slacks, sweater, boots, coat, and scarf, and got in the car.

Tony didn't look particularly thrilled, but then he never did. He was all business. John sat in the front next to Tony. I sat in the back between Mick and Marty. Mick turned and smiled at me. He lit a cigarette and blew the smoke out in a perfect ring. I wore my black slacks, socks, boots, two sweaters, a long coat, and a scarf.

My umbrella seemed a bit much to carry on the trip, so I had left it leaning against the wall near the door of the flat. The previous week I'd taken my umbrella along to Soho. For as long as I'd had my expensive Harrods umbrella, I hadn't even opened it—only once while I waited for the tube at Holland Park station, just to make sure I could. A tall, stately gentleman dressed in a dark-gray suit stood near me and watched as I fumbled with the umbrella. I got it partly open and decided to close it.

"Pardon me, miss," the gentleman said, "if I may be of assistance?" He looked at my umbrella. "May I show you the best way to roll your umbrella? If it's rolled properly it will look quite thin and unobtrusive, and also it'll wear well and last twice as long."

I handed him my umbrella. I'd seen him before waiting for the train and decided he must be a businessman of some sort.

"Do you have the cover for the umbrella?" he asked. It was somewhere back at the flat.

He held the umbrella by its pointy tip with his right hand. With his left, he moved the folds of the umbrella around from top to bottom as he twirled the umbrella. In a few seconds he'd worked

around to the bottom. It looked as neat as the day I bought it. He fastened the loop and held the umbrella up in front of him so that we could both admire the fine umbrella-rolling results. It was a thing of beauty.

He handed it back to me.

"That was wonderful," I said. And I meant it.

"Not at all."

No one would ever guess from the state of my umbrella that I was an American.

As Tony drove us out of London, he said, "I'm sorry I can't take you all the way to Liverpool. My mum is out of sorts and I'm the only child. Duty calls. Not to worry. Mick and John will take excellent care of you. The lads hitchhike frequently. It's common. It's illegal on motorways, but Mick and John know their way around."

They both had a good chuckle at that remark.

"Americans hitchhike frequently here and in Ireland and Wales. Europeans, too. It's a great way to get around," Tony concluded.

I didn't want to get around; I just wanted to get to Liverpool and the Cavern Club and stand on the sacred ground.

I'd heard that the Beatles were still someplace in England since their return from America, but where? It was possible they were in Liverpool.

A song started moving through my brain. *Hitch hike. Hitch hike, baby.* I remembered the song was by Marvin Gaye, and the "hitch hike" was a dance move that a lot of kids did.

"Have you ever heard of Marvin Gaye?" I asked.

"Listened to his records. R&B, right?" Tony said. "A bloke at Ronnie Scott's has some of his records."

"I was thinking of him because of his record 'Hitch Hike.' Did you know there's a dance called the 'hitch hike'?" I said. "I hope we don't have to do the dance to get someone to give us a ride."

"Well, if we do, we'll probably get a lift by someone with a great sense of humor," Mick said.

"They'll think we're doing a movie," John laughed.

At about eight thirty, Tony dropped us off alongside a country road that ran parallel to the motorway. It was dark outside, and I didn't see any houses or streetlights.

"Where are we?" I asked.

"Just about halfway," Mick said. "This is a good spot to get a lift."

We started walking, two by two, along the country road. It seemed like we walked forever. I was getting tired. No cars came along at all. It didn't look promising. It must have been eleven o'clock. If I didn't pee, I was going to burst.

"Is there a restroom anywhere along here?" I asked.

"Where there's no ladies' or gents', we just use nature's," John said.

Marty and I took turns behind some shrubbery.

"That's a first," I said to Marty. She scowled a silent message that said, *See, I told you so.*

"Think of it as an adventure we'd never have in Cleveland," I said.

"You mean Cleveland, where they have bathrooms," she said.

As long as we were in this odd situation, I told myself, there was safety in numbers. With the four of us it would be okay.

Mick and John discussed whether we should go on and hope for a lift or just get some kip and wait for morning when people would be driving into work. I hoped *kip* meant finding a restaurant and getting something to eat.

"We'll kip down for the night and start when the sun starts to break. The crack of dawn," Mick announced.

"What does any of that mean?" I asked. The two of them opened their backpacks and took out blankets. Mick took off his long raincoat and placed it on the grass away from the road.

"We can lie down here and get a bit of rest," Mick said.

"Is that what *kip* means?"

Mick laughed.

"Yes, American girl, kip means get a bit of rest or sleep."

"But who owns this property?"

"It's just farmland. Can you see the tall shoots going on as far as your eye can see in the field?"

I couldn't see what he was talking about. I saw a dark, huge, green field that had no ending. I didn't know how he could see anything.

"Won't the farmer be mad we're sleeping in his field?" I asked.

"Don't you worry. He'll never know we've been here."

I lay down on Mick's waterproof coat. He unfolded the blanket and covered us both. I put my handbag between us.

"Look up at the perfect sky," he said. "See all the stars?"

I'd never seen such a sky. There were no lights on the road to interfere with the clear, twinkling stars. I could almost feel the earth slowly moving on its axis.

The moon was like a crescent-shaped almond cookie. Toots always had a plate stacked with these cookies at Christmas. I would miss Christmas at home.

I remembered a Christmas card I'd made for Toots when I was in grade school. It's not easy to find a word to rhyme with Christmas, but I came up with the perfect word and wrote on the card "I Would Cross An Isthmus To Say Merry Christmas To You." I went to our library on Coventry Road to find a picture of the Panama Isthmus. I wanted Toots to be surprised, so I made my card in the library. I filled the front of the card with my drawing of the Isthmus of Panama and wrote my Christmas wish to her on the inside of the card. I signed it, "Love, Janice." I handed Toots the card and thought she would be proud.

"What's this?"

"It's a Christmas card I made for you, Toots!"

"Well," she said, "it doesn't look like any Christmas card I've ever seen." She tossed it aside.

Chapter 35

TORN LETTERS A CLUE IN MISSING GIRL HUNT

Cleveland Press—October 1, 1964

Cleveland Heights police detectives have pieced together letters found in the wastebasket of one of the two missing 16-year-old Cleveland Heights girls that may provide the means for locating them in England.

Detectives found bits of two letters and envelopes in the bedroom wastebasket of Janice. Painstakingly piecing them together, they found one letter was to a Miss Annabelle Smith, 93-97 Regent St. London.

In it, Janice told Miss Smith she had met the Rolling Stones, another English singing group, while they were performing here. Janice said she wanted to join the Rolling Stones fan club, of which Miss Smith is president. She also told Miss Smith she expected to come to England in September to live permanently.

Detectives learned Janice dated one of the Rolling Stones, Bill Wyman, while they were here.

The envelope was addressed to Wyman. The other letter was addressed to Bryan [*sic*] Epstein, manager of the Beatles, asking him to provide jobs for Janice and Martha when they arrived in England "with references."

Heights police are forwarding Miss Smith's address to the State Department to help in the search for the girls.

Chapter 36

I MUST HAVE drifted off. When I opened my eyes, Mick was awake and smoking a cigarette. The sky was starting to get a little bit light on the horizon. The green fields and the grass were draped in a white mist. The air was still, and I felt at peace. It was a little chilly, but the blanket kept me warm and Mick's coat kept me dry. I was a bit stiff, but I stretched. Oh no, my hair must be a wreck! I tried to fix it without benefit of a mirror. Then I remembered with great relief that I had my compact with a mirror in the makeup bag in my purse. I sat up, resting on one arm.

Mick held something in his hand.

"What's that?" I said.

"Meat pies. I brought them for us to eat on the way," he said.

I felt warm, glowing feelings about Mick. He almost made me forget about the Beatles. For the moment.

"I'm taking some of the cold out of them by warming them in my hands." He placed one in my hand. It felt very romantic. They were miniature pies with pinched piecrusts. "I didn't make them. Picked them up at the shop," he said.

They were delicious. I ate two. So did Mick. I glanced down the field and saw John and Marty were also awake.

"Morning, mate," John called out.

A driver passing by stopped and picked us up about six a.m., an older man who looked to be retired. He was going all the way to Liverpool.

"I can drop you off wherever you like. I'm very early going," he said. "I'm glad for a bit of company. My son is at University of Liverpool in the music department. Going to spend a week with him while the missus is on holiday with her friends in Italy. They go somewhere every year. Last year it was a cooking trip to France. I saw enough of other countries during the war. Very happy to stay right home in England. He has a small flat here. Tiny would be a better way to describe the size of it. I get up to see him whenever I can."

"Liverpool is the greatest place for music," Mick said. We all agreed.

"Oh yes, I like to get out and hear a bit of music myself while I'm there. Have a few pints, too, I don't mind sayin'."

We all chuckled. His name was Malcolm. He wore round glasses and a flat cap and was wiry and spunky, like John McCartney, Paul McCartney's fictional grandfather in *A Hard Day's Night*, but a bit younger. I wanted to hear him say the word *book* and pronounce it *boook* the way Paul McCartney's grandfather did in the movie. John McCartney was one of the funniest characters in the movie. I loved watching him run away and have the time of his life . . . until he finally got arrested for trying to sell photos of the Beatles with forged signatures.

"Well, here we are," Malcolm said. We were in Liverpool. John asked him to drop us off at the Albert Dock.

There were so many places I hoped to see in the short time we'd be in Liverpool.

"Janice," Mick had told me before we'd started out the day before, "we have work to do in Liverpool and won't be going back to London until tomorrow. I've got you a ride all the way back to your flat with my mate, George."

When I heard the name "George" I automatically thought of George Harrison. But this was not George Harrison or even George Martin.

"He's a solid bloke," Mick continued. "I've known him all my

life. Nothing to worry about. Good driver and all that. The only thing is, he has to leave Liverpool at about eleven. The Cavern won't be open until the lunchtime show, at noon or twelve thirty, but we can walk around Mathew Street where the Cavern is."

I was heartbroken, to be honest. We'd only be in Liverpool for a little over four hours. Worst of all, the Cavern wouldn't even be open. On the other hand, I was in Liverpool.

"Do you think the Beatles might be here?" I asked.

"They're back in England, I know," John said.

"They have to keep out of the public eye or they'll get mobbed," Mick said. "But they have family to see. This is their hometown."

"I'm going to keep looking for them. They could be in disguises," I said.

Mick and John gave each other a quick look of amusement. Mick looked at me with a smile and a wink.

You couldn't read anything in magazines about the Beatles and Liverpool without a mention of the Mersey and, of course, the Merseybeat style of music.

"There's the Mersey," John said as he stuck out his chest and inhaled deeply.

We walked along the Albert Dock, following it along the river and watching the sun sparkle on the water. There were all sorts of boats on the water. Some were bigger than I had ever seen and were docked sideways. Tugboats and ferries glided slowly along.

"You've heard of the *Titanic*?" John asked. I nodded. "Well, the White Star Pub is named after the White Star Line. *Titanic* was their ship. The ships used to go back and forth between Liverpool and New York with passengers and cargo.

"Blokes working on the ships brought American records that they liked back to Liverpool. Liverpool would get first crack even before London. That's why it's called the Merseybeat."

I loved knowing that Liverpool was connected to America by music.

"Do you listen to skiffle in America?" John asked.

"Skiffle?" I said.

"You've never heard of it?" he said. "It's kind of like rhythm and blues."

"John and Paul had a skiffle group in the late 1950s," Mick said. The Quarrymen. I knew that.

"Paul was interested in skiffle and went to see the Quarrymen play at a church. That's how John and Paul first met."

"The war destroyed a lot of Liverpool," Mick said. "We grew up with it. Not much work or money for a lot of blokes. Young people had to leave school to get jobs. Skiffle didn't need fancy instruments. It started with a bloke singing and playing a guitar. Maybe a washboard, maybe a harmonica, some big wooden tea boxes for drums. No one could believe the Beatles made it big-time in America. Every guitar player wanted to make it big too. But it all started with skiffle."

I had listened to rhythm and blues records all the time before the Beatles came along. I checked them out of the library. I loved R&B even though it wasn't popular.

My mind was overloaded with World War II, Liverpool, kids leaving school to get jobs and making their own music, and how the Beatles were right in the thick of it. This was their home and their life. The way John and Mick explained it, though, I felt that I could relate to the kids in Liverpool. It could easily have been my story, too.

We didn't have much time in Liverpool, and I was feeling desperate to see the Cavern Club. But I was also tired from hitchhiking. I needed food and tea and someplace to sit down. I sat right down on the grass in a small park nearby. The little meat pies had been delicious, but we'd eaten those so long ago. I needed a lot more of them—and a big mug of tea with milk and sugar to chase away a bit of the cold that I still felt from sleeping out in the open.

"What's wrong, love?" Mick said as he knelt beside me.

"I *have* to eat. Is there a coffee shop within crawling distance?"

"Let's start walking over to the Cavern Club area." Mick took

my hand. "Come on, up you go. I'm sorry we won't get inside the Cavern this time. But next time we will for sure. It's not too far."

The four of us walked through a busy section. People were rushing around to work, school, and shopping. Liverpool wasn't as nice as London, even though many of the buildings were huge, ornate, and grand, and had statues carved out of stone. Where did this Liverpool downtown end, and where did the residential part begin? Where did the Beatles live? I imagined Paul, John, George, and Ringo walking around, going to pubs and coffee bars, and carrying their guitars and drum sets to the Cavern. I didn't know how large or how spread out Liverpool was. When I got back to London, I'd go to the nearest library and find a map of Liverpool for the next visit.

We walked into a cozy coffee shop. The waitress, a small young blonde, knew Mick and John, but I wasn't surprised. In fact, it made me feel like we were in Mick's hometown. And Mick's home-town was the Beatles' hometown. I kept looking around hoping to see a Beatle. We devoured eggs, buttered toast, and tea, and then we were out the door, back onto the streets of Liverpool. I could tell it was early; not many shops were open. There was a lot to see in the short time before George would arrive.

"Here's NEMS Record Shop," Mick announced.

"Oh, I know! This is Brian Epstein's record store," I squealed. "Let's look in the windows. Maybe we'll see him come in to open the store."

"No, he doesn't do that anymore, since the Beatles," John said.

The Original Beatles Book had told me that when the Beatles first became popular in Liverpool, NEMS, the music store Brian Epstein owned on Whitechapel Street just down the street from the Cavern Club, was deluged with requests for their records. Epstein walked down to the Cavern Club to see and hear them for himself. He recognized their greatness, dressed them in Pierre Cardin collarless suits, and recorded a tape of them performing.

Through the store windows we saw all sorts of records. There

was a display with pictures of the Beatles for sale, and another display of greeting cards.

"Marty!" I said, "when we come back, we can apply for jobs with Brian Epstein right here. Not to work at NEMS, but hopefully we can get something in London."

She rolled her eyes.

We continued to walk and passed the White Star Pub and another pub called the Grapes.

"John and I have been here at the White Star Pub when the Beatles have been in having a pint or two or three," Mick said. "You'd come over all dehydrated and thirsty after the Cavern Club, because they don't serve any alcohol over there."

I was walking on the very same streets the Beatles had walked not so long ago.

"And the Grapes?" I asked.

"Yeah," John said. "The Grapes is where Pete Best came to drown in his cups after being fired as the Beatles drummer in favor of Ringo. A sad tale for him."

"He's a good drummer," Mick said. "He'll be back on his feet."

Mick asked us if we had ever heard of the Casbah. I recalled it was mentioned in one of my Beatles magazines.

"Early days," Mick went on, "before they were called the Beatles, they were the Moon Dogs, the Quarrymen, and the Silver Beetles. They were still the Silver Beetles at the Cavern Club, but they couldn't break through the loads of bands in Liverpool. The competition was insanely rough. Still is. Everyone packed into the same places trying to make it."

"Where did they grow up?" I asked. "I mean, where did they actually live?"

"Paul, I think, still has his house on Forthlin Road in Allerton," John said. "John might still live in Woolton by the park over there. George is in Speke on Upton Green. Ringo . . . I'm not too sure— the Dingle, I think. A dodgy part of town."

"Pete Best's mum said the group could practice and play in the

basement of her house," John said. "Big house. She saw a story on the telly, how some musicians played at the 2i's and got discovered. She decided to turn her basement into a dues-paying club, the Casbah. Musicians and crowds packed the place. She was trying to help Pete."

"Everybody lined up to get in to hear the Beatles play," Mick said. "The Casbah cellar had a place for the band against the back wall, a dance floor, and an espresso coffee machine—the only one around. Every Saturday night it was the place to be. Gerry and the Pacemakers played there. Cilla Black, too."

"I had no idea," I said. I hadn't read much about the Casbah in the Beatles and teen magazines.

"Actually," John said, "the Beatles got their real start at the Casbah and not the Cavern Club."

"Is it nearby? Can we walk over and look at it?" I asked.

"No. Pete's mum closed it just about two years ago when she got pregnant," John said. "It's a shame she couldn't keep it going, but it was all her running everything. It seemed to happen about the same time Pete got kicked out of the Beatles."

We walked along Mathew Street. It was a long, narrow alley with cars parked on one side of the street. The buildings were made of dark bricks with only a few signs. It looked industrial but had atmosphere for sure.

"There it is, ladies," John announced. "The famous Cavern Club!"

The club was closed. It might have been a powerhouse inside, but it wasn't much to look at on the outside. I stood across the street from the empty entrance and stared at it, wishing it would come to life. The life, I realized, came from the bands and the music and the kids who went there. It was a workday.

I watched all the lucky people walking past, people who could come to the Cavern on their lunch hour or after work anytime they wanted to. I envied them. How could I be this close and have to stand here imagining what it would be like inside? But at least I

saw the sign. "Cavern Club." *I'm coming back here no matter what I have to do.*

"We'll be back soon," Mick said. "Think of this as a preview."

We walked around the streets of Liverpool for another hour or so. George was to pick us up at eleven on the corner of Mathew and North St. John streets. As we stood on the corner, none of us knew what to say.

"So, we'll be back in London at Tony's tomorrow early afternoon," Mick said. "I've got a studio gig in London."

We decided to meet on Friday at about six outside the 2i's.

"Ring us at Tony's," Mick added. "Don't know if anyone will be there to answer. Give us a try if you can. But just the same, we'll see you then."

Mick had his hands in his pockets and looked down. I knew he was going to miss me.

"Mick, John, thank you both for this," I said. "I know you didn't have to do it." If only I could give Mick a hug, but that would be too much, so I babbled on. "What a great adventure. Hitchhiking. Seeing a bit of Liverpool, the Cavern Club, the Mersey, hearing about the Casbah, skiffle. I learned so much just in one morning."

I sounded like an idiot or like I'd never see Mick again, as if I were boarding a White Star liner headed back to New York. I was running out of things to say but tried not to forget to thank them for all they had done. They were two wonderful blokes, as they say. I felt lucky to have met both, but especially Mick.

"Hey, there's George!" John called out. They waved at him, and he pulled over. "These are the birds we told you about."

"Now don't mind George, just because he's an ugly bloke," Mick said. They all laughed. "You'll take good care of them?"

"Course," George said. "Right and we're off to . . . is it Lansdowne Road in Holland Park?"

I let Marty sit up front, and I sat in the back seat behind her. George, of course, was in the driver's seat on the right-hand side. I was getting used to the wrong side of the road. If I ever went back

to the United States, I knew I would think that Americans were driving on the wrong side of the road.

I wanted to sit in the back seat and spend my last moments drinking in the sights of Liverpool and Mick. I turned around and looked out the back window. Mick stood on the corner. I waved and he gave a little wave back. The lunch crowd rushed and hurried around him as he stood like a statue watching us drive away. I watched him until I couldn't see him anymore.

George was a bit older than the lads. He had blond hair that draped in a loose curl on one side of his forehead. Light eyes, a chiseled, dignified face with a wide, warm smile framing beautiful, straight teeth. He was easygoing and already seemed like someone I'd known for a long time. He wore an off-white, long-sleeved, cable-knit sweater with a white button-down shirt underneath, forest-green pants, and, of course, those black ankle boots. Did every man in England wear black ankle boots? Well, if they did, I liked it.

George wound through Liverpool quickly, and we were out of the city and onto some highway much too soon. The scenery all started to look the same: green trees, green bushes, green grass, green bushes, and green trees. I leaned forward a little and to the right so George could hear me over the engine.

"George," I asked, "are you from Liverpool, too?"

"Oh yes. I've known Mick and John for many years. Family still here, but I mainly work in London now."

He didn't add any information, and I didn't ask. It was too difficult to hear without him shouting. I hoped he'd volunteer what he knew about Mick's life. George and Marty chatted, and I tried to listen, but the drone of the car engine made it impossible to hear anything of interest. I picked out a word here and there. Since it was impossible to add to the conversation, I sat back and daydreamed about Mick, Liverpool, and the Beatles.

Why couldn't I have come up with a way to stay in Liverpool? But I had no money for that. And there were other reasons. Practi-

cal ones, such as needing a toothbrush and a change of underwear and socks! I wanted to get back to the flat. I felt my eyelids closing. I was powerless to keep them open; I surrendered.

"Are we keeping you awake? Janice?"

I woke up to the sound of George's voice.

"Sorry. I guess I dozed off."

"Let's stop for a bit of lunch," George said. He pulled off the highway onto a rambling road that led to an old pub right out of a picture in a history book. The interior featured lots of dark, carved wood and stained glass as if we were in St. Ann's Church, plus red leather seats and chair backs, the leather hammered into place with gold-colored tacks. The long bar had a beautiful mirror, hanging glass mugs, and bottles of liquor behind it.

"This looks expensive," I said.

"Leave it to me. I'm loaded," George replied. "Besides, a lady never pays in a gentleman's world. I can't have Mick and John's best girls going hungry now, can I? Well, they'd never let me live it down. Unheard of!"

Marty and I looked at each other. *Best girls?* Maybe George knew a lot more than we did. George was a charming gentleman, but I wondered if there was any truth behind that statement.

"First thing, pints all around."

"Beer?" I asked.

"Of course! You can't come into a pub for lunch without having a pint. Beer is one of the things that Brits do best. Now what's your pleasure?"

"Something not too strong."

"I know just the thing." He ordered three pints. The huge mugs came with light-brown beer and a thin layer of white foam across the top. George's beer was very dark.

"Is that just one pint?" I asked. George laughed heartily.

For lunch I ordered a cup of pea soup and the most delicious cheese sandwich I'd ever had in my life. The slice of cheese was as thick as a bar of soap, and the roll was round and soft and warm. I

cut into the butter on the table and slathered it onto the roll. What
could be better than warm buttered bread with a huge chunk of
cheese? With the pint, the soup, and the sandwich consumed, I
felt renewed. The next thing I wanted was a soft bed and a long
nap. This wonderful trip to Liverpool had taken it out of me.

We got back in George's car, and it seemed like only a short
time before we arrived in Holland Park.

"Which one is yours?" George asked.

Liverpool had produced the nicest group of people I had ever
met.

"George, thank you so much for everything. I don't know how
we can pay you back," I said.

"Nothing to it!" he replied cheerily, and he was off.

I forgot to ask him where he was going. I didn't even find out
what kind of work he did. I wondered if he was a musician, too.

An envelope had been pushed partway under the front door to
our flat. "Janice" was written on it. The handwriting was neat, the
envelope was pale yellow, and the ink was blue. Fortunately, our
shillings still held up and the electric was on. I pulled off my boots
and sat down. The letter didn't look official. We were paid up on
the weekly fee, and the WC chain and handle were still in place.

"Open the letter." Marty said.

Of course, that's what I should do. I tried to think who could
have left a letter for me. Someone who knew where I lived and
knew my first name. I was with Mick the whole time away. Tony
wouldn't have left a letter. Why would he want to leave me a note?
I couldn't think of anyone. I set the unopened letter on the table.

First, I decided, I needed to change my clothes, brush my teeth,
and clean up in general.

"Tea?" I asked. I made tea and put a few biscuits on a plate.
There's another word I learned. Biscuits in England were cookies
in Cleveland.

I sat back in one of the comfortable chairs, put my feet up on
a footrest, and, with my tea and biscuits sitting on the little side

table, I looked at the envelope again, trying to divine its contents. I turned it over to see if anything was written on the other side. There was no return address. I carefully peeled back the V-shaped envelope flap to reveal a card. I pulled the card from the envelope. "It's from Paul!" I immediately felt a pang of guilt. I'd forgotten all about him. I read it out loud to Marty: "Janice—been wondering where you are. Roy and I haven't seen you or Marty around the clubs. You must be touring around having a smashing time. Hope to see you. Ring me. Paul." He wrote his phone number under his name.

This was getting a little complicated. I got in bed, pulled the covers over my head, and fell asleep.

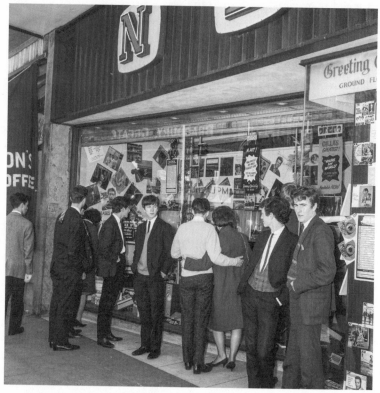

Brian Epstein's NEMS record shop on Whitechapel Street (just down the street from the Cavern Club) in Liverpool, 1964. *Trinity Mirror / Mirrorpix / Alamy Stock Photo*

Chapter 37

TWO CLEVELAND HEIGHTS BEATLE FANS
ARE STILL IN ENGLAND AFTER 18 DAYS

Cleveland Press—October 3, 1964

Now 18 days have elapsed since these two 16-year-old Cleveland Heights girls, who may be the world's No. 1 Beatle fans, set out on their $2000 pilgrimage to England. . . .

Now the belief is that the girls—who left with their winter clothing—are somewhere in the Soho section of London or in Liverpool.

Why Soho? Well it was in the Soho cafes that Brian Epstein, Beatles manager, discovered the four barbershop fugitives and guided them to international fame.

Miss [Margie] McBride has been busy writing people in England who might encounter Janice—the Catholic Diocese of London (Janice is a devout Catholic), Beatles manager Epstein, police and hotels in Soho and Liverpool.

The State Department has contacted London police at the request of Heights police. Circulars are being prepared for distribution throughout England.

But as Police Chief Edward Gaffney pointed out, the girls must still have enough money to finance them for awhile. And, he reminded, they took along their winter clothing.

Chapter 38

AS SOON AS I woke up the next morning, my first thought was Mick. *I can't wait to see him again.* Our shillings had run out, and so had the lights. The bowl near the door was empty, and neither of us had any change. Marty said it was her turn to get change and popped out. She came right back, jingling coins in her hands. We were back in business.

"I just ran into the neighbor down the hall," she said. "The one we share the WC with. He's an older gentleman. He asked if we got the letter that was left at the front door. He was the one who found it outside and slipped it under our door. He said if we ever run out of coins to just ask him. He said he's a 'pensioner,' so he's home most of the time."

"Pensioner? That must mean he's retired," I said. I was getting good at translating.

We couldn't start relying on the pensioner next door to supply us with coins when our money started to run out. I didn't know how much we had left, but we'd been here almost eighteen days. I regretted that we'd spent a huge amount on two nights in a London hotel, but there was no undoing that expense now.

What sorts of jobs could we get? It was unlikely that we would be able to get back to Liverpool, drop over to NEMS record shop, see Brian Epstein, ask him for a job in London, and get hired on the spot. Could an American even get a job in England? I hadn't thought about that during the planning phase, and I wasn't think-

ing too hard about it now. I could figure out something later; tonight we were meeting Mick and John on Carnaby Street. We'd find something to eat, and I wouldn't mind fish and chips again. Then we'd head over to the Marquee Club. *What a night it will be!*

At about three thirty, Marty and I made our way to the Holland Park tube station for the ten-minute ride to Tottenham Court Road tube station, then walked the familiar route from Oxford Street to Carnaby Street. We didn't see Mick and John at first. I began to wonder.

"Sorry we're a few minutes late," Mick said when they arrived, "but we got held back a bit."

"Oh, it's just good to see you," I said. That was putting it mildly.

We turned onto Great Marlborough Street, and they walked us to a lovely-looking place painted dark green on the outside. The sign above the door read "The Coach & Horses."

"Think you'll like it," Mick said.

Over fish and chips and pints, we talked about Liverpool, the Cavern Club, the Casbah, and of course the Beatles.

"So," John said, "tell us who's your favorite. No lies. Every girl has a favorite Beatle. The cute one, the quiet one, the sarcastic one, or the funny one?"

We all laughed.

"Don't tell, Marty," I said. "Let them try to guess, but they'll never figure it out."

"Come on now; there are only four. One of our guesses will be right," Mick laughed.

We were having such a great time, but there were many things they didn't know about our situation. I felt like I was lying to Mick just by being here. He had been so wonderful—so innocent and trusting. It didn't seem fair, but if I told him why we were really here, that we weren't just on vacation, it might ruin everything.

As we walked along Carnaby Street that night, I felt right at home, part of the mod scene, absorbed into the fun and laughter of a Friday night in Soho. The Marquee was packed, but we got

in and danced to music so loud that no one could hear anything anyone was saying. I looked into Mick's eyes and saw sparks of happiness flashing. I forgot about everything but Mick and the music.

The boys rode with us all the way back to Holland Park. It was extremely late by the time we got there.

"We can sleep anywhere, as you could see by our hitchhiking skills," Mick said. "Would you mind if we just take a small rest in the hallway outside your flat?"

"Are you serious?" I said.

"Don't worry," he said. "We'll be gone by the time you wake up. We don't want to scare your neighbor."

"Of course," I said. "We don't want you traveling this late at night. Do you need pillows, blankets?"

"No, nothing. We're going to sleep rough right out here."

I couldn't believe this. They didn't even try to come into our flat. Didn't even ask.

"The WC is at the end of the hall. Do you want something to drink or eat?" I asked.

"We'll be fine. We'll get a couple hours kip and be off and on our way to Tony's," John said.

"Janice," Mick said, "ring Tony's tomorrow and let's get together. Not too early, okay?"

I couldn't sleep. Several times I opened the door a crack and peeked. The two of them slept like babies on the carpeted hallway floor near, but out of the way of, the entrance. Mick looked so beautiful. What if my neighbor came home? It wasn't likely he'd be coming home in the middle of the night. After all, he was a pensioner. I had never heard him make a sound and hadn't run into him at any hour.

Chapter 39

I ALMOST TRIPPED over my feet dashing to the door. It was about six thirty a.m. How was it possible that I slept at all? The boys were gone. I walked down the hallway and looked at the floor where they had slept. I opened the front door and stepped out into a chilly morning and looked both ways. No sign of them. Maybe it was a dream. Did they sleep in the hallway and then disappear into thin air before the sun came up? I pulled my robe tighter across my shoulders and went back inside.

Tony's phone number was still safely tucked away in my wallet. I got dressed, took some change, and went out to the corner phone box and dialed. As the phone rang, I realized making calls would be unpleasant when winter came. I'd have to pull on a winter coat, scarf, gloves, and boots and trudge to the phone box. I missed the yellow wall phone in the kitchen at Toots's.

"The lads are working today for a few hours at the studio," Tony said. "Mick asked me to tell you to meet him at the 2i's around six p.m. You know where that is, I presume."

I did, and thanked Tony. "If he calls, will you tell him we'll be there, please?"

We had the whole day before us. Our tour map showed us so many places to visit; we didn't know where to start.

"Let's just jump on the tube and get off at our usual stop, Tottenham Court Road. We'll figure it out from there," I suggested.

We walked along Oxford Street. Every time I walked along

Oxford Street, there were so many places and stores and people to
see that it seemed as though I'd never been there before. So much
more exciting than walking along Euclid Avenue in downtown
Cleveland. Even though those department stores were wonderful
too, in London my dreams soared. I never wanted to leave.

"There's a Woolworth's!" Marty pointed out. We decided to
have a cheap Woolworth lunch-counter meal, which consisted of
a piece of chicken with something poured over it and vegetables,
probably peas and carrots, also with something poured over them.
Coke and crisps rounded out the meal.

"I want to find a library so I can look up information we might
need," I said.

"Such as?" Marty asked.

"How to find a job. Skiffle."

Marty rolled her eyes.

We decided to find the Tower of London, but when we looked
on the map it seemed much too far to walk.

"What about Big Ben?" I said.

According to the map, it seemed walkable, and we could see
a lot of London and the Thames on the way, so we decided on
Big Ben. I had heard of Big Ben in London for as long as I could
remember. The famous huge clock combined history and geogra-
phy, two of my favorite subjects next to writing and drawing.

The walk looked much shorter on the map than it actually
was. But the day was nice for walking. Maybe we didn't need to
walk right up to the tower. Seeing it from a distance would still be
incredible. I realized that if we were going to live here, we couldn't
continue to walk everywhere; we needed to learn about other tube
stations. But Tottenham Court station was the one we knew the
best, as far as getting from our flat into Soho and back again.

"How much longer will we be able to do this?" Marty said.

I knew what she meant.

"We need to go back to Liverpool for at least a few days," I said.

"What happened to your plan to get us jobs with Brian Epstein?"

I didn't have an answer. I wouldn't say my plans for a job were unraveling. More like I hadn't made them yet. I wasn't sure why.

"Well," I said, "since no one seems to be looking for us, I guess it means we have nothing to worry about except our future lives in England."

"We're on our own," we said in unison.

As we walked, we started harmonizing Beatles songs as we used to do back home in Cleveland Heights. But beneath the happiness of harmonizing "I Want To Hold Your Hand" I felt a vague undertone of sadness. I brushed the feeling aside. I should be happy all the time now that my dream had come true.

I was an alto. The St. Ann's children's choir director, a nun, of course, had me sing different parts of "O Holy Night" when I tried out for the children's choir.

"You're an alto. Stand over there."

I stood on the right of the U-shaped arrangement of children. The sopranos were in the front. Sister waved her arms to keep us in time and to signal each group when to sing. I felt so holy. When it was time for communion, we walked down the stairs from the choir loft single file with our palms and fingers tightly pressed together to indicate extreme holiness. We were rock stars. I even had a new dress. Sister watched our every movement and commented afterwards on any infraction.

"One of you, and I won't name a name, but you know who you are, lagged behind walking to communion," she announced. "I don't want to see that again. Step step step. No lollygagging."

I knew she was talking about me. I lollygagged because the strap on my shoe had come unbuckled. I didn't want my shoe to come off, so I had to quietly shuffle.

On the streets of London, Marty and I were free to sing what we wanted. We harmonized as we sang "Can't Buy Me Love," "She Loves You," and "I Want to Hold Your Hand." We laughed and sang loudly. Some passersby sang "Yeah, yeah, yeah" with us. By the time we were just about finished, we were looking up at Big

Ben and out at the Thames. We had walked through St. James's and Westminster, along streets and paths. London was a walking town, and I loved to walk, but it took patience to maneuver through some of the congested streets, such as Oxford Street. There were, however, always respites. We went back to St. James, bought some ice cream, and sat on the grass watching the ducks and birds. Some birds had long bills and resembled pelicans. And there was a charming little storybook house along the St. James path, too. Yes, London was an excellent choice.

"I wonder if we should think of Mick and John as our boyfriends?" I said.

"Has he kissed you yet?" Marty asked.

I answered that he hadn't. "Has John?

"Sort of."

"What does 'sort of' mean?" I asked.

I wasn't shocked, just surprised. Aside from being neighbors when I lived on Renrock Road and having a friendship cemented by Beatlemania, I realized I didn't know much about Marty. We both went to Cleveland Heights High, but I had gone there for only a week, having just started on September 7, after summer vacation and my transfer from Ursuline Academy of the Sacred Heart. We left for London on September 16. She wasn't Catholic, so I didn't see her at Mass. There was a lot about her I didn't know.

"He tried to kiss me, but I was too quick and turned my face," she said. "He wound up kissing me on my cheek. I know he was going in for the lips though. Not too embarrassing, right?"

"Do you think he might be 'the one'?" I asked. "Just think, you and John married and living in London." We both sighed for a moment and then laughed uncontrollably.

I had to find the "ladies," as they called it here. Not "ladies' room," just the "ladies." Extremely polite and dignified. We went into a nearby fancy restaurant and asked the first person we saw for the ladies'. We freshened up, consulted our map, and figured out about how long it would take us to walk to the 2i's.

"Oh no!" As we were discussing the walk, I remembered Paul's letter with his phone number and "ring me" message. I hadn't done it yet. I decided I would call him tomorrow. Unless, that is, the unthinkable happened tonight: being with Mick and running into Paul. We would be meeting John and Mick at the 2i's, and Paul and Roy loved the 2i's. It seemed to be their go-to spot.

Regardless of what happened with Mick and John and Paul and Roy, now that we knew the Beatles were back in London, it was time to get more serious about our Beatle lookout. It was possible they could show up individually at a coffee bar or club in disguise. But if the Beatles showed up all together, there would be no disguise great enough. They'd be mobbed. It would be dangerous. I remembered exactly what happened at their concert in Cleveland. I'd had a front-row seat for that madness—literally. They might risk going out one at a time, so they could blend into the crowd to hear great live music. I considered that George probably would never be bothered to try a disguise, and Ringo would stand out immediately. John could probably only wear a disguise for about thirty seconds before acting out, so it would have to be Paul. Paul got my vote. I believed he could pull it off.

We rounded the corner to Old Compton Street. Mick and John stood in front of the 2i's. I did a quick scan of the crowd on the street for Paul and Roy, but they weren't there.

As I looked at Mick from afar, I wondered why he hadn't tried to kiss me. I wished he'd try—and then I wouldn't let him, of course. I was happy the way things were: close but at a respectable distance. He wasn't shy at all; we did lie down next to each other in the field while hitchhiking to Liverpool. He seemed more protective than anything else. I found that very endearing. I'd just have to wait and see.

This was the first time I'd ever liked a boy in a romantic way. In the sixth grade at St. Ann's Elementary, I'd had a crush on a boy in my class. I had a general idea where he lived—up the hill. Sometimes I daydreamed that there was a big flood, and the water

carried him away and down to my house, which was of course the only place to stay. While at my house, he'd tell me he had a secret crush on me, too, and I'd be happy. The end. I didn't remember when I got over my crush, but it was probably when school ended and summer vacation began.

The 2i's was packed. The crowd was so thick it was hard to tell where the front door was.

"Fancy a sandwich?" Mick asked.

I said yes.

I waited and watched the group of Soho mods smoking cigarettes, talking, and laughing.

Mick managed to squeeze through the crowd over to the counter on the first floor. After a long while, he emerged victoriously, holding his hands above his head, a sandwich in one and a Coke in the other.

"Well done!" I said. We each ate half of the sandwich and shared the Coke.

Mick talked with some other musicians he knew, who were laughing and joking around while pushing their way through with guitars and drumsticks in their hands. Soho was his town. He knew everyone.

I looked around but didn't see John and Marty.

"They're probably downstairs," Mick said, answering my unspoken question.

Mick took my hand and led the way down into the tiny room where the band played and people danced packed together like sardines. Almost everybody smoked. Mick had his cigarette in his right hand and continued to hold my hand with his left while leading the way. Maybe George was right. Maybe I was Mick's "best girl." I certainly felt that way that night, although it was more likely that he didn't want to lose me in the crowd. I was okay with that. His hand was warm and strong.

"Mick, there's no way any of the Beatles could be at the 2i's," I said. "It's much too crowded. They'd never get out of here alive."

He laughed and nodded in agreement. Talking over the din was futile. People didn't come there to talk. They came for the music.

It was getting late, and although I didn't want the night to end, we had to start thinking about getting back to Holland Park. The four of us walked along Oxford Street headed toward Tottenham Court tube. No hurry.

"What's on for Sunday for you two Beatle birds?" John asked.

"Speakers' Corner in Hyde Park," I said.

"That's a good one for a laugh or two. Pack a lunch," Mick said.

They rode with us on the train and walked us to our door.

"Are you planning on sleeping in the hallway again tonight? You should have brought sleeping bags." I laughed. I wished.

They said it was early enough to get to Tony's.

"Back in the studio tomorrow," Mick said.

Chapter 40

SUNDAY. THE SKY was blue, the clouds white fluffs. Although it was a little chilly, we took Mick's suggestion and made some cheese sandwiches for lunch in Hyde Park. I grabbed the guidebook to read about Hyde Park and Speakers' Corner.

"We won't see any Beatles in Hyde Park," Marty joked.

"No, but maybe we'll see the Queen," I joked back. "I read the Beatles performed for the Queen Mother and Princess Margaret last year at a Royal Command Performance. They did 'From Me to You,' 'She Loves You,' and 'Till There Was You.' And, you're not going to believe this, but they did 'Twist and Shout'—for the Queen! She must be so cool. The Queen loves the Beatles."

"How do you remember all these things?" Marty asked.

"It's been in every Beatles magazine that I have. Or I should say *had*," I sighed. "They're all back in my old bedroom. At least they were there when I left. Toots has probably cleared out my room by now, though. Records, gone. Record player, thrown out."

"I'm sure my mother would never throw away any of my things," Marty said.

Marty was lucky. She had a family who clearly loved and appreciated her. I remembered how much I enjoyed being at her house and having dinner with Marty, her sister, and her mother.

"You know, you could go back anytime if you wanted to," I said. "You might not be in much trouble," I said. "Me? I'm staying. I don't want to go back. I like London just fine." As far as I was concerned there was nothing to go back to.

"Well, you have Mick now, don't you?" she said.

"It does feel that way." I couldn't be sure. I hoped so, but there were too many unknowns. Mainly ones I hadn't told him about.

We walked along what had become our usual path along Oxford Street until we saw the majestic Marble Arch. The structure stood alone, not attached to anything. The arch wasn't an actual entrance to the park but was more a marker declaring that Hyde Park was across the street. It was made of three arches with the largest being in the middle of two smaller arches.

We crossed the wide, busy street to Hyde Park. It was about noon when we made it to Speakers' Corner. There was a small crowd of what looked like tourists loosely grouped around a man standing on a wooden box. He wore a top hat and a black suit with a jacket that had long tails, and he looked like a mayor of some incredibly old British town. He made sweeping and grand gestures to the right, then to the left, then with both arms spread in front of him. He spoke slowly and with great determination, but I couldn't figure out what he was talking about. Something about the rights of some people somewhere and how important it was to do something about it, and now.

Another man went on about the Catholic religion, and some people in the crowd yelled at him. We found a bench far away from the craziness, took out our cheese sandwiches, opened bottles of Coke, tore open our bags of crisps, and sat back to enjoy the beauty of the park. I didn't feel like a tourist any longer. I was beginning to feel like I was home.

We'd passed Selfridges as we walked along Oxford Street. Paul and Roy had mentioned the store as a "must" place to shop.

"Did you call Paul?" Marty asked.

I told her I tried to call him, but the telephone rang and rang, and no one answered. I'd call later this evening. It was Sunday, so maybe he would be in. We walked around the park and decided to head for home. It had been a long week.

Chapter 41

BELIEVE MISSING GIRLS ADRIFT IN BEATLE LAND

Associated Press—October 5, 1964

LONDON (AP)—Two young girls missing from Cleveland, Ohio, and believed to be in Britain have not so far contacted the English girl to whom one of them wrote. . . . Cleveland Heights Police Chief Edward F. Gaffney said Friday drafts of letters written by Janice to British show business people have been found at her home.

One was a draft of a letter to Annabelle Smith, 20-year-old fan club organizer of the Rolling Stones Beat Group. It told of the girls' plans to visit England in July. Miss Smith said today:

"Unfortunately I don't have a copy of the letter Janice wrote. I believe it was probably thrown away after I replied to it.

"Police called on me today for the second time about the girls but I wasn't able to help them very much. Apparently the girls have been seen in the Liverpool area. They are Beatle fans and it is presumed they were visiting the Beatles' home town.

"I'm rather surprised that the girls haven't called on me yet. Since they didn't seem to know anyone here before they planned their trip. I should have thought one of the first things they would have done is to contact me."

Miss Smith said she imagined the girls' money must be running low by now—unless they had managed to find some sort of work.

Chapter 42

"MICK IS WORKING his studio gig all week," I told Marty. "I'm so glad he's in London every day. He wants to meet for a quick bite after work and then go to some clubs again."

I asked Marty how she was getting along with John.

"Great. But I'm going to stay in today and get some rest. How do you keep up this mad pace?" Marty asked.

"It doesn't feel like a mad pace," I said. "I'm having a great time." I couldn't wait to see Mick again. I had tried to call Paul, but again there was no answer. I was at a loss about what I'd say to him, anyway.

Mick and I met at the Tottenham Court Road tube station. He was wearing what I thought of as his black mod uniform: black turtleneck, black leather jacket, black pants, black Cuban-heeled boots. His hair was rolled to one side in the front and dipped onto his forehead. I'd seen a lot of other boys with similar hairstyles now, and I loved it. Boys in Cleveland would be kicked out of school if they tried to wear these cool and rebellious-looking hairstyles.

For the first time, it was just the two of us. He put his left arm around my shoulder and carried a lit cigarette in his right hand. We walked in step, looking at each other and laughing at nothing in particular.

"Crawdaddy?" Mick asked.

"Why not?"

"Marquee?"

"Of course," I said.

"Toss-up." Mick pulled a coin from his pocket. "Heads Marquee. Tails Crawdaddy."

He tossed the coin in the air and grabbed it while it was spinning. He clutched the coin in his closed fist.

"Which is it?" I asked.

"Ha! You think it's that easy?" he joked. "You'll have to guess first."

"Marquee," I said. He looked at the coin but wouldn't let me see it. "Marquee it is! We have a winner."

"Let me see that coin!" I laughed as I tried to open his hand.

He put his closed hand in the air so I couldn't get it and reached around me to put his arm around my waist. We faced each other. He was so close. We both were very still, poised for whatever was coming next. He moved closer and put his other arm around me.

Both arms were around me. I didn't want to stop him. He was handsome and warm. He smelled nice. His arms were strong and muscular, yet gentle. He pulled me to him. He was just an inch or two taller than me. A kiss would have been so easy. So natural. "Oh yeah I'll tell you something . . ." The lyrics to "I Want to Hold Your Hand" swirled through my mind. I put my hand on his chest and pushed myself away.

"Okay, come on," Mick said. "Marquee Club. Let's go."

Chapter 43

OVER THE NEXT couple of days, as Mick and I met and lived the Soho life, I became a little concerned about Marty. She said she was tired and needed to rest a lot. On Wednesday, she said she still wanted to stay in the flat.

"I wish we had a television," she said. "I'd like to just kick back and watch something for a few hours tonight."

"But we don't need one," I said. "Just come on and let's go to the clubs. You're not sick, are you?"

"No, I just don't feel like going to Soho right now. I'll stay around and explore Holland Park."

"By yourself?" I asked. "What about John?"

"We talked yesterday. We're going to have a bite somewhere around here later. We'll go for a walk." Marty said.

"I'm glad you two are getting along. That's great."

I was happy for her, but I couldn't understand why she hadn't shared any of her plans with me, as I had with her about Mick. She wasn't talking much lately, but I had no idea why. Was our friendship growing cold? It's true we hadn't seen the Beatles anywhere yet, which was the whole point of coming here. But these things can take a while. Timing is everything.

Chapter 44

"I CAN'T BELIEVE how many days we've been here," I said to Marty on Wednesday morning. "We definitely have to start thinking about the future."

"What future?" Marty said. "We don't even have our high school diplomas."

"Maybe we don't need one here," I said. "Look, we've made it, as of today, twenty-two days! The sad part is we haven't seen even one Beatle in Soho. We're going to have to go back to Liverpool. That's their home. Of course, they spend more time in London with Brian Epstein now." I was on a roll. "Finding Brian Epstein might be the key! I'll have to start working on that."

"On what?" Marty asked. She didn't seem to be paying attention.

"On finding Brian Epstein in London."

"But you had his address. You wrote him a letter."

"I can't find his address or his phone number in my things or the address for the girl I wrote to, Annabelle Smith, from the Rolling Stones Fan Club. I do remember she was on Regent Street."

The evenings were getting a little chillier, and it looked like it could rain. I put on my coat and grabbed my umbrella.

"See you later," I called out. "Are you sure you're okay?"

"I might be coming down with a cold. I'm staying in bed today," Marty said.

"Do you need me to get you anything at the shop before I leave? Soup and crackers maybe?"

"No, I'll be fine. I just need sleep." She pulled the covers up to her shoulders.

"I hope you'll feel better by Friday. Club night!"

* * * *

Mick met me at the tube station. We strolled along Oxford Street. It didn't matter what we did or where we were. I was happy.

"What are you in the mood for?" Mick said as he squeezed my hand.

"I'm stuck on fish and chips and mushy peas," I said.

"Bet you haven't been to Trafalgar Square yet," he said. "We can't let you miss seeing it."

"Mick, I'm not whining, but if I don't eat soon, I'll pass out."

We saw a little restaurant, went inside, and sat at a table. I hoped our relationship wasn't going to be a short-term thing. It didn't seem like it was. I wanted to be with him all the time, and it seemed like he felt the same way about me. After we finished eating, we walked and walked until we got to Trafalgar Square.

"This is the exact center of London," Mick said. "From here you can walk to the Thames, Buckingham Palace, Charing Cross, the National Museum, Covent Garden."

So many places. "What's Charing Cross?"

"That's the main railway connection in London," he said.

Just this one area of London had so much. I wish I had discovered it sooner.

"I might come back here tomorrow," I said. "I'll find out how to get to Charing Cross from Holland Park."

"Simple," he said. "Take the regular train you always take, but instead of getting off and walking from Tottenham Court, switch to the Northern Line and get off at Charing Cross."

"I want to go to Selfridges," I said. "I've heard it's one of the oldest department stores in London.

"Shopping, eh?" Mick said.

I love everything about this city. I can't get enough."

"We should probably start back," Mick said.

My heart sank. I didn't want us to part for even a minute. Not only did I love everything about London, but I loved everything about Mick too.

"Tomorrow's Thursday," Mick said. "How about let's get some fish and chips and then head out to the clubs? You'll have plenty of time for Selfridges."

"That sounds perfect. I'll see what Marty wants to do, too," I said.

"I think John and your friend have their own plans."

I was startled by this new information about Marty. She hadn't told me, but Mick knew? She'd been distant, distracted, even argumentative, and I didn't know why. I hadn't seen her this way before. The main thing we had in common was the Beatles and love of British Invasion music. We had a great time when that was the focus. If I could find the Beatles, she'd probably feel better. But how? I'd ask Mick to help me. Maybe tomorrow, though, because right now I was getting tired from all the walking.

"Mick, don't get mad at me, but it's been such long day, I think I'd like to get home early. Tomorrow we're going to have such fun."

"Me? Get mad at you, love? No way." He squeezed my hand.

I didn't want to part for a second, but I needed to head home—and start getting ready for tomorrow. Girls have a lot more to do than guys to get ready for just about anything.

"Do you want to walk to the Tottenham Court station, or do you feel adventurous? We could get the tube at Charing Cross," Mick said.

"I'd rather walk." I wanted to spend as much time together as possible, just Mick and me. I was in no hurry.

We meandered along, lollygagging our way to Oxford Street, talking, sneaking peeks at each other, laughing, holding hands. I could easily gaze into his smiling blue eyes forever.

Chapter 45

"EXCUSE ME, MISS."

I squeezed Mick's hand. I saw the policeman, a bobby, as he came toward us. He was smiling but looking just at me. My heart was beating fast. He looked friendly, but I had a bad feeling. I didn't say anything to Mick. An unknown and dreaded future rattled my soul. I desperately hoped I was wrong. Maybe he was walking toward someone behind me, next to me, beyond me, anyone but me. I looked at Mick. I looked at the policeman.

"Excuse me," he said again. "Are you from the United States?"

My heart sank. This was the end.

"Yes," I said.

"Would you happen to be from Cleveland, Ohio?" he asked.

"Yes, but why do you ask?" I knew perfectly well why he asked.

"Well, there happens to be two girls from Cleveland, Ohio, on holiday here. They haven't written home in a couple of weeks, and their parents are quite worried about them."

Mick stood next to me. I felt the warmth of his body. His hand gripped my hand.

"There must be hundreds of girls from Cleveland on holiday here. Why are you asking me?" My mind raced. Where was my invisible paint when I needed it?

"You seem to resemble one of them," the bobby continued.

Oh no—they had pictures of us! Maybe he would say he must

have made a mistake as he looked at me a bit closer. Mick and I could walk on to Tottenham Court tube; we'd laugh about this.

"Let's just take a walk over to the station to make sure," the bobby said.

This wasn't going well at all. The policeman let Mick and me walk along together while he kept a distance.

"What's going on? Do you know?" Mick said.

"I have to tell you before we get to the police station," I said. "I'm the girl they're looking for."

Poor Mick. The look of shock on his face broke my heart. I should have told him a long time ago.

"But you said you were on holiday."

"Yes. I am. I just didn't tell you this other part."

We walked along.

"What didn't you tell me? I don't understand."

"I'm sorry, Mick. I'm here legally, but I left home without telling anyone. I was sure I could figure out how to stay. I don't want to leave. Honestly, I didn't know anyone was looking for me. I genuinely believed my relatives would be glad to be rid of me. I didn't want to ruin how things were going here . . . with you. I didn't want to trouble you, Mick." I sighed. "I don't want to go back. I haven't done anything wrong."

"You should have told me," he said. "I could have gotten you a job as a waitress in South London."

He was kind and calm. He cared. He didn't yell or storm off. He kept walking beside me. He was a wonderful man. My heart was tearing itself apart. What had I done? Not to me so much, but to Mick. *I've ruined everything. I may never see him again.*

"I'm sorry, Mick," I said. "I didn't know anyone was looking for me, certainly not the police."

I felt the heavy blow I had just dealt him. If only we had taken the tube from Charing Cross. I'd be back in the flat by now.

PART THREE

Hide Your Love Away

Chapter 46

THE BOBBY, MICK, AND I arrived at the West End Central Police Station on Savile Row. We walked up the stairs into a large lobby. The bobby pointed up to two posters hanging high on the wall. I started laughing. Maybe there was a chance I could still get out of this.

"Ah," I said. "Now I see how you made the mistake. The resemblance is uncanny!" I was trying to be clever. My usual childhood survival rules didn't apply in this situation; maybe being entertaining would lessen the consequences.

The bobby had a look of restrained amusement. Mick let go of my hand when he saw my photo on the missing poster on the wall.

"Let's go and have a chat with these two nice ladies, and we'll get everything sorted," the officer said.

What could I possibly say that would erase this? Mick looked at me in disbelief. His expression changed as the truth dawned on him. Without a word or a gesture, he backed away, turned, and walked out the door onto Savile Row, taking his warmth and laughter with him.

Marty's picture was hanging right beside mine. I was sure he'd seen that too and would tell John.

I walked toward the "two nice ladies," who stood just inside the doorway of a narrow room with no windows, much like a closet. They both wore beige uniforms—I couldn't tell if they were dresses, or blouses and skirts—with thick beige stockings and

heavy brown shoes. They were not smiling. The one closest to the door was the biggest woman I'd ever seen.

I recalled an old Jimmy Cagney movie where Cagney, freshly arrested, sat at a big metal desk with a bright lamp pointing in his eyes. The detectives roughed him up trying to make him confess, but Cagney was no "stoolie." I stood, frozen, at the entrance to the room. No light bulbs or rubber hoses for me.

"I'm the girl you're looking for," I said. I hoped my confession would save me.

"We know, love," the smaller woman said. "Come and sit down. Let's have a cup of tea and a chat. It's going to be all right."

I had no idea what was going on. Why was this such a big thing? I had been in London three weeks, and it seemed like everything was going okay. Clearly, there must be a lot I didn't know.

I answered all their questions and gave them the address of our flat. I suddenly remembered a man who had come to our door the previous week. He'd been alone and said he was looking for a flat to rent. Did I know of any? Now I wondered if he had been an undercover policeman. Maybe they'd already known where we lived. They might have been watching for a whole week to see if we were the missing girls.

No, I decided. That didn't make any sense. They easily could have found out our names from the landlord or the real estate lady, or even from the hotel. We weren't hiding a thing. Everyone we met knew at least our first names and that we were from Cleveland.

The big woman said I would have to go upstairs and wait there for a while.

"What am I waiting for?" I asked.

Again, the smaller woman said that everything would be all right and not to worry.

"I don't understand why I'm here," I tried to explain, hoping someone would tell me something more informative.

The place where they left me waiting was a horrible room with

wooden benches lining three walls and a blue door with a small window. A policeman said to go inside and that he'd be back soon—and asked if I wanted a cup of tea. I'd learned in my three weeks in England that tea goes with everything. If you were waking up, relaxing, feeling a bit tired or low or happy or upset or dead . . . you would always be offered a cup of tea.

He closed the door and I heard it click. I was locked in, all alone, in a room in the police station. It felt like a dungeon. I was trapped. My heart pounded and my chest heaved. I began sobbing loudly and uncontrollably. I couldn't stop.

The little window in the door opened, and through it the policeman asked if I was all right.

"Yes," I managed.

"Your friend will be here soon," he said. "She's on her way now."

I pictured Marty taking the Tottenham Central line and coming to the police station.

"She's being brought by the police?" I asked.

"Oh yes. She's all right."

I started to cry again. And I had to use the ladies'.

I knocked on the big door. The window opened.

"I have to use the ladies," I said to the bobby.

He opened the door and led me to the restroom.

When I came out, I said, "I don't know what's going on or why I'm here."

"Didn't you know we were looking for you?" he asked.

"No. How would I know that?" I said. "Why was anyone looking for me?"

"Don't you read the newspapers or listen to the radio or watch the telly?" he said. "You and your friend were in the news and on the radio and the telly because of the Beatles."

"The Beatles?"

"Oh yes," the policeman said. "Quite serious to have two missing young American girls somewhere in England in the first place, and anything to do with the Beatles is very big news indeed."

"What do you mean because of the Beatles?" I said.

"Didn't you run away to find the Beatles over here?" he said.

"First of all, I didn't run away. I *left home!*"

"Oh, well, that's all right then," he said. "What about the Beatles?"

"We were trying to find them here, but we haven't yet," I said.

"Trying to find *you* is what all the police in London and Liverpool have been doing every day," he continued. "You two are very important. Why, we even have a pool that goes to the first officer to find you."

"A pool?" I was even more confused.

"Every police officer put money in the pot for the first one to find you. The one that found you on Oxford Street will get the money. A tidy sum it is, too." He smiled. "Even the Beatles themselves were looking for you."

I was stunned.

"I didn't know anyone was looking for me," I said. "I didn't read the newspaper, and we didn't have a radio or a TV." I couldn't believe what he had just told me. The newspapers, the radio and telly, the reward money . . . the Beatles?

"Look here," he said. He took a stack of newspapers opened to stories about our being missing and Scotland Yard looking for us. "Go ahead. You can read the stories. Look, here are your pictures in the papers!"

I skimmed the headlines:

"The Beatle-chasers . . . These are the girls whose Beatlemania has police in Britain on alert. . . . A police hunt has started, centered on Liverpool."

"Girls Lost On 'Beatle Hunt' . . . Scotland Yard were asked yesterday to trace two American girls, believed to have come to England to meet the Beatles."

I was astounded by the newspaper stories. How did anyone know where we went or why? (I didn't even think about Harry Martin, because he hadn't paid any attention when I called to tell

him. And Toots hadn't believed me at all.) And where did they get that awful picture of me? This one in the paper and the one on the poster were two different yet equally terrible photos. No wonder Scotland Yard couldn't find me—I didn't look anything like either one anymore.

"Look here at this one. You'll love this," the bobby said, trying his best to cheer me up. He put the newspaper in front of my face and smiled.

"Beatles Join Hunt for Two American Runaways," the headline said. I almost fainted. The Beatles were looking for us? I had been looking for the Beatles, and the Beatles had been looking for me! "The Beatles joined a Transatlantic search last night for two American teenage girls . . ." it started. It didn't say what the Beatles had done, exactly, but still I was stunned. It also said, "In Liverpool detectives mixed with teenagers at local dance halls and coffee bars trying to pick up a lead."

They must have gone to the Cavern Club!

After reading this, I was exhausted and depressed. Were they looking for us while we made a quick stop in Liverpool? I would have gladly surrendered to the Beatles if I'd only known. Go ahead, John, Paul, George, and Ringo—take me away!

The bobby opened the door to my dungeon room, and I reluctantly reentered. He said that I shouldn't mind that the door had to be locked; that was the rule and it was no reflection on me. A locked door was the least of my worries.

I was done sobbing. The initial shock was over. Now, the reality of my situation dawned on me. I knew I would have to go back to Cleveland and face whatever was to come. I was deep in thought, contemplating that anticipated unpleasantness, when I heard the lock open. The blue door opened wide, and Marty stood there.

"Here she is," the officer said to me.

I was relieved that Marty was okay. She stormed in, and it looked like steam was coming out of her nostrils. She took her coat and sweater and slammed them onto the bench.

"What have you done?" she snapped. "Do you know that because of you, I was dragged out of bed and brought here in a police car? Why did you tell them our address?"

She marched back and forth.

I tried to explain that Mick and I were just walking along Oxford Street on our way to the Tottenham Court Road tube station when a police officer came up to me.

"How could you tell them where we live?" she said. She glared at me.

"I had no choice. Did you know they were looking for us the whole time we were here? The Beatles were looking for us too!"

I knew she probably heard me say "Beatles" at least. She was in shock and angry, just as I had been. I had had a much smoother entry into this police situation because Mick had been with me. Marty had been alone, and it was more traumatic for her with police knocking at the door, asking questions, and bringing her in. Either way, it was all over for both of us.

The blue door opened a while later, and the police officer leaned in. "We've got some fried pork chops and chips for you, and some tea. Are you hungry? You can eat out here."

I was hungry and could use a huge mug of tea. Marty refused.

Now that the shock had worn off a little bit, I realized how cold I was. I held the warm cup of tea with both hands. My hands were shaking, and I tried not to spill. I didn't know what to expect next. These people had me under their control; anything could happen. But I was determined to make the best of it.

I sat and ate. And as I ate, I tried to get more information from the bobby. I told him that we were here legally and hadn't broken any laws. What had we done wrong?

He said someone would come explain everything to us soon.

When I finished eating, he unlocked the door to the little room. I turned to him. "But what have we done wrong?"

Another police officer came over. He looked like someone with higher authority. Maybe he knew why we were brought here. First,

he asked if we were all right and if we'd had enough to eat. Then he said, "Girls, you're going to stay here the night. In the morning, a man from the United States Embassy will be around to take you over to the embassy himself."

"We have to stay here all night?" I asked.

"Yes. I'm sorry, but there's no other place for you to stay. It's late now. We'll do our best to make you comfortable.

"The ladies have brought you jumpers, so you won't be cold," the bobby said. I already knew that a jumper was the British word for sweater. He walked off, then came back with two jumpers, two blankets, and two pillows.

"They're all freshly washed," he added.

"What time will the embassy guy be here?" I said.

"Not sure, but it'll be after breakfast. Now don't worry, we're not going to have anyone else staying in the room with you."

I was shocked to hear that was even a possibility.

"You mean like criminals or something?" I said.

"Not anyone. Just try to get some rest, and we'll be right out here if you need anything at all."

Marty and I each had to use the ladies'. I let Marty go first. When we were done, I put on one of the jumpers and lay down. Marty still had nothing to say. She wouldn't even look at me. I'd never known her to act this way. I decided to just wait it out. Maybe she'd cool off by morning.

I lay there in the quiet, thinking about Mick and wondering where he was and if he was okay. Was I still his girl? Hardly likely. Not after this. How embarrassing, to say the least.

I didn't want to leave England. I still had to go back to Liverpool and go to the Cavern Club. What if I could contact Brian Epstein and get a job? Would they make us leave? Maybe there was still a chance for Mick and me if they would let me stay here. I dreamed of our happy reunion. I would show up one night at the Marquee or the 2i's, and he would be there with John.

"Mick," I would say, "I'm back for good this time."

West End Central Police Station, 27 Savile Row, Mayfair, London. The Metropolitan Police officers were nice, but the holding cell was like a dungeon. *London Metropolitan Archives (City of London Corporation)*

Chapter 47

I WAS AWAKENED by someone knocking on the door. I opened my eyes.

Where am I, and what am I doing here?

As I slowly turned to get a better look at where I was, I almost fell off the bench I was sleeping on. I remembered. I couldn't get up and go back to the flat. It was like waking up forgetting someone you loved had died and coming to the realization that they were no longer with you. They had died, and they weren't coming back. Not ever. I missed my Uncle Mac and thought how hard it was to accept that he'd died and was never coming back. I didn't get to say goodbye. I never would have left home if he were still alive.

The little window in the door opened.

"Wakey, wakey," a male voice called out. "Time to get up, girls."

"Is the embassy guy here?" I asked.

"Too early for him, but we have a lovely breakfast coming up for you two."

A minute later, he brought in a tray of eggs, buttered toast, fried tomatoes, beans, bacon, and, of course, tea with milk and sugar.

"Breakfast for the Beatle girls!" he announced. "We don't get many VIPs such as the likes of you two." He was genuinely happy about our being there.

They all seemed pretty pleased with themselves for being the police station that found us—and none the worse for wear, as they pointed out.

After this sumptuous breakfast, fit for two Beatle girls, I was given my handbag. I did my hair as best I could without the benefit of any hair spray. I checked the mirror. Another Aqua Net hairspray victory—it still held from the day before. But this time it didn't matter. My heart was broken without Mick, and no amount of hairspray could put the pieces back together.

One of the policemen saw me looking downcast.

"I suppose you have a lot to face now, eh?"

I never could have imagined what was to come.

Chapter 48

AROUND TEN A.M., the U.S. Embassy guy finally showed up. He looked exactly as I expected an official from the embassy to look: tall, large build, older, gray hair combed neatly in place. *What does he use on his hair?* I wondered. He wore glasses, of course. Maybe he'd been on the football team when he was in school a long time ago. I'd never seen a man who looked so neat and important. He wore a white shirt, a gray tie, and a gray suit with dark-brown wingtip shoes. No black ankle boots with Cuban heels for him. I wondered how he got such a great job that let him live and work right here in London.

"I'm Henry Lilienfield from the United States Embassy," he said as he smiled slightly and put his hand out to shake each of ours. He looked at us one at a time and let out a small sigh. "Well," he said, "you girls have caused quite a stir over here. We're all relieved you're safe and well." He explained that, since we were citizens of the United States, the U.S. Embassy was taking over, and that we were leaving the police station and coming with him to the embassy. We would be shielded as we got into the car to take us to the embassy so no one could see us leaving the police station.

"Why is that?" I asked.

"There are a lot of reporters outside the police station who'll want us to stop so they can talk to you," he said. "We need to get you to the embassy right now. Let's go."

They led us out a side entrance of the police station. Two female detectives from the West End Central Police Station came with us. Marty and I sat next to each other, and the detectives sat on either side of us at the windows. They didn't even look at us. "These detectives are going to escort you, to make sure you stay safe on the way to the embassy," Lilienfield said.

The windows were covered with blankets. We could hear people we couldn't see calling out "Janice!" "Martha!" "Tell us about the Beatles."

The blankets stayed over the windows as we drove on. It seemed like a long time, but it was actually only about fifteen minutes later when I felt the car slow down and drive down a ramp.

"This is the basement and the parking garage for the U.S. Embassy," one of the detectives said.

The car doors opened, and we were escorted to a bank of elevators, then rode one of the elevators up to a floor with offices.

Henry Lilienfield showed us into his office. It was a lot more pleasant than the holding cell of the police station where we'd spent the night. Someone took our coats to hang them up. The female detectives had disappeared somewhere during the trip from the underground parking garage up to whatever floor we were on in the embassy.

"Please, take a seat." Lilienfield indicated we should sit in the two chairs on the opposite side of his large wooden desk, facing him. He sat down at his desk, folded his hands in front of him, and looked at us in a kindly, elderly, gentlemanly way. He looked as though he was about to say something with restrained sternness. Everyone I'd met in London and Liverpool had been open and accepting. Henry Lilienfield, even though he was from the United States, seemed agreeable, but I figured he had to act that way. He had an important job.

I looked past him out the window behind him, and I noticed the morning sun, blue sky, and white clouds perfectly framed in the large window.

"I'm sure you girls would like some American food by now," he said. It seemed as though he snapped his fingers, and someone immediately brought plates with hamburgers, french fries, ketchup, and glasses filled with Coke. I didn't realize I was so hungry until I started eating. When I was done, I sat back and stared at him. What was next? He had been shuffling some papers on his desk while we ate.

"First of all, I want you to know that you've done nothing wrong while you've been here, and you're in England legally, so there's nothing to be concerned about there."

Great, I thought. *Can I go now?* Maybe they just wanted to check on us. The thought fluttered in my mind, but I knew in my heart that couldn't be true. Not with all this fuss. The fact we had been moved to the United States Embassy meant something serious, I was sure.

"Apparently, you've rented your own flat and have been going around Soho and seeing music groups perform?" He looked at us and waited for a response.

"Yes, we have," I managed to get out.

"The police packed up all your things and put them in your suitcases," he said.

Well, that answered that question. We were not going back to our lovely flat. No more tea and toast. No more spaghetti. I would miss the WC. But most of all I would miss taking the underground to Soho, hearing live music, and being with Mick. I alternated between accepting my uncertain fate and losing my mind. My three-part survival plan didn't cover this. I thought of a line from a Jimmy Cagney movie, "Say your prayers, mugs."

"The chief of police in Cleveland Heights, Ohio," Lilienfield continued, "would like us to make sure you're safely returned. We must honor his request. They want you to go back home."

I felt like a knife had been stuck into my stomach. I had to go *back*.

"The two of you have become quite popular over here because

of the Beatles," he said. "I understand that you saw them perform in Cleveland, and then the next morning started on your journey over here hoping to see the Beatles again?"

I nodded.

"You were referred to as 'the world's number-one Beatles fans' in the newspaper."

I was honored to have the title bestowed upon me. I loved the Beatles. They had changed my life. I didn't think of myself as their number-one fan in the whole world, though. But who am I to argue?

"I met the Rolling Stones, too, when they were in Cleveland," I said, attempting to keep the conversational tone going.

This was not something that impressed Mr. Lilienfield. He fiddled with his pen.

"Well, you've been here for three weeks. That's a long time for two American teenagers to be missing in London. And Liverpool, I understand."

"Yes," I said. I explained that we hitchhiked there to see where the Beatles came from, their birthplace, and wanted to see the Cavern Club. In case he didn't know, I went on to tell him that the Cavern Club was the place the Beatles got their start, but the club was closed when we got there, and we had to leave in order to get a ride back to London. I hoped Mr. Lilienfield could understand how hard we tried to see the Beatles and that this was the reason we came to England. He had to understand how important this was.

As I was talking, Marty sat silent as a rock.

I thought I'd try begging. Maybe even crying, if that would make a difference.

"Is there any way you can arrange for us to meet them?" I asked. "Now that we have to go back. Please, is there anything you can do?"

I pleaded my case by reminding him that he worked at the

United States Embassy. "You must know everyone who's import-
ant in England," I said. "What about just a telephone call with the
Beatles?"

This was going nowhere. Should I throw myself on the floor
and have a tantrum? I decided I wasn't willing to go that far.

"First, let's talk about going back home," he said. Before he
could start doing that, the phone rang on his desk and he answered
it. "Oh yes. They're here with me. Let me ask them. Hold on." He
pressed a button on the phone and said, "The *New York Times* is
calling. They'd like to interview you over the phone."

I was terrified. What could I possibly say?

"Do you want to talk to them?" he asked.

I shook my head from side to side indicating I didn't. I suppose
Marty did the same.

He pressed the button on the phone again.

"The girls are a bit tired right now, and they don't feel up to
speaking with anyone."

Wow, he's good.

He hung up the telephone receiver, smiled, and looked at us
with his full attention. His hands were folded in front of him and
rested on top of his desk once again.

I hunched forward slightly, balanced on the edge of my chair,
and stared past Mr. Lilienfield. The white clouds poised against
the bright sky slowly began to turn gray and quietly move across
the horizon. I shifted in my chair.

"As I said," he continued, "you're in England legally. You have
passports and entered the country with enough money to take care
of yourselves. England does not have a requirement that minors
need be escorted here. And while here, you've done nothing
wrong. Nothing at all."

I was glad to hear all of this.

"So then why do we have to go back?" I asked. "I want to stay
here."

"You have a choice," he said. "You can return on your own steam, and that way you can come back anytime you want. Or you'd have to be deported, and you could never come back to England."

He paused.

I took about one second to make the decision.

"I'll go back on my own steam." I wanted to come back as soon as possible.

Marty said she'd agree to go back as well, rather than be deported.

Mr. Lilienfield looked relieved. He said he was happy to hear we'd made the decision to go back on our own.

"You'll be leaving this afternoon. We have you scheduled for a flight from Heathrow to JFK."

"You mean now?" I asked.

"Yes, we want to get you back home as soon as possible."

"But what about a phone call with the Beatles?"

He said he was sorry, but it wouldn't be possible.

How would I be able to call Mick? I didn't get to say goodbye, and I didn't get to explain anything. I was sure Tony's telephone number was still in my purse. I hoped no one took it at the police station. But why would they? I didn't do anything wrong.

"One more thing," Mr. Lilienfield said. "Because of all the publicity with you two Beatle girls, and the Beatles and the Rolling Stones, too, there's been a lot of interest from reporters and newspeople. In fact, there are some outside the embassy right now anxious to meet you both. You'll have to hold a press conference."

"What does that mean?" I asked.

"It'll just be on the front steps. Nothing formal. Some reporters will ask you a few questions. You can answer or not. After that, we'll have you come back inside and we'll head to the airport."

I was confused. I had just said I didn't want to talk to anyone, and he was making us have a press conference.

"But I don't want to," I protested.

"It'll just take a few minutes, and then we'll be on our way," he

said as we stood up. We got our coats and handbags and headed to the elevator.

The reporters had their notepads and microphones out, and photographers and television crews pointed cameras at us as we headed outside and walked down the stairs in front of the embassy.

"Did you travel here with the Beatles?" one reporter asked and then quickly put a microphone in my face.

"I understand your allegiance has switched from the Beatles to the Rolling Stones. Is there any truth to that?" another one asked.

How did anyone know I had hung out with the Rolling Stones?

"No."

"Didn't you come here to find the Beatles?"

I looked at Marty. She was talking to a reporter, but I couldn't hear her what she was saying. I just wanted the press conference to stop. I was drowning.

Suddenly it was over. We were escorted up the stairs and back into the embassy.

The two female detectives were inside waiting for us. I was relieved to see them.

"Are you all right?" one of them asked me.

"I think so," I said.

They escorted us back down to the garage, where a U.S. Embassy limousine was parked. The detectives sat on either side of us next to the windows again. The limo eased up a narrow driveway past two wrought-iron gates, turned onto a small street, and hugged the road along a park. No covers on the windows this time. Motorcycles followed us. One drove right alongside the limo. A photographer was perched on the back seat of the motorcycle, both hands aiming a large camera at us. The cameraman steadied the camera with one hand and waved and smiled at me.

What the heck, I decided. I smiled and waved back.

The detective sitting next to me tried to hold back a smile.

U.S. Embassy, 24 Grosvenor Square, London. We were brought in through the parking garage entrance and whisked upstairs. *Library of Congress*

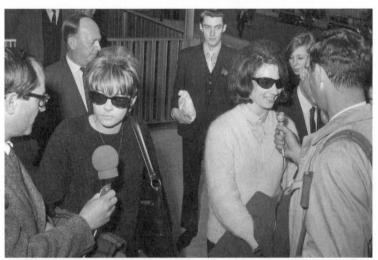

"You'll have to hold a press conference," we were told. What did that mean? I was so confused. *AP Photo*

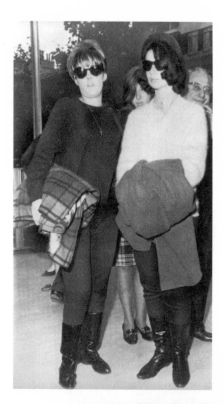

Marty and me outside the
U.S. Embassy wearing our
"fab" sunglasses and boots.

In the back seat of the embassy
limo, headed for the airport, with
one of our two female police
chaperones.

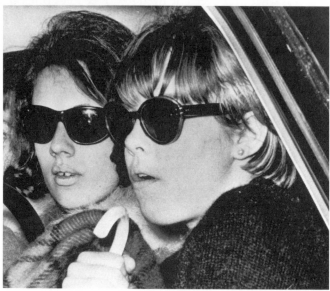

Chapter 49

AT LONDON AIRPORT we were taken to a VIP room by some mysterious route. The door was locked from the outside so no one could get in and bother us, or so we were told. The other unspoken concern, I was sure, was that we might walk out of the VIP room and manage an escape. This must be what the Beatles went through—except for the potential escape part—when they traveled by air. There must be a secret passageway from the VIP room to the tarmac, just for the Beatles and the Rolling Stones.

The detectives stayed outside, guarding the door, I supposed. So this was what the other side lived like. Free soft drinks and snacks and magazines galore. A ladies' was available so the VIPs didn't have to use the commoners' bathrooms. I had a Coke.

Marty still wasn't speaking to me. She wouldn't even look at me. I felt like our friendship was over.

The detectives entered the room and told us it was time to board. We were escorted outside to the tarmac and walked toward the Trans World Airlines jet. Flight 701 would fly us to JFK in New York. We were swarmed again by a pack of reporters who pushed microphones toward us and asked questions. They didn't give up until we started to climb the staircase up to the plane.

I decided not to look at anyone; I would just concentrate on walking quietly to the plane. I knew once I got there, the reporters had to go away. I don't know why, but I started thinking about Jackie Kennedy. I still grieved for President Kennedy and my heart

went out to Jackie, Caroline, and little John-John. *This must be what it's like for Jackie Kennedy all the time—never able to get away from swarms of reporters and photographers who want a scrap of her life.*

Once we were inside the plane, the detectives made sure we were in our seats before they left.

"Take care of yourselves," one detective said. They walked along the aisle toward the exit door, stopping to talk briefly with two of the stewardesses before they left.

I didn't know what had happened to my passport. Mr. Lilienfield told us someone had packed up our clothes and belongings. Would I get back my brown suitcase that I'd painted with flowers?

Marty had the window seat, and I had the aisle. We sat in silence. We wore our Soho sunglasses, fab black ski pants with foot stirrups, and shiny black boots from Carnaby Street. We were on our own again. Not that it would do us much good, except that it gave us a little mental space before we arrived at JFK, which I dreaded.

I had to say goodbye to London, Liverpool, Mick, the flat, the clubs, the Beatles, Brian Epstein, and Bill Wyman. As soon as I could save enough money, I vowed to myself I would come back. Mr. Lilienfield said I could.

It was light outside when the plane took off. I didn't want to look out the window. I couldn't bear to see England disappear. I kept my sunglasses on and drifted in and out of sleep. Every time I woke up, the nightmare hit me again. I was going back.

I awoke as the stewardesses served food. Two stood in the aisle near me. Since I was still wearing my sunglasses, they thought I was sleeping.

"These two have been through a lot," one stewardess said. "Let's not bother them while they're sleeping." That was the last thing I remembered before the pilot announced we'd be arriving shortly at Kennedy in New York City.

Chapter 50

THE PLANE LANDED at JFK around five p.m. It was still daylight outside. When the plane stopped completely, all the passengers stood up waiting to disembark—except us. One of the stewardesses stood near our seats and told us to remain seated. We soon found out why. When all the other passengers were gone, two men boarded and came toward us. They looked mean and aggressive.

"Come with us." They said they were detectives from the Cleveland Heights Police Department and were there to escort us back to Cleveland.

We walked along the aisle and down the stairway to the tarmac in single file with one detective leading and the other securing the end, making certain we wouldn't try to make a break for it. I walked off the plane, head held high, clutching my Harrods umbrella. My last connection with England.

Once we were inside Kennedy International Airport, a group of people I didn't know came toward us yelling things I couldn't understand, arms and hands reaching for us, trying to grab us. Another group of people quickly formed a circle around us and kept the grabbers away. It was very frightening.

Obviously, we weren't in England anymore.

Without any delay, we boarded an American Airlines jet destined for Cleveland Hopkins Airport. I had my own detective; I had the window seat, and he had the aisle. I knew I must be in a lot of trouble. As we flew into the black, angry sky over Cleveland,

rain pummeled our plane. When we arrived, once again Marty and I were the last off the plane, escorted by the two detectives.

We were back. Cleveland, the place I had tried to get away from permanently.

Even though I still had my beautifully rolled Harrods umbrella, I didn't dare try to open it as I stepped off the airplane into the pouring rain and onto the stairway that led from the plane down to the tarmac. Newsmen and photographers ran up the stairs yelling out questions. I kept silent, which was my new policy since the nightmare press conference on the steps of the U.S. Embassy in London. I was still traumatized by that. What had I even said? I didn't remember.

A new and darker nightmare awaited me. The detective who had accompanied me from New York pushed me into a waiting police car. I held tight in my mind to the words of Mr. Lilienfield: "You haven't done anything wrong."

In London, I had been escorted by polite police and embassy officials, but here in my own country, I was guarded like some rabid wild animal that had been snared in a hunter's trap. I still didn't know what was happening or why. Why couldn't we all sit down with a nice cup of tea and talk about it?

In my three weeks in London, I'd grown to love the British approach to life. I had to go back as soon as this was all over. I knew I could find a job there. If Mick was still speaking to me, he could help me find one. And I could follow up with Brian Epstein.

As we sped through dark streets, the detective said something to me but the rain pounded the car and the windshield wipers swooshed back and forth, and I didn't hear what he was saying. I didn't want to hear him.

Eventually we arrived at a building in downtown Cleveland in a neighborhood I didn't recognize. This building wasn't anywhere near the department stores where I shopped when I took the Rapid downtown—Higbee's, Halle's, May Company, and Sterling Lindner. Well, I didn't shop at Sterling Lindner; it was too expen-

sive, but I liked walking around the beautiful store. I remembered
having lunch as a child at Higbee's Silver Grille. Children's lunches
were delivered in a black-and-white cardboard stove. Open the
stove door and take out your lunch—delightful for a child.

What is this place? Why are we here? I was yanked out of the
police car and marched toward some stairs. I hadn't done anything
to annoy this police officer, as far as I knew. Another police car had
arrived just after us, and I saw Marty getting out of that car. My
mind reeled as I tried to understand why I was being treated this
way. *Welcome back to Cleveland.*

I was taken past a series of heavy doors with bars and huge key-
holes. One of the people escorting me had a ring of gigantic clank-
ing keys that unlocked the huge heavy doors.

I was taken to a room, handed a heavily starched nightgown,
socks, and shoes. *I have to sleep here?*

Someone took my clothes, my purse, and my umbrella, and I
was left with nothing of my own. A heavyset white woman with
short gray hair told me to sit on an examining table. I asked her
why I was being examined.

"Everyone gets one. You're no different," she said as she began
roughly searching through my hair.

"What are you doing?" I asked. I should have the right to ask
questions.

"Checking for lice."

Lice! Oh my God. People here had lice?

"Where am I?" I asked

"Juvie," she said.

"What's juvie?"

"Don't you know anything?" she said. "You're in the Cuyahoga
County Juvenile Detention Home."

She examined every part of my body. I was humiliated. When
she was finished, I was told to put on the scratchy nightgown, socks,
and shoes. From there I was taken to a dark and freezing-cold dor-
mitory room with rows of metal beds with girls sleeping in them.

"Where's my friend?" I asked.

I was told she was in a separate dormitory down the hall.

There was a window above the bed I was told was mine, and a cold wind whistled through it. I sat on the edge of the bed and looked around the room.

"Hey, you! White girl!" A tall black girl stood in front of me. "We been watching you on TV." She twisted her mouth and turned her head, almost touching her ear to her shoulder. "Oh yeah. Cleveland Heights rich girl. So, you went to England? You bitch! Who you think you are?"

I stood up, ready to run if necessary. I was terrified, but I looked her right in the eyes. After all, my roots were inner-city Cleveland, and I was a survivor of all kinds of stuff this girl couldn't even imagine.

"Im'a teach you a lesson, bitch. Im'a cut you!" Then she laughed like a maniac.

She must have murdered someone, maybe her mother.

She went back to her bed, but before lying down she yelled the most terrifying threat she had left in her.

"You ain't supposed to be wearing no underpants under nightgowns. Im'a report you for that!" She laughed hysterically again.

The other girls didn't move or laugh.

I was freezing, so I lay down under the skimpy covers. One sheet. One blanket. One pillow. How could anyone sleep under these conditions? The bed was a thin mattress supported by a saggy web of creaky springs. The girl had probably taken one of the springs and kept it under her pillow in case she felt the need to stab me in the night for being a "rich girl from Cleveland Heights." I felt like I was in *David Copperfield*. Would they serve porridge for breakfast?

Don't fall asleep, I told myself.

Arriving back in Cleveland with my umbrella—and police escort. *Cleveland Public Library*

Chapter 51

IT WAS DARK in the dormitory of the juvenile detention home, and the girls were still sleeping when I was awakened by a woman standing over me.

"Come on," she said. "Get up and come with me."

I prayed this meant I was leaving, but I was so wrong. I followed her to a room. She handed me some clothes, but they weren't mine.

"Put those on."

They must love starch in this place. I was given a starched dress that once had colorful flowers, but they were all sadly faded. The dress hung on me like a sack. I put on the rest of the clothes, including thin white ankle socks, and slipped into worn-out brown loafers that were too big. I already had underpants. Everything looked like it had been worn a hundred times by girls who'd passed through the grinding nightmare of the Cuyahoga County Juvenile Detention Home.

The woman led me to another room, where I ate breakfast by myself. I was grateful for this. I wouldn't have to be near that girl who wanted to cut me. After all, breakfast included utensils.

The food was predictably inedible. Powdered eggs, some watery gray slop that was supposed to be oatmeal, toast, and orange juice. No tea. I'd gotten used to tea, and I missed it. I missed everything in London. I missed Mick more than I could have imagined. I might not have seen the Beatles or Bill Wyman hanging out in Soho, but I'd had a Liverpudlian musician boyfriend! That was as

close as I could get, and I wanted that again. I couldn't wait to go back. All I needed was to save up $1,980. With only one person, the money could go twice as far.

After breakfast came a big surprise. I was going to school. Not back to Cleveland Heights High School, but to the juvenile detention school. I had already missed about a month of eleventh-grade classes. In the schoolroom, a few girls sat at desks with chairs bolted to them. Marty was there. The teacher was a man whose goal was to keep everyone busy. We had simple math tasks to figure out, then moved on to reading. Reading skills varied widely among the girls.

When class was over, a woman took me to another room and told me to get dressed. She handed me my own clothes.

"You're getting out later today," she said.

Later couldn't get here soon enough.

"Your relatives are posting your bond," she explained.

Whatever a bond was, it had to be good if it meant I got out of this hell pit. But a feeling of dread gripped me from head to toe: I would have to face my relatives, Toots and Margie, very soon.

* * * *

The feeling of freedom I felt upon being released from the terrifying juvenile detention home was quashed by the sight of Margie's waiting yellow convertible with the top up. Top up meant Toots was in the car.

I slid into the back seat behind Toots. I had dreamed of a happy family life and ridiculously hoped in a secret place in my heart that it might happen someday. What a stupid dream.

There were a few memories I savored. I remembered when I was much younger, we went to an amusement park, Euclid Beach. I rode the roller coaster that had two side-by-side "racing" coasters that supposedly competed. If you watched which one "lost" and got on that one, then you would come in first on the next trip. The big scary roller coaster was called "The Thriller." I was reluctant

to ride it, but my desire to conquer my fear won, and I rode the Thriller over and over again.

The Flying Rockets ride circled out above Lake Erie. Locals told stories about the time one of the rockets broke off the ride and fell into the lake and everyone drowned. Whether that was a made-up story or not, I stayed away from the Rockets. I remembered having picnics at Euclid Beach, going into the fun house beneath the terrifying "Laughing Sal," and sliding down a huge wooden slide while sitting on a large potato sack. I had a few bright memories. But they had dimmed as I got older and were extinguished when Mac died.

I tried desperately to hang on to any happy memory as a life preserver while we drove back to Cleveland Heights.

"Janice, you dragged our names through the mud," Toots suddenly announced as we drove along. This was the first word anyone had said from the time I'd gotten into the car.

"You don't care about me!" I blurted out.

I was shocked that I had said out loud the very thing that had caused me to leave.

"What do you know? You're a child," Toots said.

A child! She knew nothing about me.

I sat still in the car and stared out the window at every building and business that we passed, as if keeping my eyes riveted would shield me from the storm that was to hit at home. Thinking of storms, I remembered that my umbrella was missing. Someone in the detention home had acquired an expensive British umbrella. I was positive of that. There was nothing I could do about it now.

When we finally arrived at the house on Belmar Road, I went straight to my room. I didn't know what had happened to my brown suitcase. I supposed the police took everything from our little Holland Park flat and got rid of it. But I did have my purse. I opened it and hoped to find the piece of paper with Mick's phone number written on it. If I could just speak to Mick, I knew I would feel better. The way things went at the juvenile detention home,

someone might have gone through everything I had in the purse and thrown things away or stolen something. I was surprised to find my lipstick. That seemed like a good sign. But suddenly I was afraid to keep looking. What if it wasn't there?

I looked around my bedroom. My record player was there, but my Beatles and Rolling Stones records were not. I didn't much feel like playing any records anyway.

I walked into the dining room. Toots stood there. I walked over and threw my arms around her round, soft doughy body.

"I'm sorry," I said.

She stood motionless at first, but reluctantly put one arm on my shoulder and then quickly backed away and walked into the kitchen without a word.

"You'll have to go to juvenile court in two weeks," Margie announced later that day. Margie had hired a lawyer. Also, we had to meet with the principal at Cleveland Heights High before I could go back to school. I was also instructed not to answer the telephone under any circumstances. Bad people had been calling the house, Margie said.

I couldn't open any mail addressed to me. Margie told me that there were a lot of fan mail letters.

I had fans?

"Our address was in the newspaper in almost every news story." she said. "Didn't you know that we were looking for you? Cleveland Heights Police, Scotland Yard in England?" She didn't even sound mad.

I told her I didn't know about Scotland Yard until the last day at the police station in London, and I didn't know anything about what was happening at home.

"Here's some of the newspaper stories from the PD and the *Press*," Margie said.

She tossed some newspapers in my direction and then walked out.

I looked at the papers. The *Cleveland Press* from the day before, October 8, reported:

2 RUNAWAY BEATLE FANS RETURNING
FROM ODYSSEY IN LONDON CLUBS

Safe under the wing of the U. S. Embassy in London, [the] 16-year-olds . . . were to be sent homeward today, their trans-Atlantic Beatles adventure at an end.

On the 22d day since they had vanished from their Cleveland Heights homes, on the heels of a local concert by their beloved Beatles, the girls were located by London police ...

This morning's *Plain Dealer* had this article:

DREAM TRIP IS OVER: 2 RETURN WITH
THUD FROM BEATLELAND

Disenchanted Beatle fans. . . . who ran off to England three weeks ago, were reunited with their families at Cleveland Hopkins Airport last night.

The girls, escorted by two Cleveland Heights detectives, were the last two passengers to step from an American Airlines jet from New York that brought them on the last leg of their 3,500-mile journey from London.

Janice, wearing dark glasses and a winter coat with a fur collar, walked quietly down the steps.

The 16-year-olds looked none the worse for their trip. Both refused to talk to newsmen.

A police car whisked them away in a torrent of rain which came with their arrival.

Today's *Press*, which must have just arrived, since it was an afternoon paper, had another story, under the headline "Beatle Girls to Face the Music in Court":

The 16-year-old trans-Atlantic runaways were jarred back to reality today as Cleveland Heights police threw the Juvenile Court book at them.

The girls, who had a 23-day fling in England, the land of the Beatles, were charged with juvenile delinquency based on complaints of forgery, truancy, disobedience and running away.

[They] spent the night in the Detention Home after being flown home from England into the arms of Heights police.

There were more papers, with more headlines: "Beatle-Hunting Girls Safe in London," "Beatle Pilgrims Land in Heights," "2 Return With Thud From Beatleland" . . . But I couldn't read them. It was too hard to face the reality in print. This is what Toots meant when she said I had dragged their names through the mud. I didn't know what to say.

When I put the papers aside, Margie came and sat down. She didn't judge me or yell at me. It almost seemed like she wanted to help me. Or maybe she wanted to control me, like before I left, but in a weird way that made her seem nice. I had no choice now; I had to accept her help.

She said most of the letters were from other kids wanting step-by-step instructions for how to do what we had done. I wasn't allowed to see any of the letters. Honestly, I didn't want to see the letters anyway. There was no way I was going to share my plans with anyone.

Margie did show me one letter, though. It was from a couple in Japan:

Dear Janice,

We read about your adventures and were delighted and happy for you that you took such a tremendous step. Not many people have the courage to follow their dreams. We want you to know how much we admire that.

I couldn't figure out why Margie was showing me this letter, but I was glad to read something positive. People in other countries, like England and Japan, were so much nicer about the whole adventure than people in Cleveland. They didn't care that I was only sixteen years old.

Had I been older, my leaving wouldn't have mattered at all. Being a minor, under the age of eighteen—that had changed things completely. People *had* to look for you. It was the law. If adults didn't report a missing young person to the police, they could get in trouble themselves.

I guess even besides the part about the law, Toots and Margie, in their own way, cared about my welfare. But as bad as things were before I left, I was sure life would be much worse now.

I thought again about Mick. Thinking about him and what we'd had together made me feel less alone. I needed to talk to him.

I hadn't finished searching my purse and wallet for the precious piece of paper with Mick's phone number. The truth was, it wasn't that I hadn't had time to look; I had nothing *but* time. Rather, I was terrified that I would open my purse and discover the paper was gone. And that would be the end. I would never see Mick again. I couldn't face that possibility After I had found my lipstick, I had put the purse in my bedroom closet and left it there. Everything about my purse cried London and Liverpool. I didn't want to disturb the memories tucked inside.

I also didn't think anyone would allow me to keep that piece of paper if they found out about it. I hadn't gotten my passport back, so why would I be allowed to keep a phone number from England? Maybe no one here recognized an English telephone number. Hopefully, no one cared about a little piece of paper in my wallet.

I knew there was a time difference of five hours between Cleveland and London. When it was one p.m. in Cleveland, it was six p.m. in London. I opened the door to the large walk-in closet in

my bedroom. It was my secret place. Sometimes when I was feeling sad or worried, I would place a blanket and pillow on the floor, lie back, and gaze out the leaded-glass window in my closet. There, I was free to be adrift in my own imagination. Now, I would dream of going back to England, reuniting with Bill Wyman, and getting a fab job with Brian Epstein. What a great life I would have there. I just had to wait until I was eighteen and had money again. What had happened to my passport? I'd have to get another one.

I sat down on the closet floor with my purse resting on my lap and opened it. In all the craziness, I'd forgotten about all the other things in my purse: comb, hairbrush, case for my glasses, a pen, Kleenex, change purse (empty), and my brown wallet. They could have let me keep the coins at least. A few shillings were not going to get me back on a plane to Heathrow.

I opened my wallet. My library card was still there. That was a good sign. I always carried a "flying novena" prayer card with me for emergencies, and it was there too. A novena is a Catholic prayer that is said for nine days in a row to ask for a special need. A flying novena is said every hour for nine consecutive hours and is meant for the most urgent prayer requests, such as impending death or dire emergencies. The flying novena never failed me. I knew I would need it soon.

Folded and tucked near the novena card was a piece of paper. My heart stopped. I knew it had to be *the* paper. I unfolded it and read GRO0814, in Mick's handwriting. I held the paper over my fluttering heart. Apparently, the power of the novena worked even when you were not actually praying. God was looking out for me.

I knew I had to talk to Mick and try to explain everything. There had been no chance to talk or even say goodbye at the police station. I didn't blame him for walking away. It had all been so confusing. I had to find a way to call Mick's number as soon as possible. But how? I couldn't even go near the telephone.

Besides not answering the telephone, I had been given a bunch

of other rules, too many to think about. It was no use. My mind was a blur. I'd just gone from living the life I wanted to living the life someone else imposed on me.

I did realize I had caused Toots and Margie a lot of trouble, yet they still wanted me back. Margie, who had taken over as the leader of the household since Mac died, seemed to be taking the whole thing in stride. I even thought she seemed to be quietly amused. When I had been making my way down the steps from the plane, Margie was one of the people who rushed up the steps in the pouring rain. She grabbed and squeezed my arm hard.

"Don't worry," she said.

Chapter 52

GOD BLESS Theos Anderson, Cleveland Heights superintendent of schools, and Eugene Myslenski, principal at Heights High. They stood up for Marty and me and tried to persuade the Cleveland Heights police department to treat our adventure as a personal matter, not a juvenile court matter. But the juvenile court system was determined to make us pay through public humiliation—and more.

Even though I had been ordered to juvenile court on November 2, I would still have to return to Cleveland Heights High before that court day. I was looking forward to school, mainly because then I wouldn't have to be at home where rules . . . ruled.

At home it was no this, no that. I could only go outside as far as the front stoop. I spent as much time out there as I could stand, even though it was getting colder and colder. I was tough and dressed warm. I wrapped my scarf around my neck and stared out at Belmar Road and at the neat houses across the street. I watched cars back out of or into their driveways or drive toward busy Mayfield Road.

No more walks to Coventry Library. No more matzo ball soup and chocolate phosphates at Irv's Deli. No more Beatles magazines or *Teen Screen* magazines.

On Tuesday, October 13, Toots, Margie, and I met with Edwin Gally, one of the assistant principals of Cleveland Heights High.

"We want to get you back into your classes as soon as possi-

ble," he said. He added that I'd have to come back on Wednesday morning bright and early for first period. "To help you concentrate on your studies," he said, "you'll stay after school each day for one hour. This isn't punishment."

I looked up at him, remembering demerit cards at Ursuline Academy. Staying after school was definitely punishment. And every day seemed excessive.

"We're trying to prevent you from being bothered by other students," he continued.

It still sounded like punishment to me.

"If any other students ask you questions about your trip," he said, "I want you to take their names and turn the names over to me. I'll take it from there."

That was something I would never do in a million years.

The conversation over, we all stood up, apparently satisfied with the return-to-school arrangements. Toots, Margie, and I drove home—in silence, of course.

I hated every second of the weekends. No records. No phone calls. No radio. No walking outside beyond the front steps. I refused to watch television. I either stared out the window in the living room or stayed in my bedroom reading. I was permitted meals, though mealtime turned into sheer torture. Neither Toots nor Margie talked to me. I couldn't wait for Monday mornings, when I was released from the oppression of 1634 Belmar Road and could head back to school. I walked along Coventry, passing Irv's Deli and the good old Coventry Library.

"You're to come straight home after school," Toots instructed. She told me how much time I was allotted to get from Heights High to our front door. Otherwise, I'd be in even more trouble.

School was completely uneventful. I had only attended Heights High for about one and a half weeks before the Beatles concert, so no one there knew me. My last class ended at two p.m., after which I reported to the "non-detention" room, where I stayed until three. I found I didn't mind going there because it was quiet. The first

time I went, I looked for Marty, but she wasn't there. I figured she must be in a different room. They were apparently making sure we were separated so we couldn't come up with any new plans.

Not a single student asked me anything about the Beatles or England. However, when I was in art class, which I loved, and was working on a drawing, I said something to the person next to me.

"I like your drawing."

Mrs. Turner, the art teacher, yelled at me from her perch at the front of the classroom. "Janice, you're not in England anymore!" If she was trying to humiliate me, she would have to dig much deeper. She seemed to relish the moment, and once the dam broke, she continued to judge my drawings harshly throughout the rest of the semester. She wrote confusing comments next to my grade like "This is too personal!" I assumed she knew something about art. If art wasn't personal, then what was it? She never let up her criticism or stopped giving me hard looks. If I was going to give the principal any names, it would be Mrs. Turner.

Margie took me to meet with my lawyer. He was a tall, large, older man, with big shoulders that could easily carry the weight of whatever the problem was. He looked at me with kind and understanding eyes. His voice was deep, and he spoke slowly. I liked him.

He was a lot more trustworthy than Mr. Lilienfield. I hoped so, anyway. Lilienfield had thrown me to the lions, the terrifying feeding frenzy of a press conference.

"You don't need to say a word. That's my job," the lawyer said. He told me I should sit in court and look humble.

I was relieved to hear that. I believed him. Margie had told me the same thing. I believed her too; she was friends with a lot of important downtown Cleveland people.

Margie also took me to Robert Hall to buy an outfit to wear for my November 2 court date. The lawyer had said I should wear a light-blue outfit, as the color would give me the appearance of innocence. We selected a matching sweater and box-pleated skirt set. The sweater was soft and had little white bows with white

buttons on a light-blue background. The skirt had to hang slightly below my knees, so I would appear modest. I had to have a lace handkerchief to hold in my hand while sitting in the courtroom; the handkerchief was supposed to make me look ladylike. The last item I had to wear was a medal of the Blessed Virgin Mary on a chain around my neck—preferably one in color—to indicate that I was not only Catholic, but a virgin too. All these things together were to give me the appearance of a child who needed forgiveness and mercy from the judge. Final instruction: while sitting, I was to cross my legs at the ankles.

I pored over the daily and Sunday newspapers, my lifeline now that I wasn't allowed to go anywhere or do anything except school, church, and home. Even the library was out of bounds. That was just wrong. We subscribed to the *Plain Dealer* and the *Cleveland Press*. On November 1, I read that the Rolling Stones were going to appear at Public Hall on November 3.

Bill Wyman would be back in town!

The day after court.

The *Plain Dealer* story about the Stones' appearance mentioned that they would be staying at the Statler Hilton Hotel in downtown Cleveland. Plus, there was this paragraph:

> In the audience will be the England-and-back 16-year-old runaways from Cleveland Heights. The girls, who came back from their London trip staunch devotees of the Rolling Stones, have been given free seats for the show by the promoters. They are also scheduled for a face-to-face meeting with them after the show.

My eyes almost popped out of my head. When was *this* decided? I hadn't heard anything about it.

I also didn't know I had returned from my London trip a "staunch devotee" of the Rolling Stones—until I read it in the *Plain Dealer*. Sure, I'd met them and hung out with them when

they performed on *The Mike Douglas Show* back in June, but hardly anyone knew about that. I never even told Marty about it.

Since I was barely allowed out of the house, I wondered how this plan had been arranged, especially since I had yet to hear about it from Margie and Toots. Marty and I hadn't spoken a single word or seen each other since detention. Even at the detention home, we had been kept apart. I hadn't seen her at school, either. Would we both be going to the Stones' concert? Who would take us there?

I could hardly wait to see the Stones and especially Bill Wyman again. I hoped Bill remembered me. I had said no when he asked me to leave with him back in June, but even if he asked me again, I still couldn't go. Not now anyway. I was already in enough trouble. But we could have a good laugh about my trip to London and Liverpool.

Chapter 53

THE DAY OF RECKONING was here, November 2. Margie, Toots, and I made our way along a dark-brown wooden bench on the right side of the courtroom, where my attorney ushered us to sit. He whispered to Margie and Toots. He looked at me, smiled, and nodded in a reassuring way. I glanced over and saw Marty sitting between her mother and sister, and a man I guessed was her lawyer. None of us made eye contact.

The juvenile court building on East 22nd Street reminded me of St. Ann's Church and Coventry Library. The entrance was decorated with the image of a tree whose spreading branches were filled with green leaves; two open books perched on the branches like birds. The courtroom had stained-glass windows and beautiful hanging light fixtures. The rows of benches where we sat reminded me of pews, except there was nothing to kneel on. During the Catholic Mass, you had to kneel and stand up or kneel and sit down over and over again. Kneelers were padded to make it more comfortable, but this courtroom wasn't meant to be a place of ease.

I looked down at the white lace handkerchief I had been told to carry and was glad I had it to hold on to. I knew I wouldn't cry or do anything to draw attention. I learned as a little girl that crying only made people laugh at you, and your mother would hit you, grab you by your arm with her red nails digging into your flesh, and fling you across the room to make you stop. Nothing that happened in court could come close to that, I was sure. But I

didn't want to tempt fate—especially after spending a night in the juvenile detention home.

The Blessed Virgin was with me, and I was glad. I felt like she was my only friend. I didn't need a holy medal or blue outfits or lace handkerchiefs to prove I was innocent. I *was* innocent. I hadn't done anything wrong—only try to find a better life for myself.

I looked over to my right at a separate section with the same wooden benches. The benches were filled with men in suits with notebooks and pens in their hands. They talked quietly among themselves. I wasn't sure, but they reminded me of the reporters at the U.S. Embassy and at Heathrow Airport. At the front of the room was a large desk area set up on a low dais. This was where Judge Angelo J. Gagliardo would sit; his name was on a plate on the desk.

The front of the room started buzzing with activity. A bailiff, in a police-type uniform, without the cap, came in, followed by someone else. A man entered the room and sat down behind a machine and started typing on it. It seemed like a long time before the judge came into the room.

He entered near his bench with a swirl of his long black robe. Everyone stood up. He had a full head of short, dark, wavy hair. A pair of glasses perched on his prominent nose that stuck out over a big mustache. Judge Gagliardo said that we could be seated. He shuffled papers while everyone looked at him in silence, waiting for him to do something. He was the most important man in the room.

The men with the notebooks had their pens and pencils poised to take notes. My lawyer confirmed to me that they were reporters. *Oh no, more reporters.* I was not going to say a word, or look sad, or anything. I sat very still while my mind spun round and round like a record on a turntable. I tried to concentrate on what was being said by my lawyer, and the judge.

"Beatles concert . . ." I heard the judge say. I perked up at that. The judge said he had taken his daughter to that Beatles concert

at Public Hall. *This judge went to the Beatles concert!* I was shocked and encouraged at the same time. That meant the judge's daughter filled out postcards and sent them to WHK for the same contest I entered. It also meant they stood in line on June 12 at the Public Hall box office to present the letter and be given the privilege of purchasing two tickets to the concert. The judge must hear Beatles songs played at his house all the time.

The news guys scribbled away in their notebooks. They couldn't take their eyes off the judge. I was on the edge of my seat. Judge Angelo Gagliardo had been at that infamous Beatles concert, the one I was in so much trouble for. Juvenile Court Judge—and Beatles fan? Under any other circumstances, that would be so cool—right up there with Ed Sullivan. This seemed like a good sign. I clutched my Blessed Virgin Mary medal.

I'm sure my lawyer spoke eloquently about my never having been in trouble before, applying myself at school since returning, behaving myself while in England, broken home, and so on. But Judge Gagliardo already knew the speech he wanted to give about his concern over the influence of rock and roll on us. That's why he had the press there. It was all staged. It was more about Gagliardo than it was about us.

Gagliardo said that, although both Marty and I came from broken homes, we had both been good citizens and had never been in trouble before. He said that we had changed and had done something that could only be attributed to our exposure to "this rock and roll music."

But he wasn't in a forgiving or understanding mood. He called us juvenile delinquents and ruled that we were forbidden from attending any Beatles-type concerts while under the jurisdiction of the juvenile court. His order was to take effect immediately.

Oh no! That means I can't go to the Rolling Stones concert at Public Hall. I won't get to see Bill Wyman again.

Judge Gagliardo gave the reasons for the restrictions. This was why the newsmen were sitting in the courtroom. The men con-

tinued writing furiously in their notebooks. The judge, I guessed, wanted them there so he could make a public statement—which was reported by the Associated Press:

> The parents of Cleveland should hang their heads in shame that they allow their children to attend such a performance [the Beatles concert] unsupervised. . . . It's like feeding narcotics to teen-agers. It is very dangerous. It could very well lead to riots.
>
> The promoters are morally, if not legally, responsible for the behavior that results from these shows. It is a matter of wanting to make a dollar at the expense of teen-agers.

Judge Gagliardo said evidence presented to the court showed "the girls behaved while in England. They have also applied themselves in their schoolwork since returning home."

Didn't Mr. Lilienfield at the U.S. Embassy say we had done nothing wrong? Surely the judge would see that. Hadn't we already been punished enough by spending the night in that horrifying detention home? The judge didn't even mention that.

The whole day in court was emotionally draining and very confusing. The judge gave mixed messages. I understood that he had been shocked and probably terrified by witnessing firsthand so many girls and boys at the Beatles concert losing control and going out of their minds during the show. I, too, had been disappointed by their behavior that almost ruined the Beatles' performance.

Being a juvenile court judge, Gagliardo probably felt obligated to say something on the subject. So he blamed rock and roll music for everything that Marty and I had done. As the *Cleveland Press* reported:

> During the hearing, Judge Angelo J. Gagliardo condemned such teen-age concerts for "exploiting the immaturity of youngsters."

"Adults are creating a mass hysteria in order to make a profit," the judge said.

"If it were under my control, I would not permit this kind of exploitation of children," he said. "And I cannot understand how parents can allow their youngsters to attend such affairs unchaperoned."

Cleveland mayor Ralph S. Locher agreed with him. The next day he announced that from now on, the Beatles and similar groups would be prohibited from performing in Cleveland's Public Hall and all other city facilities.

According to the *Cleveland Press*:

> The ban will begin after tonight's Public Hall appearance by the Rolling Stones, an English rock and roll group . . .
>
> As reason for the ban, he cited the turmoil caused by the Beatles' appearance here which, at one point, almost got out of hand as teen-agers tried to rush the stage.
>
> "Such groups do not add to the community's culture or entertainment," the mayor said. "These groups will be able to appear here at private halls, but we do not feel we should invite this problem by making public facilities available."
>
> His announcement followed the appearance in Juvenile Court yesterday of two Cleveland Heights girls who ran off to England after attending the Beatles' show here Sept. 15.
>
> During the hearing, Judge Angelo J. Gagliardo condemned such teen-age concerts for "exploiting the immaturity of young-sters."

What a huge mess. Cleveland had just banned rock and roll. And it was all my fault.

Public Hall to Ban
All Beatlemania

Mayor Locher announced today that the Beatles and similar groups will no longer be permitted to use the Public Hall or other city facilities for their perform-a...

Cleveland mayor Ralph Locher: "Such groups do not add to the community's culture or entertainment."
Cleveland Public Library

Chapter 54

I WAS WALKING along Cedar Road on my way to catch the bus home. My schedule was tight, and I'd been warned repeatedly to get home immediately after school.

A car pulled up beside me.

"Hey, Janice!"

I recognized the voice as that of Harry Martin, the KYW disc jockey.

I so wasn't in the mood for Harry Martin.

"I have to be home in ten minutes," I said.

"Get in. I'll give you a ride home."

Like an idiot, I got in the car.

"Big day in court, huh?" he said. "By the way, I just made a deal with *Cosmo* magazine for you."

"So that's why you're following me?" I said.

He laughed loudly.

"No, I just happened to be driving by and saw you. I didn't want to call you at your home. But this is a serious offer."

"*Cosmopolitan* magazine?" I said.

"They want to interview you about the Beatles and the Rolling Stones and your adventure in London and Liverpool. They'll pay you five hundred dollars."

Cosmo would pay me five hundred dollars for an interview? Since I wasn't allowed to work yet, that sounded great. Then I'd just need to earn another fifteen hundred to go back to London.

"You owe me one, you know," he said. "You almost got me in a lot of trouble."

I had no idea what he was talking about.

"When I read in the newspaper that you actually did go to England, I let my station manager know you had called me that morning before you flew to London. I thought you were kidding around."

I looked at him in disbelief.

"Our legal team said that I could be charged with contributing to the delinquency of a minor for not telling the police your plans right away," he added. "We made a deal that I wouldn't get charged if I paid out of my own pocket for ads in the Liverpool newspapers and the London newspapers. Plus, I had to record a public service announcement asking for you to call me." He said the public service announcement was played on the pirate radio station because the BBC didn't play Beatles or Rolling Stones records. "We thought you'd probably be listening to the pirate station."

"What's a pirate station?"

"It's on a ship out in the water off the coast of England. It's called Radio Caroline."

I tried to picture a radio station on a pirate ship: *Ahoy, all Beatle fans!*

He turned and looked at me.

"Why didn't you call me?"

I told him the same thing I told the police: that I wasn't listening to the radio or reading newspapers or watching television. I was living the life at the beat clubs in Soho.

He put his hand on my left thigh and asked me to move closer to him.

"I'd like to hear more about that," he said.

"Get away," I said as I scooted closer to the passenger door. He laughed. I told him to drop me off on the corner of Mayfield and Belmar. The last thing I needed was for Toots to see me with this man.

"What about the *Cosmo* interview?" he said.

I didn't let on how excited I felt about the idea of earning five hundred dollars.

"I'll have to ask my aunt."

He said he'd drive partway down Belmar and wait for me to come back with the answer.

"No way," I said. "I'll call you at the station tomorrow morning and let you know what she says about it." I slammed the car door as hard as I could.

He drove off down Mayfield Road heading toward downtown Cleveland.

I'd try to make asking Toots about the interview as quick and as painless as possible. For the sake of five hundred dollars, it was worth the risk. I walked into the kitchen, where Toots was preparing something for dinner.

"*Cosmo* wants to interview me about my trip," I said. "Can I do it? They want to pay me five hundred dollars."

She didn't even look at me.

"Whatever it is, the answer is no."

I wasn't surprised but it was worth a try.

"But five hundred dollars," I pleaded.

"No," she said.

She didn't ask me how the magazine had contacted me, so I didn't have to tell her about Harry Martin. If she had asked, maybe he'd get in trouble and even get arrested. Not that I cared. I went into my bedroom and sat down on my bed. I felt relieved I didn't have to do the interview.

Chapter 55

I HADN'T FORGOTTEN about Mick, but between court, school, all the new rules at home, and my gloominess in general, I couldn't figure out when and where I could use a phone to call him. Home would be risky, depending on the time of day. I carried Tony's phone number with me all the time, just in case. One possibility was the phone booth on Cedar and Coventry near the school.

I wandered into the kitchen to see what Toots was doing. I hoped she'd let me help her with something—anything. Then again, now that court was over, maybe I could get my record albums back.

"Where are my records?" I asked.

"In the attic," she said.

I went upstairs to the hot and dusty attic. I loved the attic. It felt private and hidden away. A place filled with secrets. Two windows overlooked the other nearby houses. I looked around the room and saw a plastic bag of newspapers with all the stories about John F. Kennedy's assassination and funeral. I had carefully saved them all and tied them lovingly with a light-blue ribbon and a bow. Tears came to my eyes as I looked at the pictures of Jackie, Caroline, and little John-John in his light-blue coat, saluting his father's coffin.

I found my Beatles and Rolling Stones records in a paper bag, brought them down to my bedroom, and placed them near my record player. I found it hard to look at the album covers now

that both groups were banned from performing in Cleveland ever again. I took responsibility for that.

Maybe I could learn how to play the guitar. Everybody played the guitar in London and Liverpool. Maybe I could learn how to play skiffle. The Beatles all learned how to play skiffle. It just took a guitar. How hard could it be? I passed the Dick Lurie Guitar Studio twice a day on my way to and from Heights High. I could take lessons there. But I would need to save up for a guitar, and without a job that would be a challenge. All the money I'd saved from babysitting, addressing postcards, and setting my neighbors' hair in rollers had been spent in England. I had closed my savings account because I thought I was never coming back to Cleveland.

My new plan was simple: I would ask for a guitar for Christmas—even though I only deserved coal in my stocking, Toots and Margie might relent if I asked for only one Christmas present. No matter what, every kid deserved something for Christmas, I reasoned.

I hurried along to school on Thursday so I could call Harry Martin at the KYW studio without being late for class—one of the last things I wanted to do these days. Harry and Specs Howard were still on their early-morning radio program, and Harry picked up the phone.

"Hi, Harry. Just wanted to let you know about the *Cosmo* interview. My aunt said no." I hung up before he had a chance to reply, and I ran to class.

It was much too early to call London. It had to be in the evening. I'd try that later. Almost a month had passed since I'd last seen Mick as we entered the West End Central Police Station. Our final walk together was along Oxford Street. Before the bobby stopped us, we'd enjoyed another Soho evening. The evenings of coffee bars, clubs, live music, and keeping an eye out for Beatles in Soho had been an exciting routine. I missed my charming studio flat on Lansdowne, even the WC down the hall. Nothing took away the happiness I'd felt in London.

You should have told me. Mick's words resounded in my mind and heart. He was my very own handsome Liverpool-Soho musician. I was glad I hadn't told him the truth during the three weeks we'd known each other. The entire truth could have ruined everything. But I wished I'd had a chance to tell him how wonderful he was and how much I loved all our time together. He was kind and so much fun. We were happy together. I ruined that too. I couldn't think about him now without getting teary-eyed.

I'd been given my house key again so I could come home from school without disturbing Toots if she was resting. I had to walk the dog as soon I came home. His name was Pierre JoJo, but he was called JoJo. He was a little white French poodle given to Margie by a friend. The friend was getting married to a man who also had a French poodle. He told her she had to get rid of her French poodle or they couldn't get married. If it was me, I would have shown him the door. I wouldn't get rid of my dog or my cat for anyone.

I was only supposed to walk JoJo for fifteen minutes. That day, when I came back from walking him, I saw Toots was resting. I sighed. I had put her through so much. She'd been good to me, letting me live here for the past eight years. She wasn't young anymore. I wasn't sure she'd ever been young. She and my grandmother, Irene, were twins. I never met my grandmother; she died from breast cancer when my mother was twelve years old. Toots raised my mother, who she described as a "wild handful." Now she was stuck with me. She didn't deserve it.

In Cleveland, the time was about four p.m., so it would be nine p.m. in London. I picked up the receiver from the yellow wall phone in the kitchen and dialed zero for the operator.

"Operator," the woman said. I heard Toots rustling.

"Sorry. Wrong number," I said and quietly placed the receiver back on its hook. Margie never came home for dinner on Friday nights, and she almost always went out on Saturday nights. I could wait.

I also remembered the lovely note Paul had written me. He had

included his phone number. I had tried to reach him while I was still in London, but the phone just rang and rang. I wished I could have seen Paul and Roy one more time. They were such fun. Especially our "tour guide" Roy. I looked for the note, but I remembered leaving it in the flat. I still had not gotten my clothes and my brown suitcase returned to me. Paul's letter would surely be there. It was unlikely I'd get my passport back, even though I had no money to return to England.

I scrounged through my closet and dresser drawers and evaluated my pathetic clothing situation. I'd taken just about everything with me to London. Toots said that for now I'd have to make do with whatever clothes I could find in my room.

I wished I could go to St. Ann's Church and sit alone with Jesus. Maybe I could find some comfort there. But that was out, except for Sunday Mass. I begged to go to confession on Saturday, but that was out too. I was a prisoner in my home, but at least I still had my flying novena to the Infant of Prague tucked into my purse next to Tony's phone number.

Chapter 56

I DECIDED TO take a chance. It was ten p.m. in England. On any given Friday, Mick and John were most likely already in Soho at the Marquee Club, 2i's, or the Crawdaddy Club. I needed to try to make an overseas call. I didn't expect to get through, but I had to practice anyway. Margie wasn't home, and Toots was watching her programs and eating a large bowl of vanilla ice cream with chocolate syrup topped with peanuts. JoJo snoozed at her feet.

I dialed zero.

"Operator," said a brisk voice.

"I want to make a collect call to London, England," I said.

She transferred me to the overseas operator. There were a lot of strange rings and buzzing noises. Finally, an operator with a British accent came on the line. I gave her Tony's phone number. More ringing. I heard her say, "I have a call from Cleveland, Ohio, in the U.S. from Janice Hawkins. Will you accept the charges?"

"Hello?" a distant voice said.

"Tony, is that you?" I said. "I'm sorry to call you collect. This is my first chance to call."

He laughed and said they'd all seen the news about my return to the States.

"Is Mick around?" I asked.

"Ah, yes, Mick. No, I'm afraid the boys are not here at the moment," he said. "Is there a message?"

"Do you know when I can reach him at your number?"

Tony said any evening during the week, usually. But this evening they were in the studio.

"Will you tell him I called?" I said. "I need to speak with him."

He said he would, and we hung up. I looked at the clock on the wall. The call didn't last more than two minutes. Tony didn't mind accepting the charges. I was relieved. I decided to try again on Monday. Why didn't I say I'd call on Monday? The same reason I never asked for Tony's address. Why do I think of crucial things after it's too late?

On Monday, Margie was home. No chance to make a phone call. I tried again on Tuesday, but the phone just rang and rang.

I figured out that if I ran to the bus stop, I could catch an earlier bus and be on Coventry a full fifteen minutes before I had to be home after school. There was a phone booth at Irv's Deli. Wednesday was my big chance.

"Hello?" Tony said.

"Hi, Tony. It's Janice. I hope you are doing well. Thanks for accepting the charges. Is Mick there?" I said it all in one breath, trying not take up too much time.

Silence. Then, "Janice?"

"Mick!" I was so choked up with emotion I couldn't speak.

"Janice?"

"Mick! How are you?"

"The real question is how are you, love?" Mick said. "We saw something of you on the news. A celebrity. Embassy limos and such. When are you coming back? This time without all the cloak and mystery stuff, eh?"

"You don't hate me?" I asked.

He laughed a Liverpool laugh.

"No, love. I could never hate you. We miss you."

"I don't know when I'm coming back. I'm in some trouble over here at home, and it'll take a while to settle down."

"All right?" he asked.

"Yes, I'm all right. You?" Mick told me they were doing great. I

told him I had to go. He said to call when I could and not worry about the reverse charges. He'd make sure to pay Tony for them.

"All right, love," he said.

I flew home singing "All My Loving."

That would be last time Mick and I talked.

Chapter 57

EVERY OUNCE OF happiness had been drained from me by detectives, detention home, family, school, the judge, the mayor . . .

I felt all alone.

I wasn't allowed to talk about England, the Beatles, the Rolling Stones, rock and roll music, or anything related to my adventure, at home or at school. There was no one to talk to about it anyway. Marty's family had moved her someplace far away, but I didn't know where. Marty and I hadn't spoken since that night in the holding cell at the West End Central Police Station.

The best thing I could do, various people said, was just to put it all behind me and apply myself to my schoolwork. I'd already caused enough pain to my relatives, embarrassment to my church and school, and trouble for police departments on both sides of the Atlantic Ocean—not to mention the catastrophic damage to rock and roll in the city of Cleveland, with rock and roll bands banned from performing at Public Hall ever again.

There was not much else I could do, except try to put everything behind me. The less said the better. For everyone's sake, I complied.

I picked up my Beatles album, *Meet the Beatles!: The First Album by England's Phenomenal Pop Combo*. Paul, John, George, and Ringo stared out from the cover. I had lived in London and hung out in the same clubs they went to in Soho and had seen the town where they were born and raised. I liked the picture on the back of

the album. They were smiling and wearing the gray collarless suits, white shirts, ties, and "Beatle boots." Who wouldn't fall in love?

I pulled the record from the sleeve, put it on my record player, and placed the needle at the beginning of side one. "I Want to Hold Your Hand" was the first song. Two minutes and twenty-four seconds. That was all it had taken to change my world.

AFTERWORD

Life Goes On

IN 1968, I MANAGED to find Marty. We talked briefly on the telephone. I was excited to relive our adventure, but she had moved on from the past and was happy in her new life. I was glad she was happy but sad to lose my best Beatle buddy. That would be the last time she and I talked.

And that would be the last time I talked about this adventure for almost fifty years.

* * *

One day in April 2016, I had just hit the Print button on my computer after finishing the final report on an investigation I'd been working for several months. The sound of the printer chugging and the paper sliding into the tray was mesmerizing. I sat back in my chair, picked up my coffee cup, and for the first time in a long while gave myself permission to exhale and relax. I've been a criminal and civil case investigator for more than thirty years, and relaxation was not a part of my profile. My investigative mind was always churning, trolling for clues and putting pieces of a puzzle together. It was a process that also required mental stillness, in order to let the subconscious work the case and produce possible solutions—but that could never be described as relaxation.

The radio was playing in the background. Usually I worked in stark silence, but occasionally for a change of pace I tuned the radio to a pop or soft jazz station. Paul McCartney was singing "Black-bird." I sang along and looked up at the Beatles poster hanging on the wall above the printer. It was the poster from the September 15, 1964, concert at Cleveland Public Auditorium. I smiled thinking about the great adventure that started the day after the concert—that had actually begun that Christmas break in 1963 when I heard the Beatles for the first time.

I thought about how much my life changed since 1964.

A year after my Beatles adventure, unable to bear the unrelenting punishment and restrictions still placed upon me at home, I ran away again. My life with Toots and Margie had become increasingly oppressive. I could do nothing right in their eyes—and mine, too. This time, I didn't go far, staying nearby in Cleveland. After about a week I realized it was a mistake and went back home. But the Juvenile Court stepped in. I was given a choice between living with Toots and Margie or moving to Columbus and attending an all-girls' Catholic school. I chose the second option.

At my new school, I began to see what I was capable of: good grades, writing, taking college-level correspondence courses, running for class president. It was heaven. It was what I had needed all my life. When graduation approached, I begged the nuns to let me continue living there, but that was not possible.

I graduated and got a job as a cub reporter at the *Columbus Dis-patch*.

I married a musician, and we moved to New York City. (Every musician worth his trusty guitar had to go to Greenwich Village and perform in clubs and hang out in groovy coffee shops like Café Figaro and Café Reggio, drinking espresso and cappuccino.) He played an Ovation guitar, and his style was a combination of James Taylor and Ravi Shankar. He opened for the Chambers Brothers several times at Steve Paul's The Scene nightclub on West 46th Street. I would hang out in the green room as musicians,

girl friends, and roadies passed through. The marriage didn't last. After the divorce, he returned to his native Baltimore, but I had no desire to return to Cleveland. I wanted to put Cleveland memories as far behind me as possible. New York City is the best antidote for forgetting troubled pasts.

In New York, I could pursue any dream, even multiple dreams, and nothing could stop me. I was free as a bird. A hardworking bird. I worked at *Family Circle* magazine and various ad agencies, and started writing feature stories for local newspapers on Staten Island, my new home. My natural instincts of looking not just outside the box but around, under, and beneath the box led me to a life as an investigator. The same drive and luck that got me through a treacherous childhood and helped me devise my Beatles adventure was the perfect fit for undercover investigative work. I had no fear and plenty of creativity.

But my love of New York City and investigations took a sudden hit on 9/11 at the World Trade Center. I was a capital case investigator for the Legal Aid Society of New York. Our offices were at 90 Church Street, located between 5 and 7 World Trade Center. No one could be prepared for the impact of that day, and the days, weeks, and months that followed. Even the survivor skills and instincts I had honed could not help me with this one. In 2004, I decided to return to my hometown of Cleveland to try and regroup and come up with a new plan for myself.

New York City had provided a respite from my past. I had tried to push away memories of my parents and skate over the pain I caused Toots and Margie by running away on such a public stage. Now, I would face the ghosts of my childhood. I knew somehow that God had led me back to Cleveland, in part, to do just that.

*　　*　　*　　*

My reverie was interrupted by an announcement on the radio: Paul McCartney was coming to Cleveland to perform in August. Paul McCartney was coming to Cleveland!

The announcement hit me like a bolt of lightning. It ignited memories of my untold adventure. Why was I still keeping it a secret? Toots, Margie, and the Ursuline nuns were long gone. Juvenile court couldn't forbid me from attending Beatles concerts, and Cleveland Heights High had no control over me anymore. No one even remembered that the Beatles and rock and roll had been banned in Cleveland. That ban was lifted in 1966, and the Beatles performed at the Municipal Stadium. Cleveland even went on to become home of the Rock and Roll Hall of Fame.

As memories began to surface, this time, instead of pushing them aside as I'd always done, I sat back and invited them to take center stage in my mind. I remembered the manila envelope on which, decades ago, I'd written the words "Beatle Twins." In it I kept the newspaper clippings, copies of news stories, and a small notebook. The news stories documented the transatlantic, twenty-three-day, Beatle-mad, Beatle-seeking adventure with my best Beatle buddy as we escaped Cleveland and flew to London, rented a little flat in Holland Park, and melted into the Soho scene. I thought about Mick, my handsome Liverpudlian boyfriend. And the slow walk to the police station, the press conference at the steps of the U.S. Embassy, and the horrifying return to Cleveland. That was a hard memory to shake.

Mick. Would it be possible to find him again? All I remembered was his first name, that he was adorable, that he was a musician, and that he was from Liverpool but played in London. Not much to go on. After that last phone call with him, my life got very complicated, and I had to fight for survival.

All of that, and I never got close to the Beatles.

Where was that manila envelope now?

I headed to my bookcase and pulled out notebooks and photo albums and stacked them on the floor. One by one I searched until—there it was! Tucked into one of my old photo albums.

I pried open the metal butterfly clasp, pulled up the flap, and carefully teased out fifty-year-old newspaper stories.

I laid them out in chronological order and began to read.

"70 Beatle Fans Camp Out at Public Hall"

"Screaming Beatle Fans Stop Show 10 Minutes"

"Beatlemania Lures 2 Runaways to London"

"Ohio Girls Elude Scotland Yard"

"Beatle-Loving Girls Hunted"

"Torn Letters a Clue in Missing Girl Hunt"

"Two Cleveland Heights Beatle Fans Are Still in England After 18 Days"

"London Police Nab 2 U. S. Beatleniks"

"Beatle-Chasing Girls Get Cop Escort Home"

"2 Beatle Runaways Back as 'Delinquents'"

"Runaway Girls Released from Detention Home"

"Beatle Girls to Face the Music in Court"

"Two Beatles Buffs Biffed By Blunt Juvenile Judge"

"Public Hall to Ban All Beatlemania"

As I read the news stories, I began to relive my adventure anew. They were the documented evidence of my journey. There were photos of me with some of the stories. I looked confident, trendy, and very Jackie Kennedy–like. This was the girl that Mick saw.

But there were gaps in the dates of the articles I had. There must be more. In fact, I *knew* there were more. I remember the bobby at the West End Central Police Station in London showing me a few of the newspapers. I needed those, too. I had to have them all. Maybe Mick had been interviewed by someone. I had to know.

There was only one place to begin my search: the library, of course. The Cleveland Public Library first, then the British Library and other online sources. I painstakingly scoured reels of newspapers on microfilm and printed every story I could find.

I was overwhelmed to find dozens of articles and photos. There was a picture of me clutching my beloved Harrods umbrella. That crummy school photo the papers ran. The "Missing" poster. Marty and me in the back of the U.S. Embassy car wearing our "mod" sunglasses. Many of the newspaper stories had conflicting informa-

tion. I was particularly struck to read reports that a policewoman, or in some stories police*women*, first observed me walking down Oxford Street. Not so. It was one policeman—male, a bobby.

Other stories stated that Marty and I didn't actually go to London and Liverpool in search of the Beatles at all; that London was the first stop of a world tour. Two articles reported that we had gone to visit friends. None of these stories was true. The only plan had been to get to London and Liverpool and live in Beatleland forever. Where did that other information even come from?

Then, during the search, I came across something that made me cry. It was a letter to the editor in the *Plain Dealer* from November 8, 1964:

> I hold no brief for the two misguided teen-age girls who squandered their money, and it must have been theirs or they would not have had access to it, on the trip to England in search of adventure.
>
> I do contend the Juvenile Court was no place to solve their particular problems. It certainly is not the function and should not be the goal of that court to supervise on probation, or otherwise, the lives of these two girls, not to complicate their lives with reporting to the court, or with irreparable harm of the court record. Foolish, yes, they were so in the eyes of many, including me but, who has the right to interfere. Certainly not the court. . . .
>
> Juvenile Court is for delinquent children. Martha and Janice are not subjects for the court's attention. It has far more important work to do. Their cases should be expunged from the record.
>
> Clarence E. McLeod, 1516 E. 107th Street, Cleveland

I read his letter over and over, through tears. Clarence McLeod's words melted decades of silent guilt I'd lived with. A stranger had been on my side.

His analysis of the juvenile court's mishandling of the situation was very specific. He must have been an attorney or in some other way have had insider knowledge of the juvenile court system. I needed to find him and thank him for speaking out. I located one of his daughters, who said her father had been an attorney who practiced family law. He had passed away several years earlier. She asked me to send her a copy of the letter so she could read it and share it with her family. She said after she read it that it had brought tears to her eyes too. I wished her father had been my lawyer in front of Judge Gagliardo.

Now, as I looked back on the unfortunate ending of our adventure, I was suddenly struck by how differently we had been treated by the police in England compared to officials in our own home after we were brought back. I actually had fond memories of the London police officers, who treated us "Beatle girls" with care, a bit of humor, even tenderness—as well as a delicious breakfast. But my gut tightened when I recalled how shabbily, even roughly, I was handled by Cleveland Heights police detectives and the rest of the juvenile justice system of Cuyahoga County.

I looked again through some of the English newspaper clippings from October 1964. On the day we wound up at West End Central Police Station, a Metropolitan Police spokesman was quoted saying, "Because of their tender age, we shall be looking after them tonight." Another story reported: "A Scotland Yard Inspector said: 'They're both quite safe and sleeping peacefully now . . . and our only concern now is to get them home safely.'" So lovely. And it was true.

In contrast, the Cleveland Heights police detectives who met us at JFK the next day to escort us back to Cleveland didn't have one kind word. My detective grilled me on the plane as if I were a suspect in a major crime. After we arrived in Cleveland, he pushed me into the police car and then roughly grabbed me out and pulled me up the stairs into the Juvenile Detention Home—where

I spent one of the most harrowing nights of my life. And Judge Angelo J. Gagliardo—well, enough said about him already.

We didn't deserve that treatment. We'd really done nothing wrong, except annoy Cleveland Heights police chief Edward Gaffney—who, I discovered, had been quoted frequently in news stories about us. (His last comment to the news was that now he could get some work done.) I believe the tone he set contributed directly to how poorly we were treated by others, and to the punitive measures taken against us.

And then I found an article that astonished me. A story from October 9, 1964, in the *Daily Mail* (London), reported this: "As they took off for New York, a Beatles spokesman explained: 'We arranged to get Paul McCartney to see them off, but then the Embassy told us they did not want to encourage the girls.'"

Wait. What? You've got to be kidding me! I'd never known this before (and I'm still plenty angry and shocked right now as I write this). Encourage us to do what? We were already plenty encouraged on our own, and that's why we did what we did. Betrayed once again by Mr. Lilienfield of the U.S. Embassy! He had crushed my dream with one cruel and heartless swoop. I searched the Internet for Lilienfield and found his obituary. He departed this world long ago. I have no recourse now—I can't even write him a letter.

The opportunity to meet Paul McCartney had been snatched away from me without my knowledge. The very thing I had turned my life upside down for, that I had given up everything to do.

Lilienfield knew how much we wanted to meet the Beatles. Look what we'd done to get there. He would throw us to the reporters on the steps of the embassy but not allow us to just say "Hello, Goodbye" to Paul McCartney.

There was nothing I could do about it now except take some solace in the fact that at least Paul knew about us at the time—so many yesterdays ago.

* * * *

In 1964, when I sat in front of Mr. Lilienfield's desk in his office at the U.S. Embassy, I made a silent vow to come back to London and Liverpool as soon as possible.

I finally returned to Beatleland in 2018, more than fifty years after I'd left. I called it my "reunion tour" and did victory laps to celebrate my return. I revisited the U.S. Embassy on Grosvenor Square and found it was in the process of being converted into a luxury hotel. The West End Central Police Station at 27 Savile Row was in the process of closing. I spoke to a woman who was entering the police station and explained how I came to spend the night there so long ago. She said everyone from that era had either retired or passed on.

On to Rolling Stones Fan Club secretary Annabelle Smith's address, 93-97 Regent Street. No such address anymore. The closest was 99-101 Regent Street. I asked a man standing at the entrance if he remembered Annabelle Smith or the Rolling Stones Fan Club, but he said it was too long ago. If only I had a time machine.

I soothed my soul by taking a Beatles Tour. I visited Abbey Road and walked across the iconic zebra crossing.

On to Liverpool, the Cavern Club, and another Beatles tour that included the Fab Four's childhood homes, Penny Lane, Strawberry Fields, the Casbah, the Jacaranda Club, and the Mersey.

I finally made it inside the Cavern Club—sort of. It wasn't the original Cavern, which had been torn down in 1972, but a re-creation just across from the original on Mathew Street. I carefully made my way into the club down a narrow, winding, dimly lit stairwell. Tourists and musicians packed the halls of the windowless basement cave. I pushed and shoved my way through the crowd, just as Mick and I had done long ago at Soho coffee bars, trying to get close enough to the stage to see the musicians. The crowd was dancing, drinking, and singing along to the Beatles songs played by a tribute band. I had come heartbreakingly close to experiencing this in 1964, before being jolted back home. But I was satisfied that the Beatles experience had taken on a life of its

own. These people were just as much in love with the music as I had ever been.

The Beatles and their music transformed Liverpool and continued to infuse the city with life. The Royal Albert Dock, which had been lined with scruffy industrial warehouses when I walked along it with Mick in 1964, was now a huge tourist destination with restaurants, shops, galleries, and the Beatles Story museum.

I was strolling along the Albert Dock, taking in the Mersey, when I received a text message from a friend I had met on the tour. It was a picture of Paul McCartney. The message said Paul was there, right now, on the Albert Dock—at the opposite end— filming an episode of *Carpool Karaoke*. I tried to look down the length of the Albert Dock, but the waterfront was miles long. Even if I grabbed a taxi, I would never make it in time to catch a glimpse.

Many say that God has a sense of humor. I concur.

I sat down on a bench and gazed out on the Mersey. It had taken more than fifty years, but I had finally fulfilled the promise I made to myself while sitting in the U.S. Embassy in London back in October 1964: to return to London and to Liverpool.

Satisfied, I made my way back to my hotel. Eventually I returned to Cleveland—a second time.

And I started writing.

Author's Note

Dialogue in quotation marks is based on my recollection of what people said and how they said it, but I can't guarantee that it's quoted 100 percent verbatim.

This book is my story and is told from my point of view. Although Marty was an important part of the events in this book, I made no attempt to assume her point of view.

Acknowledgments

I'D LIKE TO THANK the following people who helped me with this book project:

Christopher Axelrod, classic rocker, who first recognized that I had an interesting story and helped me get the ball rolling.

Peter Miniaci, Beatles memorabilia historian and consultant, who told me I had a great story and said, "All you have to do is write it down."

Chris Turk, my attorney.

John Mays, flight expert at the TWA Museum.

Corinne Welty-Dupui, friend and former TWA flight attendant.

Violet Sky, 1980s pop culture enthusiast.

Nancy R. Zawada, Todd Rundgren enthusiast, horse lover, environmental educator, best friend.

Dave Van Horn and the Cleveland Writer's Group cheer team.

Ann Wicker, editor.

Karen Bogen, editor.

Karin Wiberg, editor.

Rosalie Wieder, copy editor.

Anastasia Pantsios, proofreader.

Cleveland Public Library research staff: Terry Metter, Evonne Jeffries, Sarah Dobransky, Karen Blackford, Brian Meggitt, Lisa Sanchez, Chatham Ewing.

Cleveland State University's Michael Schwartz Library Special Collections staff: Bill Barrow, Vern Morrison, and Beth Piwkowski.

Jennie Thomas, director of archives, Rock & Roll Hall of Fame Library and Archives.

Ursuline Sisters of Cleveland archivists Sister Colette Livingston and Sister Cynthia Glavac.

Sophia Lambert of the Ladbroke Association.

Anthony Hogan, author of *From a Storm to a Hurricane: Rory Storm & The Hurricanes, The Beat Makers: the Unsung Heroes of the Mersey Sound*, my Liverpudlian friend and supporter.

Pamela Swanson, friend and believer.

John Soeder, who made the final connection to my publisher.

David Gray, publisher, editor, creative realist, and visionary who knew a good story when he saw one.

Ann Moses, author of *Meow! My Groovy Life with Tiger Beat's Teen Idols*, who encouraged me to soldier on after telling me my story was "gold."

Marisa Barber, my criminal justice student with an eye for detail and organization skills.

Patricia A. Hawkins and John Kaiser.

The family of Clarence E. McLeod.

John, Paul, George, and Ringo: without them, this story would never have happened.

About the Author

JANICE MITCHELL is a retired federal investigator, a private investigator, an adjunct professor in the criminal justice department of Tiffin University, and a lifelong Beatles fan.

As an award-winning investigator, Mitchell worked on high-profile capital, criminal, and civil cases in New York City, including the Wendy's Massacre and the Carnegie Deli Murders. She has also worked on international investigations for Rolex, Gucci, Warner Bros., Levi Strauss, Hard Rock Café, and other trademarks. She was dubbed "a modern-day Nancy Drew" on CourtTV after she uncovered new evidence in a criminal case that led to the exoneration of a wrongfully convicted man.

After 9/11, Mitchell relocated from New York City back to her hometown of Cleveland, where she lives with with her Yorkshire Terrier, Dashiell Hammett. She is a supporter of animal rescue organizations.